The Complete Idiot's Reference Card

The Twelve Things to Remember as You Take Pen in Hand

➤ Work on a slanted surface and sit up straight.

➤ Use your whole arm to form the letters, not just your hand. Try to imagine your fingers, hand, and wrist in a plaster cast so they can't move individually, and that all the work of directing the pen is being done by your shoulder and elbow.

➤ Use a light pressure on the nib. Press evenly so both sides of the nib are in contact with the paper.

➤ Some people find that extending their little finger gives the hand a bit more stability.

➤ The pen should be held at about a 50-degree angle to your writing surface.

➤ The nib must always be pointing in the same direction—the one called for by the style in which you are writing.

➤ Choose your paper according to what will happen to it after you write on it.

➤ Work out how high to make the letters by drawing a ladder.

➤ If the ink flows too fast after you've filled your nib, you might have put in too much— simply write on scrap paper until your strokes are the right density. Another possibility is that a new nib still has some of its protective coating on it.

➤ If the ink does not flow immediately into the nib tip, don't press hard against the paper; check that the reservoir is in contact with the nib, that it's not grasping the nib too tightly, and that it is close enough to the edge of the nib. You also can try using another part of the paper to write on. The ink you are using might be old and too thick for the nib. Try thinning it down with a few drops of distilled water.

➤ To get the ink flowing, put a drop of ink on a piece of scrap paper and dip the tip of the nib in it to get it started. Draw a few short pulling strokes on the paper.

➤ The three-step way to study an alphabet is to first study the letter forms, then trace them, and finally to practice them on ruled paper.

The Important Things to Know About Formal Italic

➤ The letters are oval rather than round.

➤ They should be drawn on lines 5 nib widths apart. Ascenders and descenders need an extra $3^1/_2$ nib widths at top and bottom. Capital letters are 7 or 8 nib widths tall.

➤ You must keep your pen at a 45-degree angle.

➤ All the letters are the same width except the ones that are a single pen stroke—i, j, and l—and the double letters m and w.

➤ There is a slight slant—10 degrees—to the letters.

The Important Things to Know About Cursive Italic

➤ The letters are oval rather than round.

➤ They should be drawn on lines 5 nib widths apart. Ascenders and descenders need an extra $3^1/_2$ nib widths at top and bottom. Capital letters are 7 nib widths tall.

➤ You must keep your pen at a 45-degree angle.

➤ All the letters are the same width except the ones that are a single pen stroke—i, j, and l—and the double letters m and w.

➤ There is a slight slant—10 degrees—to the letters.

alpha
books

The Important Things to Know About Roman Capitals

➤ The letters are upright.
➤ The letters should be drawn on lines 7 nib widths apart. Because they are capital letters, there are no ascenders or descenders; therefore, the lines can be as close together as you want them to be.
➤ Keep your pen at a 30-degree angle for most letters, but at 45 degrees for letters with diagonals such as A, V, W, X, and Y. The Z needs a 20- or 30-degree angle for the horizontals.
➤ The thicks and thins of this style are not as contrasted as they are in italic. The curved lines should be slightly thicker at their widest points than the straight strokes. That way, they give the optical illusion of being the same thickness.
➤ The shape of O is a circle—remember this when you are making any of the circular letters. The thinnest letters, E, F, L, S, and J are half as wide as an O.

The Important Things to Know About Unicals

➤ The o is a slightly extended circle.
➤ Uncials should be drawn on lines 4 nib widths apart.
➤ Keep your pen at a 20-degree angle.
➤ Ascenders and descenders are small, extending 2 nib widths beyond the line for the x-height.
➤ There is no slant to the letters; this is an upright style.

The Important Things to Know About Foundational

➤ There is a characteristic oval shape to the counters or white spaces of the o—but the outside shape is circular.
➤ This is an upright style of writing.
➤ Foundational should be drawn on lines 4 nib widths apart, with the capital letters drawn on lines 7 nib widths apart.
➤ Ascenders and descenders are drawn on lines $6^1/_2$ nib widths apart.
➤ Keep your pen at a 30-degree angle.
➤ The g is an unusual letter. Notice that its top circular part is not the full depth of the writing lines.

The Important Things to Know About Gothic

➤ The letters are narrow and rigidly straight up and down rather than round or oval.
➤ Gothic should be drawn on lines 5 nib widths apart.
➤ Keep your pen at a 40-degree angle.
➤ Keep the white spaces inside the letters the same width as the black strokes.
➤ Ascenders and descenders are very short, only 2 extra nib widths.
➤ The shape of o is a compressed, angular rectangle with no curves.

THE COMPLETE IDIOT'S GUIDE® TO

Calligraphy

by Jane Eldershaw

alpha books

201 West 103rd Street
Indianapolis, IN 46290

A Pearson Education Company

Publisher
Marie Butler-Knight

Product Manager
Phil Kitchel

Managing Editor
Jennifer Chisholm

Senior Acquisitions Editor
Renee Wilmeth

Development Editor
Tom Stevens

Senior Production Editor
Christy Wagner

Copy Editor
Rachel Lopez

Illustrator
Chris Sabatino

Cover Designers
Mike Freeland
Kevin Spear

Book Designers
Scott Cook and Amy Adams of DesignLab

Indexer
Angie Bess

Layout/Proofreading
Angela Calvert
Svetlana Dominguez
Daryl Kessler
Stacey Richwine-DeRome
Gloria Schurick

Contents at a Glance

Contents

Introduction

Calligraphy is both a craft and an art. As a craft it's a skill available to all who take time to learn and practice (and when you love letter forms that's a pleasure, not a nuisance). In fact, calligraphy can be a very calming pastime. You can fall into a state very like meditation as you concentrate on letters and the shapes they make.

Calligraphy also is a way of drawing, but one that perhaps is easier than conventional drawing because you're working with the alphabet that is familiar to you. As an art it's a mode of creative expression—each writer brings a personal interpretation to each script. The words are like a musical score, and the calligrapher is like the pianist, interpreting how to present them.

Not only does your hand gain manual dexterity from calligraphy, but also you learn to see in terms of shape and composition—the way an artist does. Looking at different styles, picking out their differences, and comparing them with your own efforts trains your eye. You feel the same satisfaction that an artist feels when a project works out well and other calligraphers—who know that it's not as easy to write beautifully as it looks!—admire what you've done.

Sure, it can be infuriating at times; even expert calligraphers have terrible accidents with ink and paint water, ruining hours of work. There's also the frustration of getting angles right and strokes straight. Calligraphy can be a perfectionist's nightmare. However, the immense satisfaction of making a line that sings is worth it all.

Words, and graphic expressions of them in type or calligraphy, have always made me happy. Heretical as it might sound, I get far more pleasure from looking at the Japanese calligraphy I collected in Japan, or at the wonderfully playful ways in which an artist such as Saul Steinberg uses lettering, than I do from gazing at a Van Gogh or Rembrandt.

I'm not alone in loving lettering. Calligrapher Satwinder Sehmi says calligraphy "is the most happy and perfect expression of my life," which gives an indication of how much enjoyment it's possible to derive from this craft. I hope you, too, feel the satisfaction and joy of creating beautiful letters and that this book is the beginning of many happy hours of practicing calligraphy.

How to Use This Book

I've tried to arrange this book so that you start actually doing calligraphy as soon as possible, and then learn more about the tools and methods as you become more proficient.

The book is divided into six parts:

Part 1, "Start Write In," introduces you to a little history of calligraphy and outlines some of the uses it has today, in an era of computers. There's help in assembling the first tools you'll need, as well as setting up a place to write and learning how to hold a pen, so you can get started immediately. You'll learn about pen angles and letter shapes and start right in with italic, beginning with the letters that use the most common strokes in this alphabet.

Part 2, "The Write Stuff," covers all the basic tools available to calligraphers and gives you tips on how to optimize the time you spend practicing for best results. You'll learn about serifs and the variations they provide to lettering, along with the decorative possibilities of capital letters with flourishes.

Part 3, "The A to Z of Designing with Words," teaches how to organize your thoughts on paper through design. First, we cover the elements of spacing—between letters, words, and lines—one of the keys to good design and good calligraphy. Then you'll learn how to interpret text and make a good layout. Also included are some easy projects to begin with.

Part 4, "Turning Words into Art," provides how-to's for a variety of challenging projects: wedding invitations, scrolls, oriental calligraphy, family trees, and posters. We suggest ways to delight your friends and family by commemorating good food and good people with your own handmade awards and menus.

Part 5, "The Medium Is the Message," outlines a range of different tools and shows you some of the different effects you can make with different materials. You'll learn the basics of making your own quills and pens from a variety of tubes, plus all sorts of ornamenting techniques with ribbons and 3-D effects. Once you've made a masterpiece, you'll want to see it in print or frame it for display—and the how-to's are here.

Part 6, "Try Your Hand at These," introduces four more calligraphy hands for you to practice, all with different personalities. Roman capitals are for classic, dignified headlines; Uncial is for when you want a sprightly, whimsical look. Foundation is solid and steady and Gothic is dignified and dark, antique, or Christmasy, depending on how you use it.

Extras

This book includes additional asides, comments, and explanations to help along the way:

Scribe-Speak

This is where calligraphy terms are defined and you learn the language of the craft.

Ink Blots

These are warnings—pitfalls to watch out for and things to be avoided at all costs.

Sharp Points

Here's where you'll find tips, information, and advice gathered from expert calligraphers.

Additional Flourishes

These are interesting extras you don't have to know but that add to your knowledge of the art.

Acknowledgments

My deep and sincere thanks go to Nan Deluca (nbci.members.com/scribenyc) of the Society of Scribes (societyofscribes.org), herself an accomplished calligrapher and author, for her help.

I also am immensely grateful to the following calligraphers who kindly contributed their work to this book:

Holly V. M. Monroe of Heirloom Artist-Calligraphy and Design in Cincinnati, Ohio, a third-generation calligrapher whose motivation is to "feed the soul by making meaningful words beautiful." Her work is found in commercial, corporate, and church collections, as well as several presidential collections. Holly teaches a variety of workshops and conference topics (HollyVM@aol.com).

Harriet Rose (BFA), an artist and calligrapher in New York City for more than 20 years, teaches at the Learning Annex and privately. Her work has been featured in *Bride's Magazine, Manhattan Bride,* and the recently published book from HarperCollins, *The Perfect Wedding Reception: Stylish Ideas for Every Season,* by Maria McBride-Mellinger (www.rosecalligraphy.com).

Margaret Harber, a professional calligrapher who has taught calligraphy at the Learning Annex, the New York Public Library, and the Society of Scribes. She has many high-profile corporate and social clients in New York City. With her husband, Margaret owns the New York–based printing company Kaleidakolor (212-475-1653).

I'm also deeply grateful to Mr. Shinji Narasaki for the Japanese calligraphy.

And thanks always to Elisabeth MacIntyre and George Ladas for their love and help and patience.

Trademarks

Part 1

Start Write In

You want to pick up a pen and start writing beautifully right away, and this part helps you do just that! First, there's a brief look at the venerable history of calligraphy—the craft you'll master has a long and artistic tradition. You'll discover how calligraphy is used today, and why.

Then there's help in assembling the first tools you'll need, setting up a place to write, and holding the pen. The first calligraphy hand you'll learn is italic, starting with the letters that use the most common strokes, set out in an easy-to-learn, stroke-by-stroke format. Once you can do those, you've learned almost the whole style!

Finally, you'll practice letters in similar groups, covering a whole section of the alphabet at a time.

The ABCs of Beautiful Handwriting

In This Chapter

➤ Becoming part of an ancient tradition

➤ Appreciating the art of fine letter forms

➤ Learning what professional calligraphers do

➤ Why you don't need artistic skill so much as a will to succeed

Calligraphy, the art of beautiful handwriting, is one of the most satisfying crafts you can learn. Aside from using it daily to add elegance to everything you write, you'll also be able to create lasting keepsakes commemorating special occasions for friends and family such as handwritten wedding invitations, fancy labels and signs, and one-of-a-kind greeting cards.

You don't need to buy a lot of expensive tools to begin; in fact, you can improvise many of the things you'll want. Instead of buying a sloping board with an aligning parallel rule along the side, you can use a wooden tray from the kitchen. For large letters you can use a piece of cardboard cut from a cereal box. And for practice paper to start with, a school notebook is fine. Calligraphy is a hobby that can be as expensive or as cheap as you wish to make it.

Moreover, if you learn the basic alphabets by using a calligraphic felt-tip pen, you'll find that when you do examine the wide range of *nibs* available, you have an idea of what kind you want to buy. You'll be able to feel a paper's surface, too, and know if it is smooth enough to write on. And when you pick up a pen holder you'll be able to judge how comfortable it will be to use—all because you've had some experience.

When you've mastered the basics, you can go on to experiment with all sorts of exciting new materials: gold paint, colored paper, and nibs in all different styles.

Scribe-Speak

Nibs are the metal points you write with.

Scribe-Speak

The word **hand** is used by calligraphers in different ways. A style of lettering can be called a "hand"; for example, we talk of an italic hand. Or when you like the way someone forms her letters, you can say that she has "a good hand."

B.C.: Before Computer

Today, when information can be sent to almost all corners of the world in a matter of seconds, it's hard to imagine a time when every single book that came into being was laboriously written out by hand. However, for hundreds of years before printing with moveable type was invented in the mid-fifteenth century, that's exactly what happened. Manuscripts (documents written by hand) were copied by monks and priests working away in church libraries with quills during the Dark Ages.

Almost all the letter forms that calligraphers use today are based on those centuries-old manuscripts, some of which you can still see in museums. Many were preserved only because the monks decorated them with gold and precious stones. At the time they were written, learning and scholarship were not valued.

Different Styles, Different Names

Like architecture or any craft, writing styles are influenced by the tools and materials available. Just as in an area where there are a lot of tall trees, local inhabitants will build houses of wood, so different forms of writing, or *hands*, develop when different writing instruments and surfaces are used. In ancient Roman times when words were carved onto buildings, capital letters evolved—upright and elegant with each letter based on a square—because they were relatively easy to chisel into stone.

But it's hard to duplicate carved letter forms when writing with pens on a smooth surface. The curvier scripts that we know as *calligraphy* naturally developed as scribes used quills and *parchment* to write with.

Scribe-Speak

Calligraphy comes from the Greek word beautiful, *kallos*, and the Greek word *graphein*, meaning "to write."

Originally, **parchment** was the word for a lamb or goat skin scraped of its hair and flesh to provide a writing surface—scribes have used it at least since the second century B.C.E. (Have you ever heard a college degree called a "sheepskin"? That's because parchment has long been used for important documents.)

Everyone has his or her own style of handwriting—some nearly illegible—even though we all might learn to write the same way as children. In the eighth century, as the demand for holy books grew, Charlemagne, conqueror of most of Western Europe, tried to establish a

standard script to achieve a level of uniformity. The clear, simple, and efficient letters he favored became known as Caroline Miniscule, and most of the calligraphic styles we use today are directly descended from it.

In different parts of Europe, other communities of scribes, being much more isolated than they are today, evolved their own unique styles. For example, the pointed, spiky letters called Gothic or Old English probably were influenced by the Gothic architectural style in the fourteenth and fifteenth centuries in Northern Europe.

INK

Additional Flourishes

All the capital letters of the alphabet as we know it (except for u, j, and w) were being used as early as 200 B.C.E. They were the classic Roman capital letters, the kind you see carved in stone behind Lincoln at the Lincoln Memorial. Small letters were developed later—they were easier to write with a pen and were introduced by the scribes of the Middle Ages.

Even after the invention of printing there was an interest in beautiful handwriting, with Italian masters during the Renaissance writing "how-to" books and reviving the Carolingian letter form and creating a style of calligraphy that was quicker to write by making the letters slightly slanted and eliminating the need to constantly lift the pen nib when writing.

Senza la quale auuertenza, è impoßibi-le peruenire alla uera perfettione delo Scriuere .

Calligraphy by the Venetian master Giovanbattista Palatino, 1561.

Handwriting as Art

What makes calligraphy beautiful? An English medical student, Edward Johnson, revived the art of calligraphy at the beginning of the twentieth century by analyzing old manuscripts in the British Museum to discover the secret of their beauty. His studies convinced him that it was the consistent angle of the broad-edged pen making distinctive thick and thin strokes that give calligraphy its elegance.

Experts use the same kinds of words to describe good calligraphy that artists use to describe a successful piece of sculpture or music. They say it has structural uniformity, integrity, and strength. It might take a while before you can look at writing and identify these characteristics for yourself, but the more you examine fine examples of calligraphy the more your eye will be educated.

As a beginner, your first aim is to produce a piece of writing that is clear and easy to read. Next, you should strive for consistency of shape, angle, and spacing. The repetition of similar shapes creates a rhythm that is pleasing to the eye.

Good calligraphy also has a joyful spontaneity—but that comes only after you have complete familiarity with the letter forms and tools you are using. Keep practicing and keep looking at examples of good calligraphy by both modern professionals and ancient masters and soon you will learn to see for yourself what makes calligraphy beautiful.

Calligraphy in an Electronic Age

Why bother to strive to keep your letters even, consistent, and repetitious, when computers do that sort of thing far more efficiently? Because a computer can't put life into writing the way a calligrapher does. Beautiful writing is not just words on paper; it is art. The spirit of the person who did it comes through unmistakably. It's the difference between a hand-knitted sweater and a machine-made one; a hand-blown piece of crystal and glass produced in a factory.

Calligraphy is a unique medium for artistic self-expression. Some master calligraphers blur the lines between writing and art by making their work purely abstract and expressionistic, using their pen strokes as if they were paint and interpreting letter forms in unique ways.

You don't have to go that far to express your individuality. However careful you are in forming the letters, your personality will come through in whatever you write. Just like painters and writers, calligraphers learn in the beginning by copying others, but go on to develop a unique style.

Apart from what you create, you will find that the activity itself is rewarding. Calligraphy coordinates hand, eye, and mind. And when everything is going smoothly, when your hand is steady and the ink flowing well, it's a very soothing, relaxing pastime, almost like meditation. You will feel a communion of spirit with the scribes of old.

Calligraphy by Joe Henninger who taught illustration at the Art Center School in Los Angeles, collection of George Ladas.

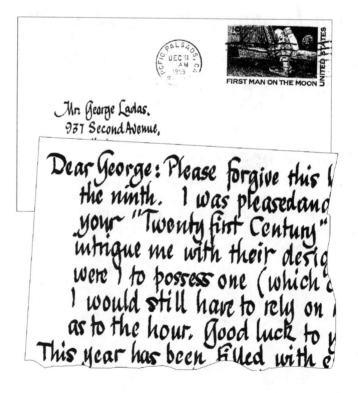

People Get Paid for Doing This?

As computers make it easy to churn out printed envelope address labels, calligraphy is gaining in popularity as a stylish, nonmass-produced alternative. Professional scribes find themselves called upon to produce all sort of invitations, greeting cards, invitations, announcements, labels, tags, posters, and place cards. Many civic government, business, and religious organizations need decorative certificates, charters, and scrolls. Calligraphy also is used increasingly in advertising, magazines, publishing, packaging, and graphic design. Today you'll see book jackets, wine labels, and even ceramics decorated with script. See the following figures showing examples.

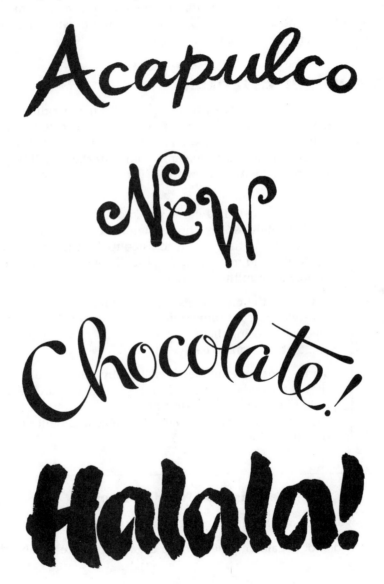

Don't make the mistake of thinking you will be able to earn money from calligraphy next week. Professionals spend lifetimes perfecting their craft. However, you can get started quickly.

How long will it take to master calligraphy? Everyone learns at a different rate, but if you start this craft with the goal of selling your work rather than expressing your creativity, you'll never become an expert.

It's true that calligraphy has commercial potential for those who become proficient—the initial business outlay is not great and the market is established—but becoming accomplished takes many years of practice. Professionals know it's more than just being able to create beautiful letters. You need to know how to interpret the words of a text and how to enhance them with color and design.

Practice making cards and scrolls for friends. Develop your own distinct style. Learn how to let the words you write become the inspiration for the way you write them. Develop an eye for beautiful letter forms and a pleasing layout. Wherever it ultimately takes you, calligraphy is a charming craft and a relaxing hobby.

Artistic Talent Not Essential

The good news is that you don't need artistic talent or good handwriting to be a good calligrapher. It's far more important to have the dedication to practice 30 minutes a day. Everyone learns at a different speed, but if you are willing to put in the time to learn, it won't be long before you are creating art that you'll be proud of. You'll see progress within a few weeks if you set aside half an hour a day to practice.

If you've ever studied music you know that first you have to master the fundamentals—scales, chords, simple exercises—before you can produce anything that is a joy to listen to. It's the same with calligraphy. You will spend many hours repeatedly drawing letters before you will be able to form them without constantly referring to the book.

But one of the nice things about calligraphy is there are so many different styles of letter formation, writing instruments, and ink or paint and methods of using them, you are sure to find a method that suits you and that you can do easily.

Start a folder of examples of calligraphy from magazines, look up Web sites at the end of this book, and collect poetry and texts that you would like to copy out. Most of all, commit yourself to practicing regularly and enjoy yourself. You will be able to produce beautiful artwork only if you love what you are doing.

Sharp Points

Train your eye to see subtle differences in shapes and pay close attention to details. Try to look at original manuscripts by both old masters and modern artists. You can't draw what you don't see, so by studying good calligraphy you'll know what you're aiming for.

The Least You Need to Know

➤ Calligraphy is an ancient craft that is as useful as it is beautiful.

➤ You don't need a lot of cash or equipment to begin to practice making elegant letter forms.

➤ Skill comes with practice and the ability to notice subtle differences in letter forms.

➤ You don't need artistic talent, or even have beautiful handwriting, to learn how to do calligraphy.

Pick Up Your Pen

In This Chapter

➤ Gathering your first tools

➤ Why posture matters

➤ Holding the pen at the right angle

➤ What to do if you are left-handed

➤ Mastering the most commonly used strokes of Cursive Italic

You want to get going right away—and you can! You'll be delighted to see how easy it is to start writing beautifully. You might already have many of the first tools you need somewhere around the house.

To begin, you don't even need nibs and ink. In fact, practicing with a felt-tipped calligraphic pen or a pencil lets you get familiar with the motions of making the letter forms without distraction. Mastering the technique of using a dip-in pen and ink—without spills!—comes later.

First you'll set up your work table and get a comfortable grip on your pen, which will make it easy to get comfortable forming the letters. You'll begin to learn how to really look at letters, too, so you can recognize good calligraphy and know what to aim for. This is the chapter in which you start putting pen to paper.

The Only Tools You Need to Begin

Gather together the following items:

➤ A board at least 18 by 24 inches. You can even use a serving tray or a heavy piece of cardboard.

➤ Four sheets of paper that is a little smaller than the board.

Sharp Points

A light source from the left is ideal (or, if you're left-handed, from the right). Try not to let shadows fall on your work. Indirect light is best; direct sunlight reflecting off the paper creates glare that is very tiring on the eyes.

➤ A sheet of blotting paper as wide as the board.

➤ Masking tape.

➤ A 2mm-wide calligraphic felt-tipped pen or a carpenter's pencil sharpened to 2mm wide.

➤ A sheet of tracing paper.

➤ A few pages of graph paper ruled with a grid.

➤ A few pages from a ruled legal pad (or photocopy the pages used in this book).

When you start using a dip-in pen and ink you'll need more supplies, but to begin with you can use a pencil or calligraphic fiber pen. That way you can concentrate on forming the letters without worrying about getting the ink to flow properly from your pen nib or making a mess of expensive paper. What you must have, however, is a good work surface.

Slant Board

Calligraphy should be done on a slanted surface. This allows for a more comfortable pen angle than if you were working on a flat table. It also means that your eyes are parallel to the writing surface and it prevents you from hunching over. Later, when you use ink, working at an angle means the nib is less likely to flood. You will need a board at least 18 by 24 inches—some people prefer a larger board of about 24 by 30 inches. Use whichever size and angle that feels most comfortable to you.

Additional Flourishes

You can buy adjustable table easels with folding legs and a strip of metal down the side (called a true edge) from an art supply store, but there's no need yet. Many professional calligraphers use a board that they rest on their laps. If you or a friend have carpentry skills, making a slant board is not a difficult project.

How do you use the board? There are two methods calligraphers use. The simplest is to rest the board on your lap, with the top edge propped up against a table. Alternatively, you can put the whole board on the table and rest it against a stack of books. Prevent the lower end from slipping off by clamping a thin strip of wood to the edge of the table.

Cover the board with about four sheets of paper a little smaller than the board and tape them down. This gives a slightly softer surface to work on than bare, hard wood.

You'll need a sheet of paper as wide as the board to use as guard paper. Blotting paper is good, but any paper will do. This is to protect your work from your own sweaty hands. Tape each end to the sides of the drawing board. The paper you are working on slips underneath this guard paper.

Before each session, wash your hands. Your paper probably will pick up grease from your hands anyway, especially while you are learning, but it helps to start off as clean as possible. Make sure to take off any bracelets or rings that might get in your way.

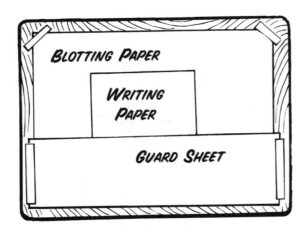

This is how your work surface should look when you begin.

Carpenter's Pencil or 2mm Felt-Tipped Calligraphic Pen

When you are doing lots of calligraphic projects you'll want to have lots of different nibs, each with a different width, so you'll be able to make small words with the small nibs and bigger letters with the bigger nibs. Right now we're specifying a 2mm width because it's the perfect width to use on legal pad paper, which usually has rules about 10mm or 5 pen widths apart. Unfortunately, every company that makes pens or nibs uses a different way of coding the width. If your pen is a different width, turn to Chapter 5, "Practice, Practice, Practice," where you'll learn to rule lines five pen widths apart.

If you want to use a pencil, look in a hardware store for a flat carpenter's pencil with a wide, chisel-shaped "lead"—or you might find one in the toolbox at home. The graphite is graded like other pencils; H are hardest, B is softest, and HB is in the middle. An HB pencil is better than a soft point, which will need sharpening more often. You will need an X-acto knife or block of sandpaper to shape it 2mm wide and to keep it sharp.

Ink Blots

Never use a calligraphy marker for finished work. Markers, although great to practice with, do not have a long life. They quickly develop the fuzzies, so edge definition does not stay crisp. Also, the ink in a marker is not the true black you'll need for finished pieces, and the color will fade over time.

A carpenter's pencil can be shaped to the width you want.

Posture Makes Perfect

When you create calligraphy you're not just using your hand—your whole arm gets into the act. That's why posture is important. If you're not sitting properly you'll soon get uncomfortable and tired.

Sit up straight with your feet on the floor, your arms on the writing surface, and your eyes no closer than about ten inches from your paper. Every now and then while you work, you should check to see that you have not unconsciously slipped in to a hunched-over, twisted position because it really can cramp your style.

Sit up straight!

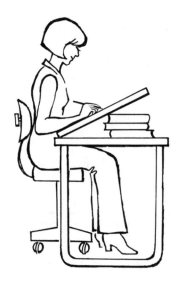

Sharp Points

If your arm has to move too far across the work surface, your letters will be distorted and your arm will get tired. To prevent this, keep your hand in the same general area and instead move the paper up and down and to the left and right with your free hand as you work.

Get a Grip: How to Hold the Pen

Although you hold the pen in your hand the same way you do for normal handwriting, the way you move it is different from the way you were taught in elementary school. In normal handwriting the wrist controls most of the movement; in calligraphy, try to imagine your fingers, hand, and wrist are in a plaster cast so they can't move individually, and that all the work of directing the pen is being done by your shoulder and elbow.

Hold the pen normally—not too tightly—about half an inch from the end, pressing on the paper with a light pressure; but always make sure the nib is pointing in the same direction. The pen should be held at about a 50-degree angle to your writing surface. Some people find that extending the little finger gives the hand a bit more stability; try it and see if it works for you.

Feeling kind of awkward? Don't worry. Keeping all these instructions in mind at the same time will be hard at first—like brushing your teeth with the wrong hand—but keep practicing and it'll soon become second nature.

Here's how to hold the pen.

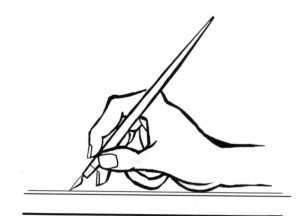

Left? Write!

If you are left-handed you might have some difficulty finding what works best for you. Some alphabets are more suited to left-handers than others. You might find that the Uncial style is easy for you to do because nib is held almost flat.

If you try different positions eventually you'll find one that works for you—and it probably won't simply be a mirror image of what right-handers do. Try writing slightly to the left of your body and turning your *hand* as far left as possible with your paper slanted uphill to the right. You also can try using a nib with a slant, called a left-oblique nib, so you don't have to twist your wrist too much. You can experiment by cutting balsa wood pens (see Chapter 13, "Making Posters and Playing with Words").

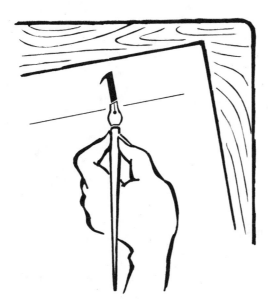

If you're left-handed, this probably is the most comfortable position to hold the pen.

Working the Angles

Each writing style in calligraphy requires you to hold the nib at a different angle. It's this consistent angle that makes the thick and thin strokes that gives calligraphy its rhythm and beauty. Pen angle refers to the angle made between the edge of the pen nib and the writing line—don't confuse it with the angle at which you hold the pen.

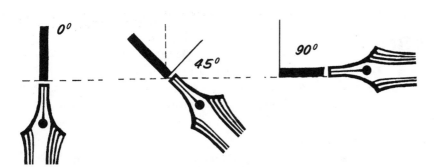

Here's the direction the nib should be facing for different angles.

13

For the style that you'll be learning first—Formal Italic—you'll need an angle of 45 degrees; but for Roman, for example, you'd need an angle of 30 degrees.

Here's an easy way to find the right angle and help you understand how it works. On your graph paper, mark off an area five squares by five squares. Now draw an X from corner to corner. The first stroke, from top left to bottom right, will be the widest your pen can make. The second stroke, top right to bottom left, will be the thinnest your pen can make—and you made them both at the correct 45-degree angle.

Making an X will show you a 45-degree angle.

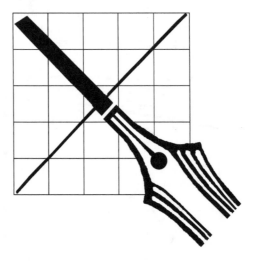

Some Warming-Up Exercises

Warming-up exercises for a calligrapher are as necessary as a piano player doing scales. Do some zigzags on your ruled paper to get used to the correct pen angle of 45 degrees and do zigzags before each practice session to make sure you have the correct angle.

A few lines of zigzags make a good warm-up exercise.

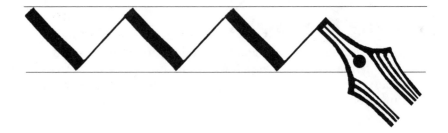

Learning Your ABCs

The first script you'll learn is Formal Italic. We'll begin with the small, or miniscule, letter m. The strokes you use to make this letter are used for many of the letters in this style. Once you master this basic stroke you are well on your way to forming the rest of the letters in the alphabet correctly.

There are three steps to learning any new handwriting style, or hand, and you should follow them when doing this first exercise. First study the letters, then trace them, and then do them by yourself on ruled paper.

Study the Letters

First, look carefully at the way the letters of the alphabet you are studying are formed. Look for shapes that the letters have in common. There are subtle differences in styles. For example, look at the master sheet for Italic in Chapter 3, "Starting in Style: Formal Italic." Notice it's a condensed form and that the O is not round but oval. All the letters are the same width, except for i, j, l, m, and w.

The following figure shows two different variations on the letter m so you can note the difference. They both are italic, but they are different. Notice how the ends of the letters finish. In the first example, they stop abruptly but keep the angle of the stroke. In the other, the pen curls around to make a curved serif.

Additional Flourishes

Do you know which is the most used letter in English? E! And the runners-up are a, o, i, d, h, n, and r.

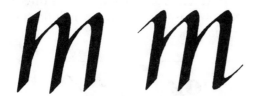

Notice the difference between these two calligraphic versions of the letter m.

The next thing you are looking for when you study a letter is the stroke sequence. In calligraphy you must lift your pen up off the paper more than you do in regular writing because a dip-in pen nib will splatter if it's pushed up or to the left. Each stroke of the pen is done in a specific order each time. In the following figure, you see the stroke sequence for the Cursive Italic m.

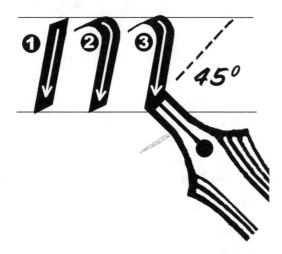

Always follow this stroke sequence for the letter m.

You also should notice both the angle of pen nib relative to writing line for each style you are studying and the letter slope; that is, the slope of a normally upright letter such as an l in relation to the writing line.

Trace

Okay, you're ready to begin! Place a sheet of tracing paper over the m in the preceding figure and trace it with your flat pencil or calligraphic pen, keeping your nib at that 45-degree

angle, following the stroke sequence and remembering all those other instructions! Don't worry—it will get a lot easier.

Take the tracing paper away and compare your letter m with the original. Are the hairlines thin enough? Is the letter wobbly? Trace the m again until you are happy with the result.

Practice on Ruled Paper

Now it's time to jump right in on your own. Use the legal pad with ruled lines. Do a whole row of ms and compare them to the original. The turns at the top should not be too round or too pointed. Turn your page upside down. The letters now should be curved like u, not v. The beauty of calligraphy is based on the even repetition of similar strokes. Do yours have that eye-pleasing regularity of form?

Okay, now it's time to move on to the next letter, a. You'll follow the three steps again: First you'll look carefully at the letter to see how it is formed. Then you'll try tracing it. Finally you'll make the letter by yourself on ruled paper.

The next letter you'll study is a; when you've perfected your a, do a whole page of "mama-mama."

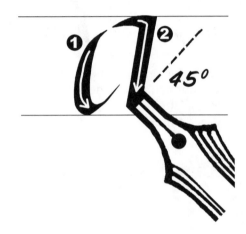

Congratulations! You've mastered the most-used strokes necessary to write in Formal Italic. The rest of the alphabet, in the next chapter, should be a snap.

The Least You Need to Know

➤ Work on a slanted surface and sit up straight.

➤ Use your whole arm to form the letters, not just your hand.

➤ Keep your nib at a consistent angle—it's the key to beautiful letter forms.

➤ The three-step way to study an alphabet is to first study the letter forms, then trace them, and finally to practice them on ruled paper.

Starting in Style: Formal Italic

> **In This Chapter**
>
> ➤ Why italic is a good place to start
>
> ➤ Forming letters with a stroke-by-stroke guide
>
> ➤ Learning how to make similarly shaped letters as a group
>
> ➤ Studying the stroke sequence for each letter

Italic is considered by many calligraphers to be the most beautiful lettering style. The basic principles have stayed essentially the same for 500 years—even the legendary Italian artist Michelangelo was proud of his Italic handwriting. Italic's rhythm and movement—due to its slight angle and springing arches where the strokes join—make it elegant yet lively.

Many people use italic for their everyday handwriting, which is a good habit to get into if you are serious about calligraphy. Although you don't have to take a great deal of care when dashing off a note or a shopping list, having the discipline to form italic strokes every time you write is great practice. It'll mean that when you sit at your drawing board to do an art piece, you'll have a fluency that translates into less tension in your hand and more exuberance in your letter forms.

So What's Formal Italic?

Today calligraphers make a distinction between two *italic* scripts: formal and *cursive*. In formal the letters are not joined; in cursive they are. Most people find it easier to start with formal.

Additional Flourishes

Scribes in Italy developed the italic style during the Renaissance, inspired by the rounder Caro-lingian style popular in ninth-century France. It was lighter and freer in style (a change from the heavy gothic styles that came before) and met the need for a quicker, more elegant letter for the growing number of religious documents that had to be copied. If you study the works of the Venetian writing masters—there's a sample in Chapter 1, "The ABCs of Beautiful Handwriting"—you will see italic done at its best.

Scribe-Speak

Italic means any style that is slanted instead of straight up and down. **Cursive** means any writing that is linked together, like most people's handwriting. It's quicker to do than styles in which you have to lift your pen after each stroke.

The Important Things to Know About Formal Italic

Every style in calligraphy has features that make it distinctive. Look for the following characteristics in the pages that follow and keep them in mind when you form the letters yourself:

➤ The letters are oval rather than round.

➤ They should be drawn on lines 5 nib widths apart. Ascenders and descenders need an extra $3^1/_2$ nib widths at top and bottom. Capital letters are 7 or 8 nib widths tall.

➤ You must keep your pen at a 45-degree angle.

➤ All the letters are the same width except the ones that are a single pen stroke—i, j, l—and the double letters m and w.

➤ There is a slight slant—10 degrees—to the letters.

Stroke Sequence

As you learned in Chapter 2, "Pick Up Your Pen," each stroke of the pen in calligraphy is done in a specific order each time. A guide with a stoke-by-stroke numbering system as shown in the following is called a *ductus* or *exemplar*. The arrows show the direction of the stroke and the numbers show the order in which you should do them.

The letters are arranged in logical groups according to how they are made—once you've learned how to make a small a, for example, you learn how to make similar letters such as g and q. Just as you did with the letters m and a, first look carefully at the letters, then trace them, and then try doing them on your own.

Check that your strokes are parallel and evenly spaced. Because most of the letters are the same width it's easy to work out spacing of the letters. Your aim is to make an even distribution of space inside and outside the letters.

Scribe-Speak

The word **ductus** means the direction and sequence of letter strokes. An **exemplar** originally was a book from which a master's work was copied; now it means an ideal pattern or model worthy of imitation.

Sharp Points

Springing arches are a feature of italic. Look carefully at how the letter n is formed. The arch starts about two thirds up the stem of the first stroke and springs out at an angle. One of the most common mistakes beginners make is to form a round and symmetrical curve, which is wrong for this style. Try to lighten your pressure as the nib starts this stroke because you are pushing it uphill and the ink can splatter if you are not careful. This same shape is repeated at the base of letters a, d, u, q.

How do you like writing in Formal Italic? If you find it easy, keep practicing as much as possible until it becomes automatic. If you find it awkward, try the variation in Chapter 6, "Elegant Variations: Chancery Cursive." Some people find that the serifs on this type of italic make it easier. Alternatively, try a different style altogether—Foundational (see Chapter 19, "Foundational") is one that many beginners like. The important thing is to find a style that you are happy using.

Sharp Points

If the paper you are using is too slippery for the pen, try rubbing it all over with a soft eraser.

The Least You Need to Know

➤ Italic is one of the most beautiful styles, and you can use it for everyday handwriting.

➤ Keep the letters all at the same angle—10 degrees—and the angle of your nib at 45 degrees.

➤ Study each letter carefully before you begin. The letter o is oval in shape and has distinctive springing arches.

➤ Italic should be drawn on lines 5 nib widths apart.

➤ All the italic letters are the same width except for the ones that are a single pen stroke—i, j, l—and the double letters m and w.

The letter *a* is key to italic. Once you can draw it comfortably
this group of letters, based on the *a* shape, will also be easy to draw.

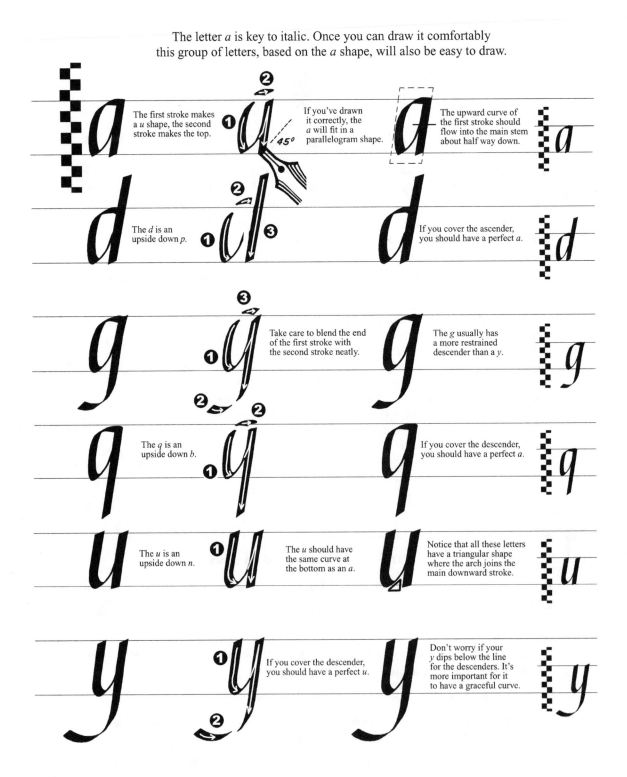

The first stroke makes
a *u* shape, the second
stroke makes the top.

If you've drawn
it correctly, the
a will fit in a
parallelogram shape.

The upward curve of
the first stroke should
flow into the main stem
about half way down.

The *d* is an
upside down *p*.

If you cover the ascender,
you should have a perfect *a*.

Take care to blend the end
of the first stroke with
the second stroke neatly.

The *g* usually has
a more restrained
descender than a *y*.

The *q* is an
upside down *b*.

If you cover the descender,
you should have a perfect *a*.

The *u* is an
upside down *n*.

The *u* should have
the same curve at
the bottom as an *a*.

Notice that all these letters
have a triangular shape
where the arch joins the
main downward stroke.

If you cover the descender,
you should have a perfect *u*.

Don't worry if your
y dips below the line
for the descenders. It's
more important for it
to have a graceful curve.

45° *Italic*

These letters all begin the same way — with a
straight line on a ten degree angle.

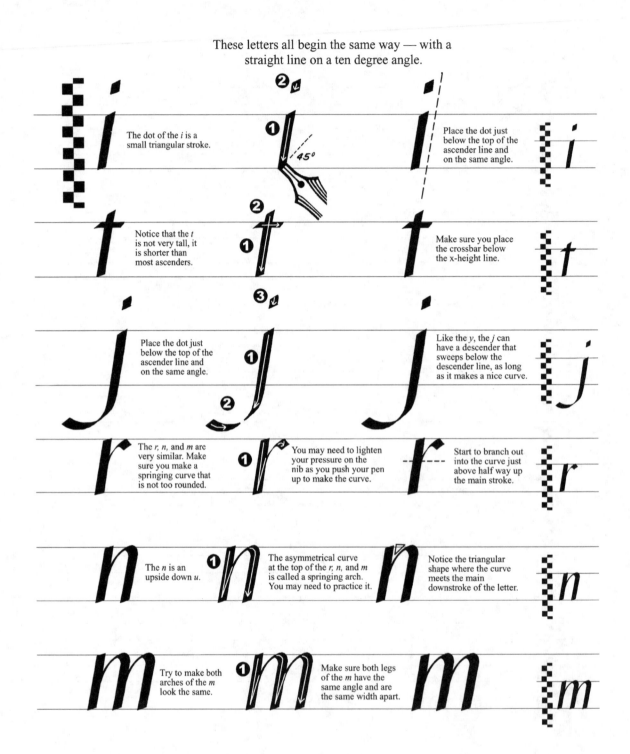

The dot of the *i* is a
small triangular stroke.

Place the dot just
below the top of the
ascender line and
on the same angle.

Notice that the *t*
is not very tall, it
is shorter than
most ascenders.

Make sure you place
the crossbar below
the x-height line.

Place the dot just
below the top of the
ascender line and
on the same angle.

Like the *y*, the *j* can
have a descender that
sweeps below the
descender line, as long
as it makes a nice curve.

The *r, n,* and *m* are
very similar. Make
sure you make a
springing curve that
is not too rounded.

You may need to lighten
your pressure on the
nib as you push your pen
up to make the curve.

Start to branch out
into the curve just
above half way up
the main stroke.

The *n* is an
upside down *u*.

The asymmetrical curve
at the top of the *r, n,* and *m*
is called a springing arch.
You may need to practice it.

Notice the triangular
shape where the curve
meets the main
downstroke of the letter.

Try to make both
arches of the *m*
look the same.

Make sure both legs
of the *m* have the
same angle and are
the same width apart.

45° Italic

This group all start with a similar first stroke.
Practice the *l* thoroughly and the other letters will be easy.

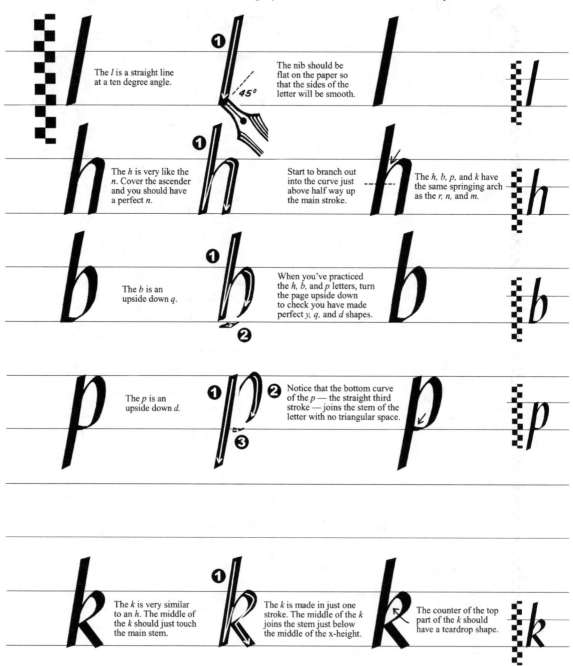

The *l* is a straight line at a ten degree angle.

The nib should be flat on the paper so that the sides of the letter will be smooth.

The *h* is very like the *n*. Cover the ascender and you should have a perfect *n*.

Start to branch out into the curve just above half way up the main stroke.

The *h, b, p,* and *k* have the same springing arch as the *r, n,* and *m*.

The *b* is an upside down *q*.

When you've practiced the *h, b,* and *p* letters, turn the page upside down to check you have made perfect *y, q,* and *d* shapes.

The *p* is an upside down *d*.

Notice that the bottom curve of the *p* — the straight third stroke — joins the stem of the letter with no triangular space.

The *k* is very similar to an *h*. The middle of the *k* should just touch the main stem.

The *k* is made in just one stroke. The middle of the *k* joins the stem just below the middle of the x-height.

The counter of the top part of the *k* should have a teardrop shape.

45° Italic

The *c*, *e*, and *o* are all based on the *a*,
they have a similar curve and the same width.

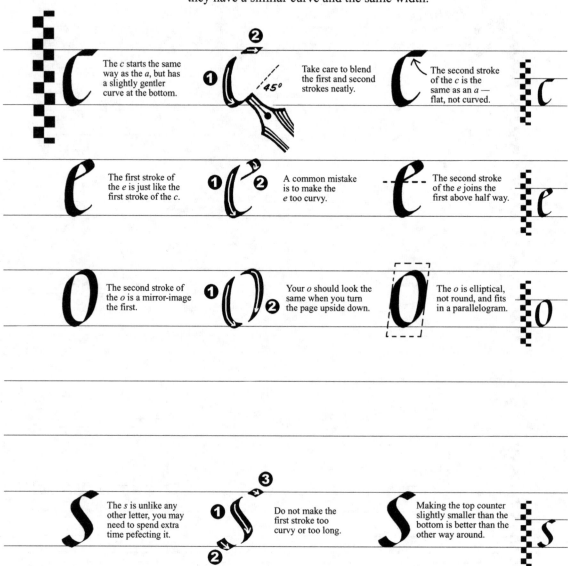

The *c* starts the same way as the *a*, but has a slightly gentler curve at the bottom.

Take care to blend the first and second strokes neatly.

The second stroke of the *c* is the same as an *a* — flat, not curved.

The first stroke of the *e* is just like the first stroke of the *c*.

A common mistake is to make the *e* too curvy.

The second stroke of the *e* joins the first above half way.

The second stroke of the *o* is a mirror-image the first.

Your *o* should look the same when you turn the page upside down.

The *o* is elliptical, not round, and fits in a parallelogram.

The *s* is unlike any other letter, you may need to spend extra time pefecting it.

Do not make the first stroke too curvy or too long.

Making the top counter slightly smaller than the bottom is better than the other way around.

45° *Italic*

Pay attention to the diagonal angles of these letters, they do not conform to the rules that govern the other letters in the alphabet.

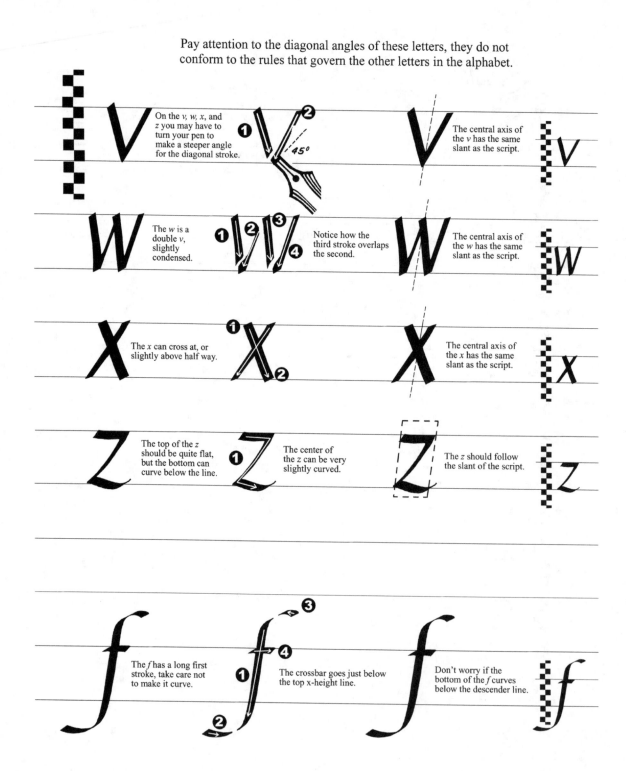

On the *v*, *w*, *x*, and *z* you may have to turn your pen to make a steeper angle for the diagonal stroke.

The central axis of the *v* has the same slant as the script.

The *w* is a double *v*, slightly condensed.

Notice how the third stroke overlaps the second.

The central axis of the *w* has the same slant as the script.

The *x* can cross at, or slightly above half way.

The central axis of the *x* has the same slant as the script.

The top of the *z* should be quite flat, but the bottom can curve below the line.

The center of the *z* can be very slightly curved.

The *z* should follow the slant of the script.

The *f* has a long first stroke, take care not to make it curve.

The crossbar goes just below the top x-height line.

Don't worry if the bottom of the *f* curves below the descender line.

All these circular letters are based on the letter *O*,
which, like the lower case *o,* is elliptical.

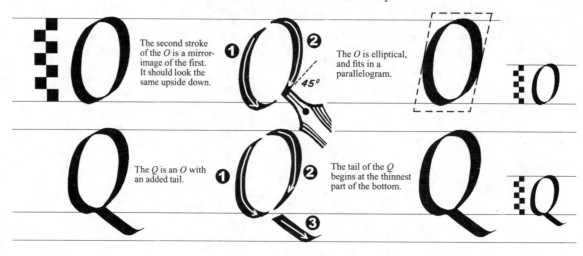

The second stroke of the *O* is a mirror-image of the first. It should look the same upside down.

The *O* is elliptical, and fits in a parallelogram.

45°

The *Q* is an *O* with an added tail.

The tail of the *Q* begins at the thinnest part of the bottom.

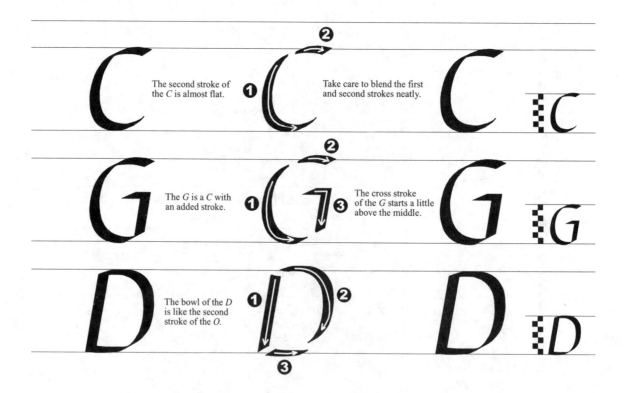

The second stroke of the *C* is almost flat.

Take care to blend the first and second strokes neatly.

The *G* is a *C* with an added stroke.

The cross stroke of the *G* starts a little above the middle.

The bowl of the *D* is like the second stroke of the *O*.

45° Italic

This group is made up of straight lines at a ten degree
angle — but watch where you place the crossbars.

The nib should be
flat on the paper so
that the sides of the
letter will be smooth.

1

45°

Don't make the foot
of the L too long.

1

The *L, F, E,* and *T* should
all be the same width.

2

1

3

The third stroke
should be half
way down or a
little below.

The two top cross strokes
of the *E* should be the
same length, the bottom
one is a little longer.

1

2

3

4

The third stroke
can be a little
above half way.

The top of the *T*
lies below the
x-height line.

1

2

It is easier to start with
the cross stroke, then
make a second stroke
down from its middle.

Do not make the *H*
too wide, it should be
no wider than an *O*.

1

2

3

Draw the crossbar
slightly above
half way.

Pay attention to the angles of the letters in this group.

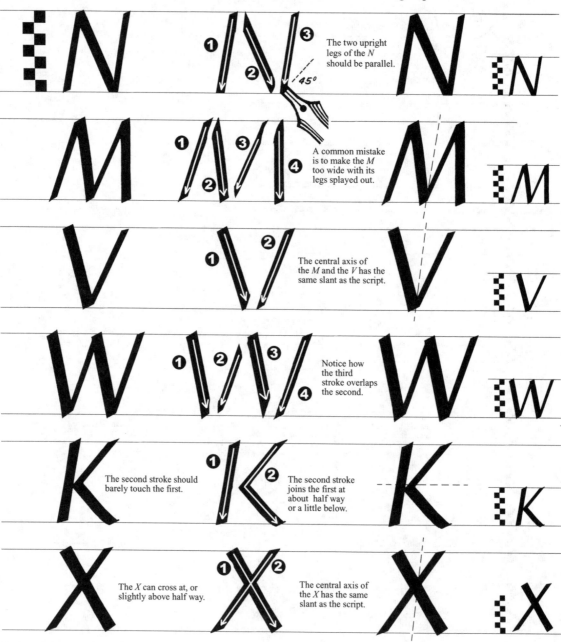

The two upright legs of the *N* should be parallel.

45°

A common mistake is to make the *M* too wide with its legs splayed out.

The central axis of the *M* and the *V* has the same slant as the script.

Notice how the third stroke overlaps the second.

The second stroke should barely touch the first.

The second stroke joins the first at about half way or a little below.

The *X* can cross at, or slightly above half way.

The central axis of the *X* has the same slant as the script.

45° *Italic*

These letters have small bowls based on the letter *O*.
Take care to make them the right size.

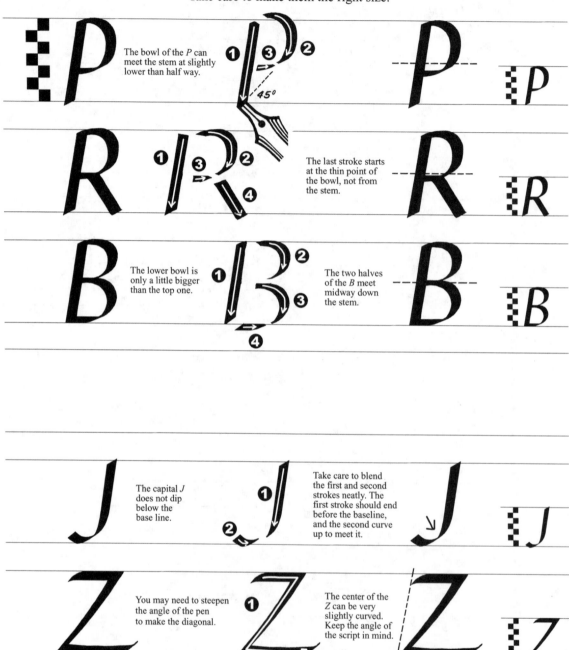

The bowl of the *P* can meet the stem at slightly lower than half way.

The last stroke starts at the thin point of the bowl, not from the stem.

The lower bowl is only a little bigger than the top one.

The two halves of the *B* meet midway down the stem.

The capital *J* does not dip below the base line.

Take care to blend the first and second strokes neatly. The first stroke should end before the baseline, and the second curve up to meet it.

You may need to steepen the angle of the pen to make the diagonal.

The center of the *Z* can be very slightly curved. Keep the angle of the script in mind.

45° Italic

This group includes letters with unusual angles.

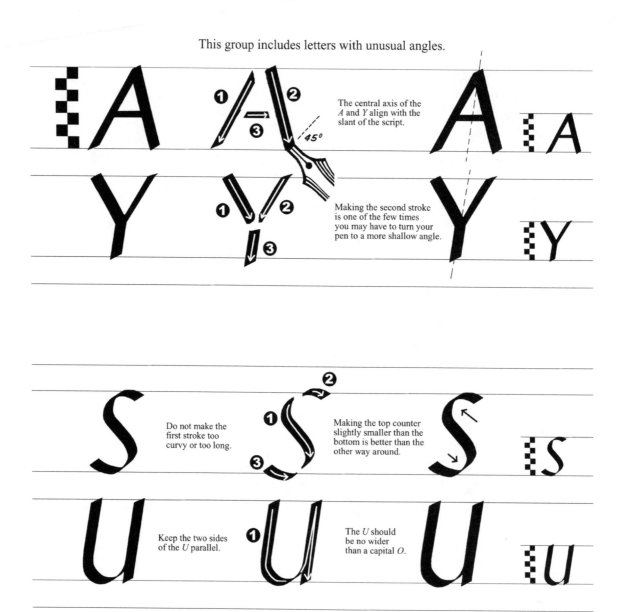

The central axis of the *A* and *Y* align with the slant of the script.

45°

Making the second stroke is one of the few times you may have to turn your pen to a more shallow angle.

Do not make the first stroke too curvy or too long.

Making the top counter slightly smaller than the bottom is better than the other way around.

Keep the two sides of the *U* parallel.

The *U* should be no wider than a capital *O*.

45° Italic

Numerals and punctuation for most styles of calligraphy follow the stroke sequences shown here, but should be made using the pen angles and characteristics of their own alphabet.

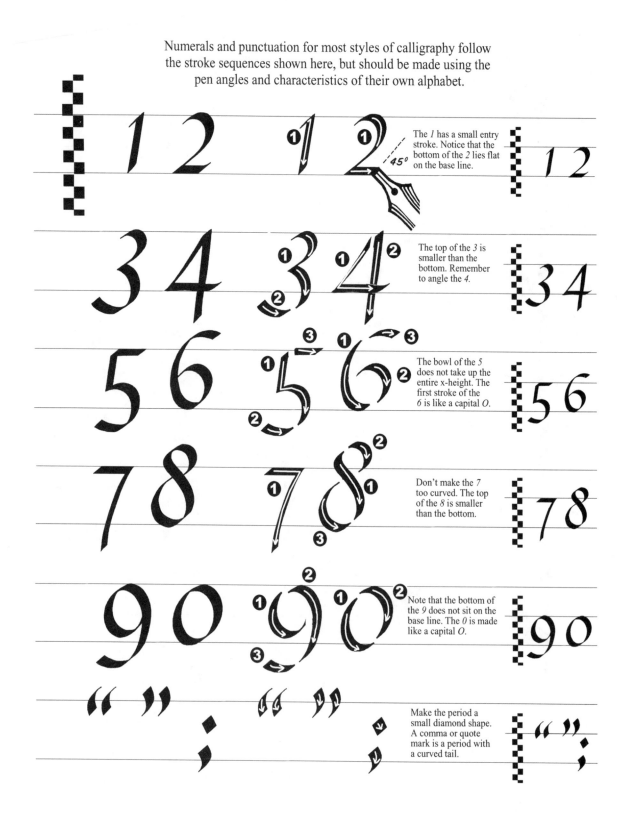

The *1* has a small entry stroke. Notice that the bottom of the *2* lies flat on the base line.

The top of the *3* is smaller than the bottom. Remember to angle the *4*.

The bowl of the *5* does not take up the entire x-height. The first stroke of the *6* is like a capital *O*.

Don't make the *7* too curved. The top of the *8* is smaller than the bottom.

Note that the bottom of the *9* does not sit on the base line. The *0* is made like a capital *O*.

Make the period a small diamond shape. A comma or quote mark is a period with a curved tail.

45° Italic

Part 2
The Write Stuff

Once you've started to get a feel for calligraphy, you'll want to explore all the different tools available. This part covers the basics.

As well as the stuff to write with, you need to have the right stuff—the will to practice, practice, practice. However, this isn't a chore if you love calligraphy and heed the tips here. Practice just half an hour or so a day, and you'll soon see improvement. To add variety, you'll try some of the fun strokes—beautiful decorative capital letters with flourishes.

Tools of the Trade

<div style="border:1px solid">

In This Chapter

➤ Why the tools you use are as important as what you write

➤ The pros and cons of fountain pens

➤ How to buy pens and nibs and put them together

➤ Choosing the right paper for the job

</div>

Tools are part of the craft itself. The magic of calligraphy lies in coaxing beautiful forms out of mundane materials—and that magic is much easier to work now than in ancient times when scribes had to take hours to prepare their own parchment or vellum and were constantly cutting at their quills to provide a new, clean edge with which to write.

At first, you might find confusing the variety of pens, nibs, and papers available today. Don't worry; until you've mastered the basic letter forms, expensive nibs won't help. It's the same as learning to cook: Until you've mastered the art of making a cheese soufflé with plain cheddar, having exotic, imported cheese won't make any difference in your technique.

However, once you are proficient in calligraphy, it's fun to experiment with different tools to give a new look and feel to your work and to find out what suits you best. With so many to choose from, you'll eventually find a combination you like, whether it's discovering a nib that's angled in a way you find comfortable to use, making your own reservoirs, or finding a paper that's the perfect surface for your favorite ink.

Calligraphic Fountain Pens

Fountain pens usually are more expensive than a penholder plus nib, but if you want a portable pen to practice with, you might find them worthwhile to buy. There are advantages and disadvantages to fountain pens. The best advantage is that they do not have to be constantly refilled, as dip-in pens do. Also, you can easily carry them with you anywhere to practice lettering at any spare moment during your day.

However, the nibs in fountain pens tend to be less flexible and sensitive than a dip pen. Although some fountain pens come with a range of different nibs, it's usually a limited choice. Also, you will have to use a special, water-soluble ink that is thinner than normal so that it will not clog the mechanism of the fountain pen, which means you don't get the nice, dense, opaque black letter that's essential for those special pieces of calligraphy that you want to display and keep without fading over the years.

Calligraphic Broad-Nibbed Pens

You might have been using a pencil or felt pen so far, but once you feel fairly confident that you can make all the letters of the alphabet, it's time to try a pen and nib. Felt-tipped pens are no good for the finished pieces of artwork you're going to create. You want a tool that can make crisp, clean letters and use a variety of different inks.

A dip-in pen consists of a holder and nib, which usually are purchased separately. Try out a few different pen holder varieties—some are round, some are faceted, some are wrapped with cork or made of wood—and get one that feels comfortable in your hand. You also should be sure that the holder will firmly grip the type of nib you want to use with it.

There's no universally agreed-upon system for categorizing nib size; every manufacturer follows a different system. For the beginner, a wide nib, at least 3.5mm (0.15 inches) wide, such as Mitchell's Round Hand nib size 1½, will be easiest to use. However, Brause and Speedball also are good brands.

The main difference between brands is flexibility. Most calligraphers like a flexible nib because it is more sensitive to their strokes. If you've ever experienced flipping pancakes, you know that using a springy spatula is much more satisfactory than, say, trying to flip with a rigid knife. Nibs are not expensive, so buy a few different sorts and experiment.

When buying nibs, examine them carefully to make sure the nib is not bent or the points separated or uneven. If you run your finger along them, they should feel smooth, with no little extra bumps of metal that were missed during the production process.

The nib fits into the penholder.

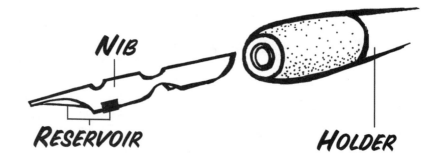

NIB

RESERVOIR

HOLDER

Assembling a Pen

A new nib comes with an oily coating of shellac or wax to protect it. You can remove this coating by soaking the nib in hot water for half an hour and then wiping. Alternatively, dip it in waterproof ink, which has a slightly corrosive effect. Wipe and repeat three times.

Push the nib into the penholder until it is firmly attached. Add the reservoir, or if the nib comes with its own reservoir check that it is in the right position. Be sure that the two sides of the nib are not crossing over each other.

Reservoirs

Reservoirs are little bits of metal designed to fit on to a nib to increase the amount of ink it holds—this gives a more even flow. Some nibs come with reservoirs, some don't, and some reservoirs are permanently attached to their nibs, which make them slightly more difficult to clean. Some reservoirs are meant to sit on top of the nib, which might mean you can't see the point at which the nib touches the paper. A few calligraphers make their own reservoirs each time they write by fixing a tiny piece of tape across the underside of the nib.

You will need to experiment for yourself. You might find that you do not like using a reservoir at all. Whatever feels right for you, helps you produce beautiful letters easily, and is most comfortable to use is what you should be using.

When you're assembling a pen and nib, be sure the reservoir touches the nib but does not protrude beyond it (the part you actually write with should be the nib, not the reservoir).

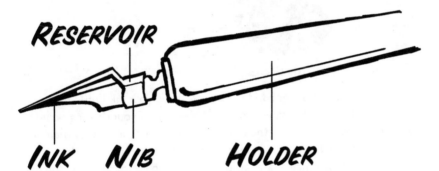

How a reservoir works.

RESERVOIR

INK NIB HOLDER

Loading a Pen with Ink

Although they are called "dip-in" pens, dipping a pen into a bottle of ink isn't really the best way to fill a nib with ink. Filling it that way can flood the nib and reservoir; you'll have to get rid of some of the excess, and run the risk of getting drips on your working surface.

To fill the nib with ink, take an old paintbrush and dip that in the ink. Turn your pen upside down and stroke the bristles across edge of nib at its widest point, so that the ink fills the space between the nib and reservoir. If your ink bottle has a glass dropper attached to its lid and a rubber bulb on top, use that to squeeze a drop of ink onto the nib. Alternatively, you can use a separate eyedropper. Always be sure that no ink gets on the upper surface of nib.

How to load a pen with ink.

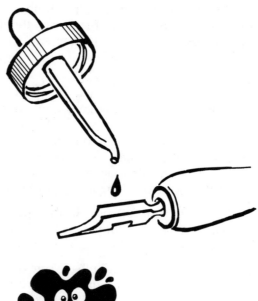

Ink Blots

To avoid accidents of the disastrous kind, it's a good idea to always keep your ink bottle in the same place—for right-handers, on the your left side, and vice versa—and off your drawing board. Some calligraphers make a broad-based holder for their ink bottles by cutting a hole for them in a piece of foam. Alternatively, you could use masking tape to make sure the bottle won't tip over, and a piece of corrugated cardboard makes a good place to hold pens so that they don't roll away.

Sharp Points

If you get into the habit keeping the pen in your right hand (if that's the hand you write with) and using your left hand to fill the pen with ink, you will save a lot of time by not frequently changing hands.

Fixing Ink Flow Problems

If the ink flows too fast after you've filled your nib, you might have put in too much. Simply write on scrap paper until your strokes are the right density. It's also possible that the new nib still has some of its protective coating on it.

If, on the other hand, the ink does not flow immediately into the nib tip, don't try to fix the problem by pressing hard against the paper. This can damage the nib. Instead, be sure the reservoir is in contact with the nib, that it's not grasping the nib too tightly, and that it is close enough to the edge of the nib. Also make sure you're not trying to write on a part of your paper that has picked up grease from your hands. Try another part of the paper and be sure you're using a guard sheet.

If your ink is old and has evaporated a little it might be too thick for the nib. Try thinning it down with a few drops of distilled water. To get

the ink flowing, put a drop of ink on a piece of scrap paper and dip the tip of the nib in it to get it started. Draw a few short pulling strokes on the paper.

Cleaning Pens

If you use waterproof ink that dries quickly, you might have to stop and clean your nib frequently as you write. You'll know that too much ink is building up when your strokes lose their crispness.

Keep a small jar of water near your ink bottle so you can dip the nib into it when ink has begun to dry on the nib and interferes with your writing. Blot the nib dry with a rag or tissue and be sure there are no small bits of debris caught in the nib. Do the same thing if you have to stop what you're doing for a few minutes, especially if you're using waterproof ink.

When you've finished for the day, slide off the reservoir, rinse it under running water, and dry it with paper towel. Soak the nib overnight in a special solvent such as Higgins Pen Cleaner or ammonia to remove the pigment, and use an old toothbrush if necessary to get it clean. Next morning, rinse it in cold running water and dry it thoroughly with a paper towel, taking care to not bend the nib. Store your nibs in a small box.

Get into the habit of cleaning your equipment after each use, not just to be neat but because a true craftsman always cares for his tools. Besides, it's harder to remove dried ink that has not been cleaned off the pen immediately. It's a waste of time and paper to not keep nibs in good condition.

Other Equipment You'll Need

You'll need a method for ruling lines. If you don't have a drawing board with a sliding parallel ruler attached you'll need a T-square and large, plastic triangle, or the triangle plus a 15-inch ruler.

Use medium-hard pencils to rule lines. You might think harder would be better, but in fact, a very hard pencil can leave an indentation in the paper that picks up the light and is impossible to erase. Use soft pencils for layouts and sketches.

Cheap paintbrushes are good for mixing *gouache* and feeding ink into pens and old toothbrushes for cleaning nibs. You'll also need a water pot, masking tape, a rag for cleaning your pen, and blotting paper, both to cushion your drawing board and to serve as a guard sheet.

Scribe-Speak

Gouache (pronounced *g'wash*) also known as "designer color" is watercolor that has been made opaque. Most art supplies shops sell it in small tubes. Windsor-Newton and Pelican are good brands.

You'll want to have both ink and pencil erasers. A soft, nonabrasive eraser such as a kneaded eraser or a white plastic eraser will not harm the paper. If you have made a mistake in ink, a mildly abrasive eraser can be useful, although it will take some of the paper surface off along with the mistake.

An Olfa knife is good for slicing paper and shaping reeds, balsa wood, and crayons into pen shapes. These knives are light and easy to handle, and you can quickly and easily access a sharp, new blade point by snapping off the old, used part.

Ink

Any liquid substance can be used to write with, as long you can get it to the right consistency to pass through your pen nib. For good calligraphy, you want a fluid that makes a solid black stroke when it dries on the writing surface; one that will last for years and not fade over time (a quality known as *permanence*). Unfortunately, it's difficult to find both those qualities together in one liquid. Of course, you may like to write in soft pale ink, and not mind if the letters fade, but if you want your work to be reproduced in print, you'll need to write in a very black ink.

Inks are labeled either waterproof or washable. Waterproof (also sometimes called indelible ink) is a very black ink and has lasting qualities, but it tends to clog nibs and will not make really fine lines.

Water-soluble or washable ink flows easily, but is sometimes watery and uneven in coverage. To overcome this, some professionals mix washable ink with black gouache to produce a fluid that's dense and black but flows easily.

The ink you can make from a Chinese ink stick provides a good, deep black that works well on many papers to which other inks have a hard time adhering, but you must grind it yourself. If you decide to try an ink stick, get a large ink stone, as it will be easier to use than a small one. Put a few drops of water—distilled water is best—on the ink stone and rub the ink stick into it with a circular movement until a smooth pool of ink forms. Keep testing the ink on paper to see if it is black enough and keep grinding and adding water until you have enough ink to use for that day—it will not keep.

Ink Blots

India ink is very dense, good quality, permanent black ink, but it should be used only with nibs specially designed for it. The ingredients in India ink that make it permanent have a corrosive action on brass pen nibs.

Grinding an ink stick takes time but produces a good quality ink.

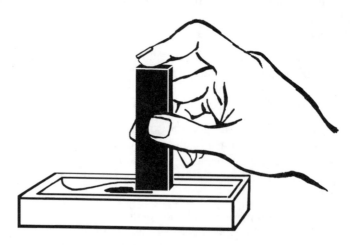

Color

Color gives your artwork a whole new dimension and adds energy and vigor. You can use color to draw the eye to different parts of your layout, to enhance words or mute them, to balance a layout or create a discordant note, or to give high drama or serenity. Using the same color for two different elements on your page unites them.

Rather than try to mix your own colors, consider just buying, to begin with, the exact shade of gouache you want to use for a particular job, plus black and white. That way you get exactly the color you want—when you mix colors yourself they often turn out muddy.

Also, it's really hard to mix up a color to exactly the same hue every time. If you have a tube of the right color, you don't have to worry about whether you've mixed enough paint for the whole job. And as you do different projects you'll slowly build your palette.

If possible, keep a nib just for using with colors, and never use it with black ink. You'll need old paintbrushes for mixing and you may want to work with a wide watercolor brush. Other necessities are a dish to mix paint (a white saucer is best, so you can judge the colors at their truest values) and a water container for rinsing nibs.

Traditionally, calligraphers used red paint for emphasis. (The expression "It's a red letter day" originated when scribes used red pigment for saints' days on medieval calendars to make them stand out.)

Today, however, you don't have to stick with red; you can do calligraphy with any fluid that is thin enough to pass through your pen nib. That includes inks, dyes, metallic and fluorescent colors, watercolor, gouache, tempera, and acrylic paint—as well as using pencils and chalks or pastels.

Color Inks

Inks come in beautiful colors and need no mixing. The bottles often come with a rubber bulb on top and dropper inside to make filling your pen easy.

Inks tend to fade over the years, so don't use them on a piece you would like to have last for decades. Also, inks are transparent, and don't give a flat even coating of color—but this isn't necessarily a disadvantage. Transparency can create a beautiful effects that you might enjoy working with.

Watercolors, also, are transparent, and more permanent than inks, although the colors are not as luminous and bright.

Gouache

When you want the flat, opaque coverage of colored paint for your calligraphy, use gouache. Poster color is not as smooth and acrylics dry too quickly and are difficult to use. Choose artists' rather than designers' gouache; it's more finely ground.

Squeeze some paint from the tube into a white mixing dish and add a few drops of water with an old paintbrush. Mix until the fluid is the right consistency—about the same consistency as ink. This takes practice: too thick and it won't flow properly, too thin and your letters will be thin and pale. Add water drop by drop; you can thin paint much more easily than you can thicken it.

If possible, mix gouache about four hours before you need it and let it stand, well covered. It will flow more evenly and be less sticky than freshly mixed paint.

Paper

There are thousands of different papers available in different parts of the country, and each kind has a different texture—smooth, medium, or rough—that reacts differently to the various inks and nibs. Most calligraphers have their favorites, just as they have certain pens and paints they prefer. The only way to get to know the characteristics of each type of paper is to experiment. Poor quality paper can make the ink spread and will leave a mark when you erase mistakes. Test paper before you buy a lot of it.

To narrow down the choices when you go to buy paper, think first of what you are going to do with it and what sort of surface and weight you'll need. For practicing calligraphy, a good-quality bond paper designed for copy machines is fine. (It'll be labeled 20 pound or 75 gsm, which is a measurement that tells you how heavy it is.)

Additional Flourishes

Paper merchants buy and sell paper by a complicated system called basis weight, designed for the use of manufacturers who buy paper in bulk. Luckily, it's possible to go in to an art supply shop and pick out a piece of paper to buy without knowing its specifications, but here's a quick overview of basis weight.

A paper might be described as 80-pound cover or 24-pound bond. The words cover and bond refer to the grade of paper (in much the same way as sedan and SUV refer to different types of car). The weight refers to what 500 sheets of it would weigh. But different grades are manufactured in different size sheets, so the numbers don't relate between grades—24-pound bond is thicker and heavier than 20-pound bond but you can't compare a 24-pound cover and a 24-pound bond.

To make things more complicated, 24-pound is sometimes written # 24 or sub 24. And even though two different brands of paper may have the same basis weight, the thickness of each sheet of paper can vary. Paper made in countries that use metric measurements is weighed in grams per square meter, or gsm.

If you are lettering a project that will be printed by a commercial printer, the look of the paper you use doesn't matter—the job will be printed on paper you select later. You can use whatever works well, such as Bristol board, which has a surface that enables you to easily scrape off the ink if you make mistakes. If you are going to put a watercolor wash behind your calligraphy, you'll need paper heavy enough that it will not ripple or buckle when it gets wet.

The time to splurge on a really good paper is when you are planning a special, one-of-a-kind project that you hope will be treasured forever. For that, a 100 percent, long-fibered rag paper would be best, with a gsm of about 160. (Most papers are made with wood pulp, but one that is made from rags is much stronger.)

You also should be sure that any paper you want to last is acid free. Have you ever noticed how quickly a newspaper goes yellow when it's left out in the sun? That's because newsprint is a very cheap type of paper, made with a lot of acids. Paper that is made to be used with chalk pastels—called pastel paper—is an example of an acid-free paper with a high rag content. It comes in all sorts of colors, is either textured or smooth, and is ideal for calligraphy projects.

Strathmore charcoal paper is good to write on. Ingres, a mold-made paper named after the French painter, comes in many nice colors. Watercolor papers are usually too rough to use

with a pen. Printmaking papers are good for resists and embossing and linoleum prints, but some are too soft for nib.

Remember, though, that you don't have to write directly on colored paper to get that lift that colored paper provides. You can always write on a piece of white paper of the type you prefer using—and do it over and over without ruining an expensive piece of colored paper—and then glue the white paper on to a piece of colored paper. This looks even more effective when you tear the edges of the white paper.

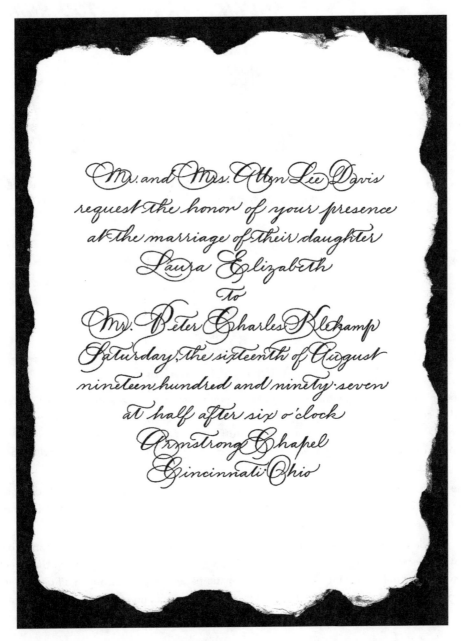

This invitation by Holly Monroe of Heirloom Artists-Calligraphy and Design in Cincinnati was done on handmade paper.

(© Holly V. M. Monroe)

Inferior paper might be impossible to write on.

PAPER TOO ROUGH

PAPER TOO SHINY

PAPER TOO ABSORBENT

PAPER TOO GREASY

Additional Flourishes

Paper is made by mixing either wood pulp or ground-up rags into a watery soup of whiteners and thickening material. This pulpy moisture is whisked quickly along a mesh conveyer belt. The water falls away and the fibers in the pulpy stuff that remains are all jiggled into a similar direction as they're carried along toward rollers that squeeze out the last drops of liquid. What remains after the pulp has gone through the rollers is paper.

The surface that the paper ends up with largely depends on these rollers. Heated rollers means the paper is very smooth, and it's called a *hot-pressed* paper. *Cold-pressed* paper is less smooth, and paper that is not pressed at all has a rough surface.

Handmade paper is made much the same way, but because the pulp is shaken up and down by hand rather than along a conveyer belt, the fibers go in all directions, not just in the direction the conveyer belt was going. This means handmade paper is equally strong in all directions. You'll see why you need to know this when you start folding paper and making cards and invitations.

The best way to get a "feel" for papers is to actually examine the surface and rub a sheet between your fingers. You will feel it if the paper has a good "tooth," that is, whether the surface is rough enough for your pen to get a grip. A smooth surface is fine, but not one that is very shiny or greasy.

Hold the paper up to the light. Good papers have a watermark, and if you can read it properly, you have the right side. You don't have to use that side—you can use either one—however, one side might be smoother than the other.

When you're transporting paper try to avoid rolling—it's easy to get marks on it that way. You might need to invest in a large portfolio to carry it, or ask the shop to wrap it flat with a large piece of cardboard.

Sharp Points

If the paper you are using is too slippery for the pen, try rubbing it all over with a soft eraser.

The Least You Need to Know

➤ Learn to use a dip-in pen with ink.

➤ Always keep your nibs clean; it saves time and energy.

➤ There's no one right nib or reservoir. You'll need to experiment to see what suits you best.

➤ Choose your paper according to what will happen to the piece of calligraphy you write on.

Practice, Practice, Practice

In This Chapter

➤ Learning how to practice effectively

➤ Loosening up and getting in the groove

➤ Ruling up your paper

➤ Making your mistakes invisible

Learning all the styles in this book will give you a vocabulary with which to speak in calligraphy, but to speak any language you need to put in a lot of practice time. Beautiful handwriting is not a skill you can learn in just one weekend. If you love calligraphy, this won't be a chore. However, to keep yourself motivated, collect examples of writing you admire and try to catch exhibitions of work that inspires you.

Keep a folder of your own work, too. Date each piece—even your first attempts—and use a notebook to record what nibs and ink you used. Make a photocopy of any work you give away. It won't be long before you see how well you are progressing—always great motivation to encourage you to continue.

The Route from Awkward to Graceful

Aim to practice for about half an hour a day. As a beginner, you should try to follow the form of the examples as closely as you can. As you write, keep the ductus, the pages which show you how to make the letters, in sight and constantly compare your letters with the illustrations in the book to see how you can improve before starting again. Don't copy the letters you made yourself.

This all might seem obsessive, but you must develop the ability to assess your own efforts. The correct shape of the letters and the order in which the strokes are made have to become completely familiar to you before you can create good calligraphy.

Begin each session by checking the work from your previous practice session. Take note of anything that does not look right—weak characters, poor spacing, or wobbly strokes.

After you check your previous work, start by doing exercises—some zig-zags to check that you have the right pen angle, perhaps a few rows of writing "mamama," or letters that you are having trouble forming. When the individual letters look right, start doing words, and then sentences.

Write slowly and deliberately. Each letter must be completed with evenly drawn, uniform strokes. Don't press so hard that the two sides of the nib spread out or become uneven, making one side of the stroke ragged. You should not be putting pressure on one side of the nib more than the other. This can easily happen if the writing surface is too hard, so don't forget to put a few cushioning pieces of paper under your work, as described in Chapter 2, "Pick Up Your Pen."

After you've finished half a page of practice sentences or words, check your work against the examples in the book. If they don't seem to be the same, keep looking back and forth until you see the mistakes and can work out what you are doing wrong. Circle the problem areas with a red pen and do a whole line correctly. At the end of your practice session, tape your work up on a wall, or look at it reflected in a mirror to be able to get a more objective assessment of it. Then start all over again tomorrow.

Sharp Points

The distinctive features of a letter are in its top half. When we read, we're really only looking at the tops of letters. Cover the bottom halves of the words you've written to check that you're forming the all-important top halves of the letters correctly. You should be able to read the words even with the bottom halves covered.

If you don't press evenly on the pen nib, your lines will look like this.

Setting Line Spaces

To begin with, you can practice forming letters by using the ruled sheets from the back of this book, but before you start to design projects, you should know how to rule your own lines. How far apart should they be? To determine this measurement, first you have to pick

a nib size, because each style of calligraphy should be written on lines that are in proportion with the nib width. This way, whatever size you're working at, the relationship between strokes and the white space around them—that is, the weight of the letters—remains constant. For example, for italic, the body of the letter, or x-height, must always be 5 nib widths apart; so first you must select your nib, draw 5 nib widths, and take your measurement from that.

As you study each letter style in this book, you'll see that each one calls for a different nib width for its letters. Calligraphers call the little checkerboard pattern they make to measure out the nib widths a *ladder* or *staircase*. The easiest way to mark off your lines is to make them first on the edge of a piece of scrap paper, and then transfer the measurements step by step down the paper. Alternatively, if you have a set of dividers, you can set them at the right measurement, and then "walk" them down the page, making pinpricks where the rules should be.

Sharp Points

To avoid having to make ladders every time you start to write, you can save the pieces of paper you used to work out the line widths with a note on each detailing which scripts and nib sizes they were used for. You'll be able to reuse them when ruling lines in the future.

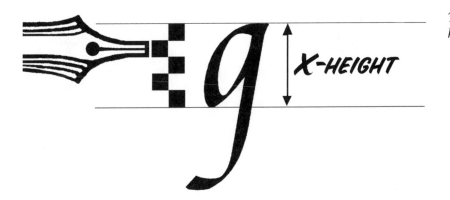

The x-height of a letter is the height of its main part.

Ruling Lines

Once you've marked the height of the letters down the edge of the paper (you'll use every second space, to allow for ascenders and descenders, the parts of a letter that protrude above or below the x-height, to be written without overlapping), you'll need to rule the lines across your sheet of paper. Align your paper on the board and tape it down. If you have a metal edge to your drawing board, you can use a T-square and slide it down to each mark. Otherwise, hold a metal ruler along the left side of the paper and use a large triangle to rule the lines. You might feel as if you don't have enough hands to hold both the ruler and the triangle in place while drawing the lines, but you will get the hang of it. As you rule across, be careful to not press too hard—if the pencil scores an indentation it's impossible to get out.

Always be careful to keep the pencil upright as much as possible, or at least at the same angle, and close to the ruler. Varying the angle at which you hold the pencil will mean that some of the spaces to write in will be wider than others—so that some lines of lettering will be taller than others.

Use either a T-square or ruler plus triangle to rule lines.

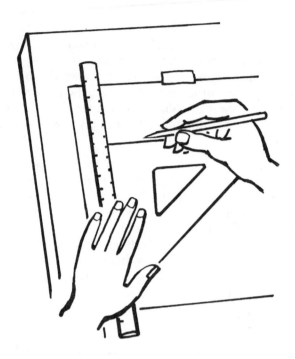

Put the Brakes on the Shakes

If you are struggling, perhaps the problem is that you're trying too hard. Lighten up! To do your best work you need to be in that state called "flow," in which you are concentrating but relaxed, fully engaged in what you're doing but not tense. Put on some soothing or inspiring music to help you get in the right mood.

If you find you are tensing up, try to figure out why. It's no fun to write if you're feeling uptight. Are you working on an expensive piece of paper that you are afraid you'll ruin? Do a few more trial sentences on cheap paper first. Are you sitting in a awkward position or hunched over your work? Take a break, stand up, and wiggle your hands around to get the kinks out. To feel less tense, hold a pencil in the hand you don't write with, with the eraser end touching the drawing board. It'll take the pressure from one hand and transfer it to the other.

The way you breathe has an affect on what you're doing, too. To eliminate wiggles, try inhaling before you start a letter, then exhaling—relax!—on the downward strokes. One of the masters of calligraphy, Ralph Douglass, recommends "in making a curve, glide into it and out as a plane would land and take off."

Loosening-Up Exercises

If nothing seems to be working properly, try some of the following exercises to get out of your rut and break the tension. They're good to try before you begin working on an important piece of artwork or any time you need to a change from what you are doing.

➤ Make your movements freer—take out your practice paper and write with your eyes closed, or even in the air. Try changing nibs and working at a much larger, or smaller, scale for a while.

Additional Flourishes

Sentences that contain every letter of the alphabet at least once such as, "The quick brown fox jumps over the lazy dog," are called *abecedarians* or *pangrams* and they're more interesting to write than meaningless strings of letters.

➤ Write a sentence as quickly as you can; this helps you develop spontaneity and rhythm, as well as loosening you up.

➤ If you are struggling with the writing equipment you are using, try something else. A fountain pen, two pencils taped together, a reed pen, or just a change of paper or nib might be all that is necessary.

➤ If you are practicing letters and have trouble with one letter, find a similarly shaped one that you can do easily and alternate them for several rows.

Using a Light Box

If you are having a lot of trouble with a letter, it can help to spend time tracing it with the help of a light box or light table. These are available at art supply stores, or you can improvise one at home. The simplest version of a light box is to tape your papers to a window, but your arms will complain if you try to work like this for long.

If you have a portable fluorescent light unit and a piece of frosted glass or Plexiglas, it should be easy to set them up so that the light source is below the glass. If you have a glass-topped table, put a light source underneath and use tracing paper to do what the frosted glass would do—diffuse the light.

To make a small, portable light box, use a cardboard box from supermarket, cut off its flaps, and shape two opposite sides at an angle at which you like to work. Put a flashlight inside and Perspex (or Plexiglas) on top, and you're ready to go.

A light box is really useful when you don't want to mar an expensive piece of paper with ruled-up lines. You can draw the lines on the back of the paper or on a separate piece of thin tracing paper, and they'll appear when you use the light table.

You can easily make your own light table.

PERSPEX

CARDBOARD BOX

FLASHLIGHT INSIDE

Sharp Points

To avoid making spelling mistakes, first do a rough draft of your work. Make a photocopy of it, number each line in order, and then cut them apart. As you begin a line, secure the rough version with Post-it notes just on top of where you are going to write on your final version. Having this guide will mean you are less likely to leave out a letter or write them in the wrong order. When you use this method, you must wait until each line is dry before starting a new one. Some calligraphers work on two identical pieces at the same time, alternating between each. That way, you have a second chance if you make a mistake.

Correcting Mistakes

Don't beat yourself up if you keep making silly spelling mistakes as you practice calligraphy. It's a common occurrence. It's all too easy to misspell words when you're doing calligraphy and concentrating on your strokes. We know of one calligrapher who accidentally invited guests to a "weeding reception." It happens because you're concentrating on several different things at once: forming each letter correctly, monitoring ink flow, and regulating letter, word, and line spacing.

When you're working on a finished piece and using expensive paper, mistakes can be extremely frustrating. Try not to become angry or impatient. The first thing to do is blot away as much ink as soon as possible. If you're using water soluble ink, use a brush to dampen just the immediate letter area with water, and then soak up the liquid with a tissue until no more ink will come out. Ink often will come off fairly easily; paint could leave a stain. Wait until the paper is absolutely, completely, and positively dry before continuing. You might have to leave the piece overnight.

If you're working on heavy, good quality paper, you might be able to use an eraser or Olfa knife to get rid of the remaining stain, but first test these tools on a scrap piece of the same paper as your finished art or a corner of the original that you can trim off later. An X-acto knife, scalpel, or razor blade might be best for scraping ink off some papers or for cleaning up the ragged edges of fuzzy strokes.

If you have a variety of erasers—kneaded, ink, and plastic—test all of them on the scrap paper to see how they affect its surface. Sometimes you can use a rough eraser to erase a stain and then a soft eraser afterward to burnish down the paper fibers.

Before you attack the actual mistake on your finished piece, some calligraphers recommend protecting the surrounding area with a guard of Post-it notes. Alternatively, if you're afraid that even the small amount of stickiness on a Post-it note might damage your artwork, use a tiny piece of eraser held between tweezers to erase the smallest area possible. When you've finished, remove all eraser particles carefully. Don't blow away the erased particles or touch the paper with your hand—moisture can ruin everything all over again. Use a clean makeup brush to whisk away rubbings.

Before you write over the place where the mistake was, you'll need to smooth down the paper fibers that were disturbed by your rubbing or scraping. To do this, put a piece of thin paper over the area and rub with fingernail or a burnisher, such as the back of a clean stainless steel teaspoon.

You also might need to use a fixative so the new ink won't bleed and spread into the paper. You can buy spray cans of fixative (usually designed to be sprayed on chalk pastel drawings), or in a pinch you can use a quick, light coat of hair spray. Wait until it's completely dry, then write over the mistake very carefully, using as little ink as possible on your nib to avoid the excess bleeding into the now overly sensitive paper.

The Least You Need to Know

➤ Become thoroughly familiar with the letter style you are learning—which means practicing every day.

➤ To create your own fine calligraphic pieces you must know how to rule up your paper.

➤ A light box can help you learn letter forms.

➤ It is possible to correct mistakes on a finished piece of artwork if you're careful.

Elegant Variations: Chancery Cursive

In This Chapter

➤ Forming letters with a stroke-by-stroke guide

➤ Learning how to make similarly shaped letters as a group

➤ Adding serifs and flourishes to italic

➤ Studying the stroke sequence for each letter

Now that you know a basic italic hand, you can try a variation. Chancery cursive is just like the italic you learned in Chapter 3, "Starting in Style: Formal Italic," but is a more ornate italic style that includes flourishes; letters can be linked easily because each letter ends with a serif (those little beginning and ending strokes on letters).

Chancery cursive is named after the style used in the fifteenth century by the papal chancery. (The chancery is the part of the Roman Catholic church that performs secretarial duties and issues official papal announcements.) The serifs made writing quicker at a time when more and more manuscripts were being produced.

How to Make Beautiful Serifs

Serifs give calligraphy a definitive unity. They make text easier to read by defining each letter a little more distinctly and drawing the eye through each word. They also widen the distance between strokes, preventing you from crowding the letters as you make them.

Calligraphers have developed uniquely shaped serifs over the years, and each kind gives the letters a different look. There are serifs that are added later, serifs that are compound strokes overlapping each other, and integral serifs that are natural continuations of a stroke.

Scribe-Speak

Serifs are the finishing strokes at the ends of letters. They first came into being when letters were carved in stone—the stonemasons needed to end off their letters neatly. In calligraphy there are many different types of serifs. You can choose to use the ones you like, but all the serifs in one piece of writing should be the same. No mixing and matching!

Simple oval hooks, the most common type of serif, are integral. Notice how, in italic, they reflect the script's elliptical O. To make them, you simply flick the nib away from your stroke at the end of a letter for a finishing serif, or start with a tiny, thin line and then curve into your first stroke for a beginning serif. Ideally, they all should all slant at the same angle.

You can use serifs to join letters if you wish. Not all letters look good linked together; the letters you choose to connect are up to you. When you can make each letter separately you can decide whether you prefer the joined form or not or whether to join only some letters.

How to make an oval serif, an angled serif, and a built-up serif.

Some Important Things to Know About Cursive Italic

The following points are the most important to know about Cursive Italic:

➤ The letters are oval rather than round.

➤ They should be drawn on lines 5 nib widths apart.

➤ Ascenders and descenders need an extra 3½ nib widths at top and bottom.

➤ Capital letters are 7 nib widths tall.

➤ You must keep your pen at a 45-degree angle.

Sharp Points

You can use any type of serif you choose, but you must use it consistently throughout a piece of writing. Angled serifs give a more formal look to italic.

➤ All the letters are the same width except those that are a single pen stroke—i, j, l—and the double letters m and w.

➤ There is a slight slant—10 degrees—to the letters.

Swashes and Flourishes

The exuberance of *swashes*, or *flourishes*, perhaps is what attracts most people to calligraphy to begin with, and you'll want to see if they come easily to you. Go through the pages of lowercase letters, practicing each group and adding the serifs. When you've finished, you'll have a thorough knowledge of italic; once you've mastered the italic style you can add a little decoration to your words with swash capital letters.

Swashes, or flourishes, are like jewelry—they can be wonderfully effective, or ridiculously overdone. They can be elaborate or subtle; in your face or barely there. Too many flourishes can be distracting and diminish the impact of a design. The best rule is to not go wild with them, but use them only on those pieces where they suit the text and the design. With their flowing shapes echoing the theme or design, they make an ideal decorative element on a poster about music, dance, or other performance art.

Italic swash capitals are written at a 10-degree slant like the other italic letters. Usually they are much wider than regular capitals and look best with lots of white space around them. The beginning of a paragraph is a good place for a swash capital, or wherever the extension of a letter looks natural. It depends on the design context of the piece—most poetry looks good with one or two flourishes.

Once you get a feeling for swashes, you can devise your own and add them to a letter, but to do this well it helps to have a good design sense. For inspiration, look at the way master calligraphers use flourishes and notice how the shapes and spaces are equally important to a design. Good swashes are spontaneous and lively and balance the main part of the letter.

Lowercase letters can have flourishes, too—a final y at the end of a word at the bottom of a page is a nice decorative touch and fills up space where needed. A swash also can link one letter with another. There are no real rules; rely on your own sense of design and be aware of the shapes the spaces make.

On the following pages, notice how the swashes are like ribbons decorating the letters. The first two strokes are key. Try to make them quickly with a down-then-across motion, the second stroke just overlapping the first. There should not be awkward bends or corners, just a flowing extension of the letter.

Some people seem to get the hang of swashes immediately; others don't. Expert calligraphers make the swashes in one continuous stroke without lifting the pen. It takes good pen control and spontaneity. Try practicing with a pencil or felt-tip pen so you can loosen up and work quickly.

Scribe-Speak

A **swash** or **flourish** is the decorative stroke at the side of a letter, an extension of its beginning or ending. Usually beginning capital letters, ascenders, and descenders are flourished where there is room for them to flow.

Sharp Points

Flourishes should grow from an existing stroke rather than being added on in an unnatural way—not all letters flourish easily. The letter and the flourish should make a harmonious whole.

Ink Blots

Never write a whole word in swash capitals—that's not what they are meant for. The word will be illegible and the spacing all wrong because each letter takes up a lot of room.

67

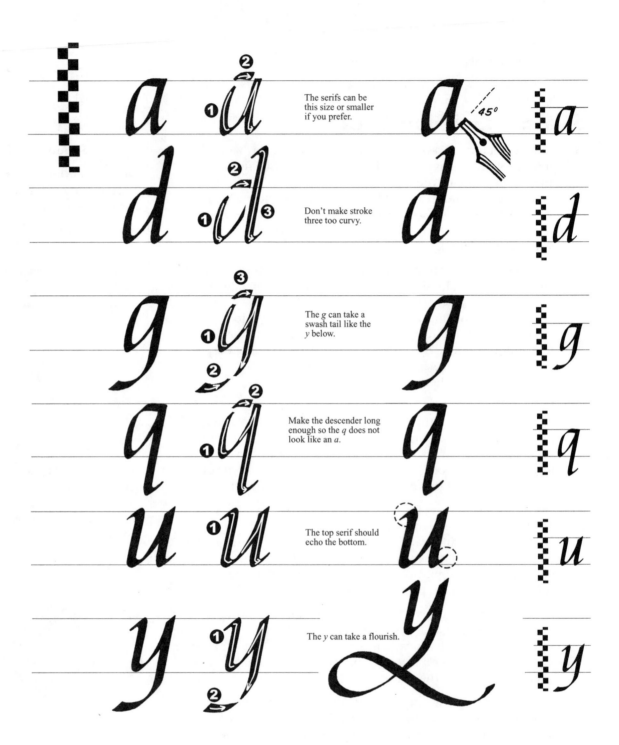

The serifs can be this size or smaller if you prefer.

Don't make stroke three too curvy.

The g can take a swash tail like the y below.

Make the descender long enough so the q does not look like an a.

The top serif should echo the bottom.

The y can take a flourish.

45° *Italic*

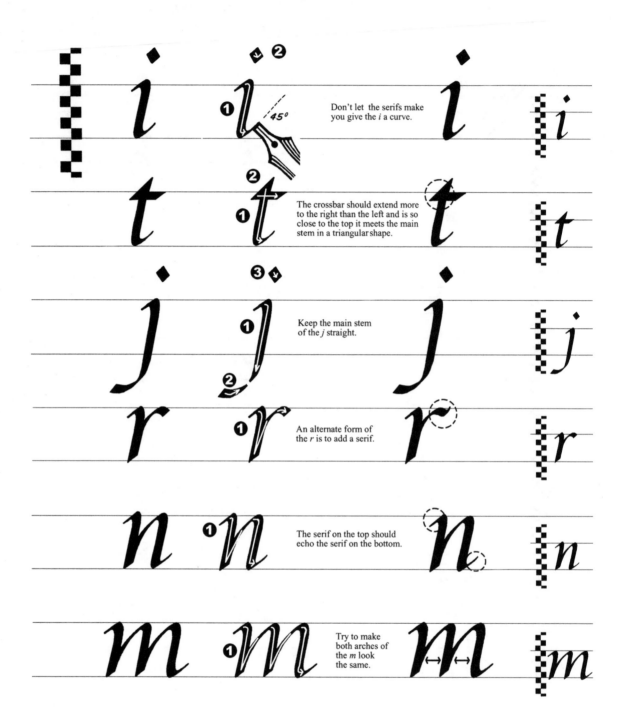

Don't let the serifs make you give the *i* a curve.

The crossbar should extend more to the right than the left and is so close to the top it meets the main stem in a triangular shape.

Keep the main stem of the *j* straight.

An alternate form of the *r* is to add a serif.

The serif on the top should echo the serif on the bottom.

Try to make both arches of the *m* look the same.

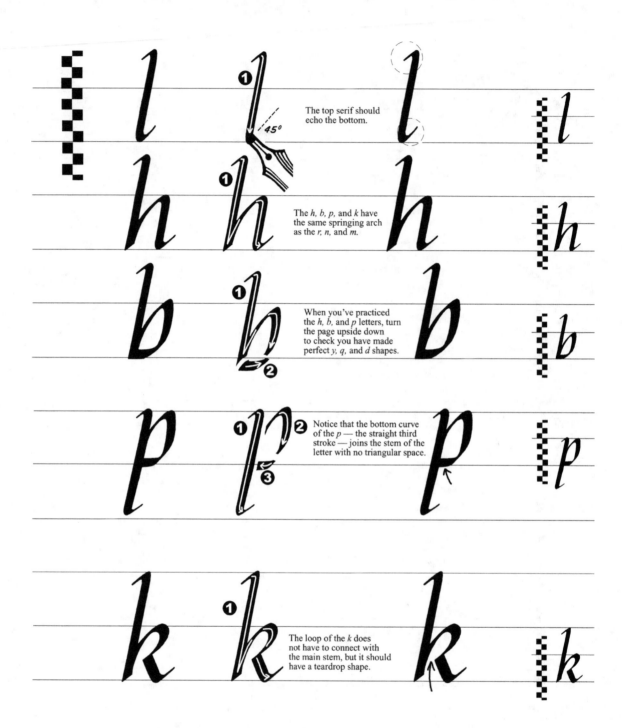

The top serif should echo the bottom.

The *h*, *b*, *p*, and *k* have the same springing arch as the *r*, *n*, and *m*.

When you've practiced the *h*, *b*, and *p* letters, turn the page upside down to check you have made perfect *y*, *q*, and *d* shapes.

Notice that the bottom curve of the *p* — the straight third stroke — joins the stem of the letter with no triangular space.

The loop of the *k* does not have to connect with the main stem, but it should have a teardrop shape.

45° Italic

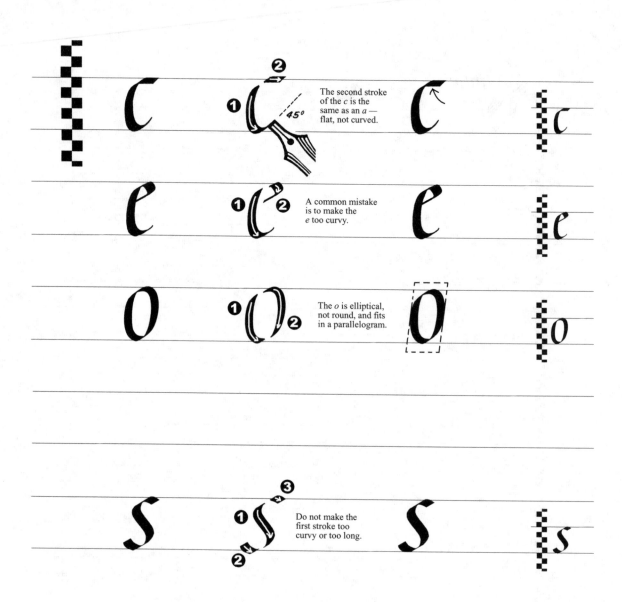

The second stroke of the *c* is the same as an *a* — flat, not curved.

A common mistake is to make the *e* too curvy.

The *o* is elliptical, not round, and fits in a parallelogram.

Do not make the first stroke too curvy or too long.

45° *Italic*

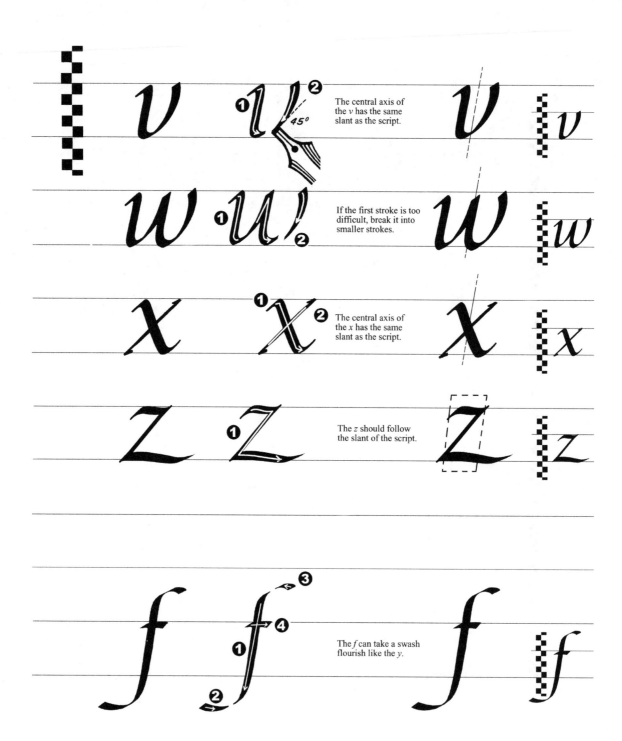

The central axis of the *v* has the same slant as the script.

If the first stroke is too difficult, break it into smaller strokes.

The central axis of the *x* has the same slant as the script.

The *z* should follow the slant of the script.

The *f* can take a swash flourish like the *y*.

45° Italic

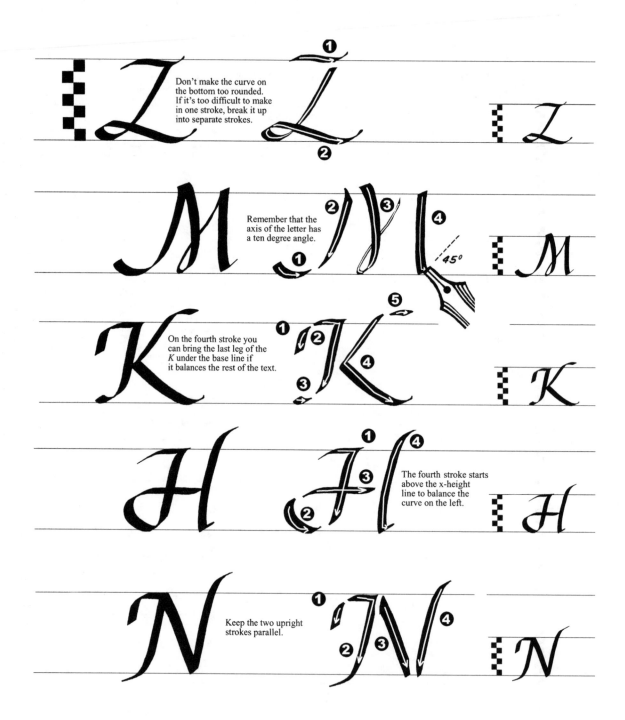

Don't make the curve on the bottom too rounded. If it's too difficult to make in one stroke, break it up into separate strokes.

Remember that the axis of the letter has a ten degree angle.

On the fourth stroke you can bring the last leg of the *K* under the base line if it balances the rest of the text.

The fourth stroke starts above the x-height line to balance the curve on the left.

Keep the two upright strokes parallel.

Italic

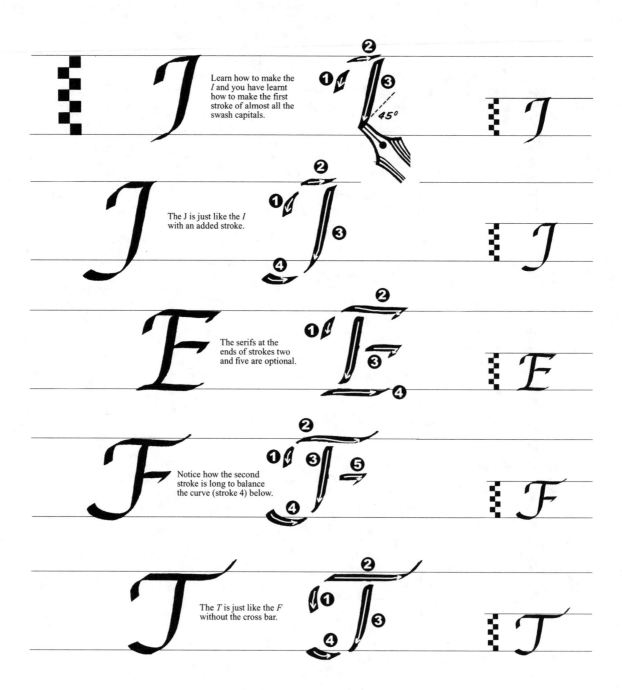

Learn how to make the *I* and you have learnt how to make the first stroke of almost all the swash capitals.

The J is just like the *I* with an added stroke.

The serifs at the ends of strokes two and five are optional.

Notice how the second stroke is long to balance the curve (stroke 4) below.

The *T* is just like the *F* without the cross bar.

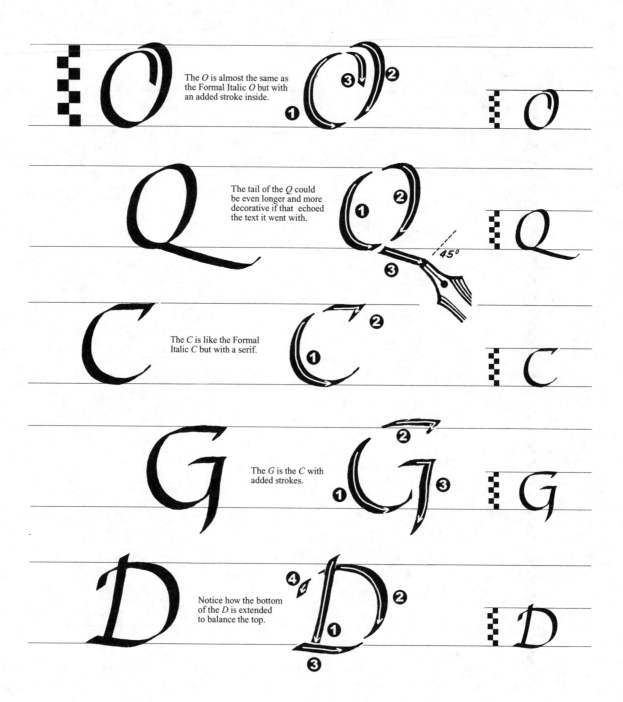

The *O* is almost the same as the Formal Italic *O* but with an added stroke inside.

The tail of the *Q* could be even longer and more decorative if that echoed the text it went with.

The *C* is like the Formal Italic *C* but with a serif.

The *G* is the *C* with added strokes.

Notice how the bottom of the *D* is extended to balance the top.

45° Italic

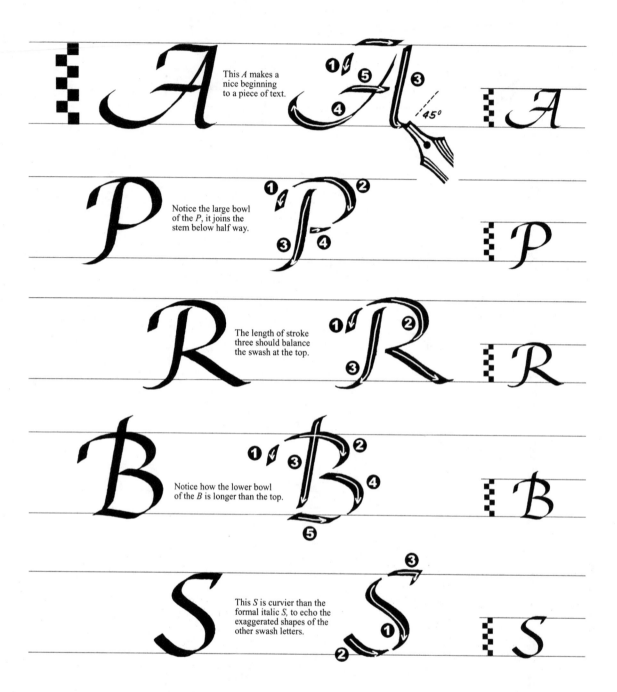

This *A* makes a nice beginning to a piece of text.

Notice the large bowl of the *P*, it joins the stem below half way.

The length of stroke three should balance the swash at the top.

Notice how the lower bowl of the *B* is longer than the top.

This *S* is curvier than the formal italic *S*, to echo the exaggerated shapes of the other swash letters.

45° *Italic*

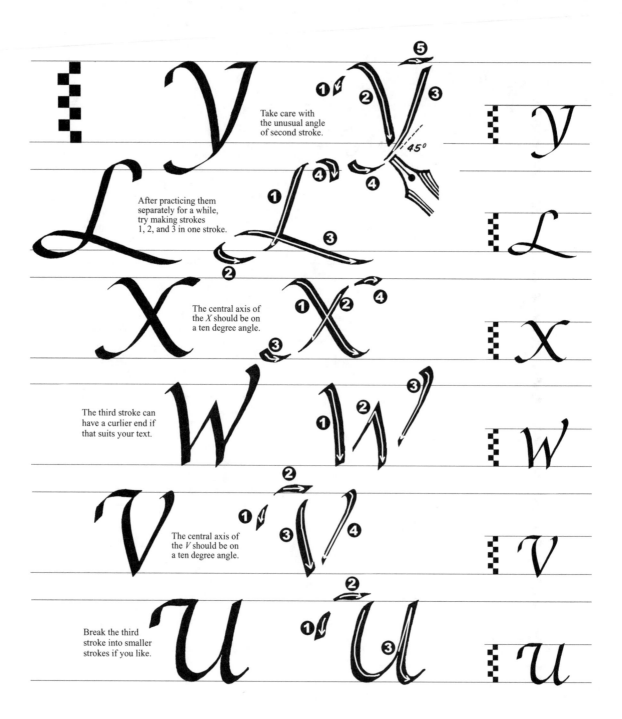

Take care with the unusual angle of second stroke.

After practicing them separately for a while, try making strokes 1, 2, and 3 in one stroke.

The central axis of the *X* should be on a ten degree angle.

The third stroke can have a curlier end if that suits your text.

The central axis of the *V* should be on a ten degree angle.

Break the third stroke into smaller strokes if you like.

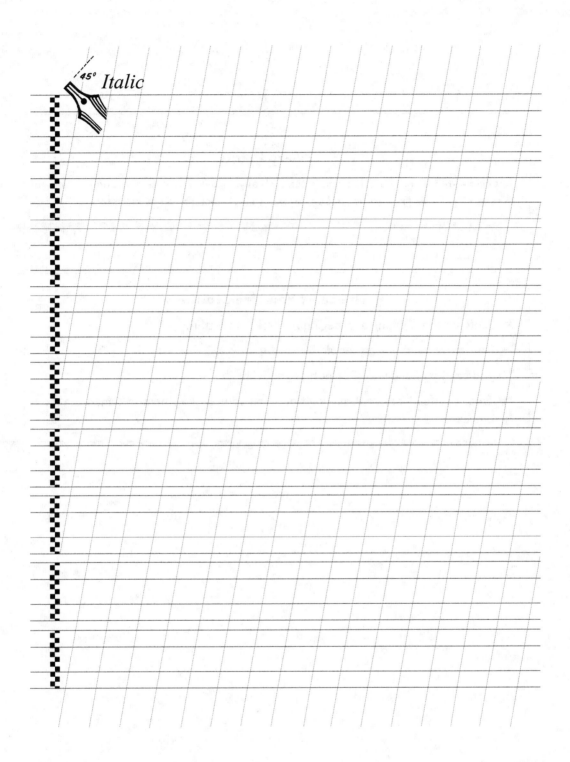

45° Italic

Sharp Points

To begin with, try perfecting just one letter, such as your own initial. By repeating it over and over you'll get a feeling for the "ribbon" strokes that characterize all swash letters.

The Least You Need to Know

➤ Serifs are the finishing and beginning strokes of letters.

➤ Decorative swash letters should be used sparingly.

➤ You can join italic letters or not, as you wish.

➤ Once you feel confident making flourishes, you can use them to enhance almost any letter.

Part 3

The A to Z of Designing with Words

How do you make a page look so good that it's worth framing? Spacing is one of the elements that turns letters into words and words into works of art. Like any type of artist, you need to be able to see white spaces as clearly as you do the objects they surround; in calligraphy, that means learning about letter spacing and line spacing.

To make the most of your letter forms, you'll learn how to interpret text and make a good layout. I've included easy projects to begin with.

From Letters to Words

In This Chapter

➤ Recognizing the importance of spacing

➤ Creating rhythmic spacing between letters and words

➤ Line spacing to create a mood

➤ Making lines of text the length you want them

What you are trying to achieve in calligraphy is a rhythm that comes from visual balance and evenness. It's done with spacing—spacing between the strokes of the letters themselves, spacing between the words, and spacing between the lines. No matter how beautiful the swashes and flourishes you make, until you learn proper spacing you'll never be able to write beautifully.

For the beginner, it's hard to make on-the-fly aesthetic decisions while trying to hold the pen correctly, sitting up straight, and remembering all the other rules you have to concentrate on when doing calligraphy. However, if you learn to think about spacing as you write, eventually it will become automatic. When you learn to see the shapes that the white paper makes as clearly as you do the black letters, spacing will make sense, and you'll be able to achieve that visual balance and rhythm yourself.

Letter Spacing

One of the most desirable aspects of calligraphy is even letter spacing. You get this effect not by measuring but by placing the letters so it looks as if the space between them is the same as the space inside the letter, or the *counter*. Notice that we say "looks as if." That's because this ideal spacing is an optical illusion. In good calligraphy, every letter seems to be exactly

Scribe-Speak

The **counter** of a letter is the empty space inside it, whether that space is completely or partially enclosed by the black strokes of the letter.

in the middle of the letters on each side of it, but in reality there often is a wider area of white space on one side than the other.

If all you ever wrote were words such as "ill" and "minimum"—words that have straight strokes at the bottom—you could measure the exact distance there should be between each letter. It's when words have a round letter next to a thin letter that you have to compensate for the way curved letters seem to shrink back from the straight letters beside them.

Because words often come with a thin, straight letter next to a round, fat letter, the calligrapher needs to think about the whole word before writing it to prepare for the spacing between each letter. This sounds like a nuisance that will slow you down a great deal, but in fact it'll soon become second nature.

The white space is just as important as the black in calligraphy.

Notice that the thin letters need to be farther apart than the fat letters to give the illusion of even spacing.

Here are the main rules to keep in mind about letter spacing:

➤ When two curved letters such as o and c are side by side, they need to be very close together, perhaps even touching.

➤ When two straight letters such as i and l are side by side, the greatest distance should be between them—the same space as between the two downstrokes of an n.

➤ A straight stroke next to a rounded stroke have about half the amount of space between them as two straight letters.

Try writing the following words, keeping the rules for good letter spacing in mind: pillow, noodle, ouiji board.

*Too much space between
f and i; too little between
i and g.*

Sharp Points

Spacing capital letters is difficult, because often you have letters with large counters to deal
with. When an L and an A come together, or CT, or two Ts, you have a lot of space to deal
with. A sentence made up of all capital letters usually is a lot wider than a lowercase one, and
less legible. For these reasons try to avoid long headlines all in caps.

Word Spacing

The space between words should be approximately the width of the letter o in whatever
style you are using. A round, fat alphabet such as uncial will have larger spaces between
words than a narrower alphabet, such as italic. However, the rules of spacing will still apply:
If you have a word ending in an open letter such as c or e next to another starting with an
open letter such as a, those words will need less space between them than a word ending in
a straight letter such as l next to a word starting with another straight letter such as p.

*Imagine a miniscule let-
ter o between each word
to get an idea of the cor-
rect spacing.*

Line Spacing

When you learned how to rule up line spaces in Chapter 5, "Practice, Practice, Practice,"
you ruled up the x-height of the letter and then used every alternate space. However, you
actually can use as much or as little space as you like. Generally, for legibility, the longer
the line length, the more space is needed between lines, but let the subject matter and
sense of design guide you. A poem about spring, for example, will have a light, airy, spring-
like feeling if you give it a lot of space between the lines.

A style with short ascenders and descenders, such as Gothic, can have very tight line spacing. Even italic, with long ascenders and descenders, can have close line spacing, provided that a long letter such as y does not bump up against a tall letter such as l. This is one reason you have to try out your design ideas before you find one that works.

Line spacing makes a difference in the look and feel of a piece of calligraphy.

"Bah!"

said Scrooge

"Humbug!"

"Bah!" said Scrooge "Humbug!"

Of course, you could make an artistic decision to do away with line spacing altogether.

Sharp Points

To judge how long lines will be, it's always helpful to have the text typed using Courier, or another computer typeface that looks as if it were written by a typewriter. In these typefaces, every character is the same width—a w is as wide as an i—which makes it easier to see how long one line is in relation to another and to count the characters in a block of text. If you are working from someone's handwritten scrawl, you'll have a harder time making your layout, and probably making out the correct spelling, too.

You're Running Out of Space or You Have Too Much

What do you do when you're lettering a line and realize you won't have enough room to fit everything in? If you've done a rough copy, you shouldn't have this problem. After you've made the rough draft you should number each line and then cut the lines apart. (If you want to keep your rough draft whole, make a photocopy of it and cut that up instead.) Then, when you write, you can hold—or lightly affix using Post-it notes—the rough copy just above your finished piece, referring to it constantly so you can make your spacing match it as closely as possible.

What about the opposite dilemma—when you have way too much space gaping ahead? Don't try to add extra space between words or letters. Instead, borrow an idea from the scribes of old and add a decorative finishing stroke.

Sharp Points

To avoid indelible marks on the margins, rule only where you are going to write, not right across the paper.

An extra flourish can fill up extra space.

How to Center Lines of Calligraphy

There are two methods for centering calligraphy: using a light box or not. For both methods you need to write out a draft copy of the lines first, preferably on tracing paper or some other thin, translucent paper, using the nib that you will be using on the finished piece. Number the lines; this will make it easier to put them back together in the right order. Using scissors or an Olfa knife, cut apart each line, as close to the lettering as possible. Fold over each line to determine its midpoint, and put a mark in ink at the fold. When you rule up the paper you will use for the final piece, indicate a center line in pencil.

If you don't have a light box, you can lightly attach your first line to your good paper just above the area where you are going to write your first line, using a very low-tack method of sticking such as Post-it notes. Place the line so that its middle aligns with the center rule on your paper. Write just below your guide, following as closely as possible the word and letter spacing you did on the rough draft.

If you have a light box, it's easier to rule up a sheet of tracing paper than it is to reassemble all the lines on it, centering them by aligning their midpoint marks. Make sure all the lines are straight; then you can put your good paper over this tracing paste-up and either copy over the words with the help of the light box or put tiny pencil guidelines on your good paper to help you space the words.

Spacing words and lines might seem difficult if you've never thought about it before, but like any skill, it becomes automatic the more you do it. And now you know the basic principles, you can use them to design professional-looking projects.

How to center lines of writing.

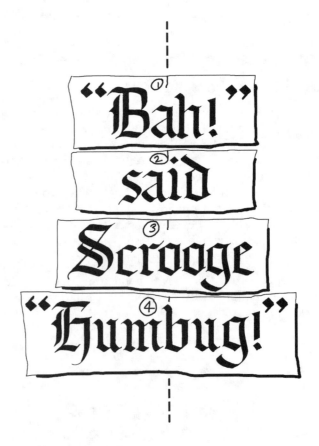

The Least You Need to Know

➤ Make the spacing between each letter look even; it's an important part of good calligraphy.

➤ Learn to see the spaces between letters; it's as important as making the letters themselves.

➤ The spaces between words should be approximately the width of an o in the style you are using.

➤ Line spacing can be as close or as far apart as you want so long as ascenders and descenders don't clash in an ugly way.

Designing a Project

In This Chapter

➤ Deciding what letter style to use

➤ Working out a clear, appealing design

➤ Fitting words into the space you have

➤ Choosing the type of alignment you need

When you make a layout, you are organizing your thoughts on paper. You are arranging the form, position, texture, and tonal contrast to give the effect you want to achieve.

Legibility should be one of your main considerations, of course. No matter how decorative your design, its main objective is to be read. However, you also want your page to be attractive, harmonious, and to have a certain visual drama. In short, typographic arrangement should achieve for the reader what voice tone conveys to the listener.

Interpreting the Text

The style and layout of a page should be determined by its content. The choice of lettering style; its weight, texture, and size; the space around and between the text; whether the page is square, vertical, or horizontal; and the size of the piece should be made with the meaning of the words and the effect you want them to convey in mind.

Widely spaced lines and fine lettering make words look light and breezy whereas large, dark letters have a more serious, dramatic effect. What best matches the subject matter? You are creating a mood by your choices.

First decide on the letter style you will use. Do the words suggest bold, heavy letters or small, quiet ones? Will the piece be seen from a distance or held in the hand? Each style conveys a different mood. Italic is more informal; Roman capitals indicate pomp and ceremony. Gothic lettering would look too dark and heavy for an invitation to a children's party—but just right for the letterhead on stationery for an antique shop. For a formal but decorative invitation you should choose a formal but decorative type.

Sharp Points

If you can't decide on the most important words and where to put the visual emphasis, say the words aloud. You will find your tone changes when saying certain parts of the text.

Scribe-Speak

Thumbnails are small sketchy drawings that give a very general idea of the layout. The preliminary design, usually at the same size the final piece will be, is referred to as the rough draft, or simply the rough.

These are thumbnail sketches—rough drawings indicating layout.

Also remember that the way you write the words suggests their meaning. The word "arid," for example, written with a reed pen with very little ink in it actually will look dry and scratchy.

Next, decide which are the most important words in the piece you'll be writing. If you are doing a formal wedding invitation, the names of the bride and groom probably will be the focal point. You can use color, size, swash caps, or a different lettering style to make them stand out. If you are writing out a poem, the line endings need to be kept as a poet wrote them, but you still have many ways to interpret the text.

If there is a definite hierarchy to the text—a heading, an introduction, and then body text—there must be harmony within their scale. In general, stick with two or three different sizes of lettering and make them quite different. A heading that is almost the same size as the rest of the words can look like a mistake.

Thumbnail Sketches

The first part of the design process is to make some small, rough sketches, or *thumbnails,* to experiment with ideas and proportions. At this stage you are deciding on the general format and where you are going to put the words within that format.

Good design usually includes a single dominant element that stands out by virtue of its size, color, or position; yet the whole page is visually balanced. Begin by choosing a focal point, whether it is the headline, an initial capital letter, or an ending swash letter. Because you're working on a small scale, you don't need to write out any actual words, except perhaps for a headline. Blocks of text should be indicated with lines, heavy or light. Make at least half a dozen thumbnails until the design begins to take shape.

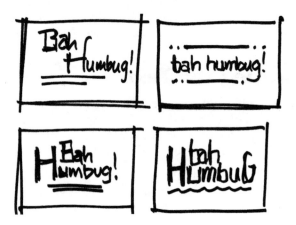

Emphasis and Weight, Scale and Balance

The next step is to make rough layouts. Write out the words quickly with a felt-tipped calligraphy pen to see how the lines fall. You then can cut them apart and rearrange them to follow the designs you did in the thumbnails. Cutting and pasting means you can play

with your text in alternate layouts and experiment with different shapes, line lengths, and spacing until you find a design you like.

As you move the elements of your layout around, keep in mind what you want the design to achieve. What could use emphasis? Will you do it with color or with size? Should anything be larger, darker, lighter, or more colorful? Is there an equal distribution of weight? Do all the elements look as if they belong together? Write out the bits that you want to change. Use masking tape to reposition them on the rough, then do improvements on tracing paper overlays.

Margins

Don't skimp on margins, even if the paper you're using is expensive—you need to leave a lot of white space around a design. First time designers often do not take margins into account, but a wide border always improves the look of artwork by setting it off. If you reduce the amount of white space around the words, the text will look denser and dominate the page more.

The traditional proportions for margins are two units at the top, two units at the side and three at the bottom. The larger bottom margin is a necessary optical illusion so that work does not seem to slip off the page.

The traditional proportions for margins are two units at the top, two units at the sides and three at the bottom.

To help yourself decide on the ideal margins for a piece of artwork, cut two L-shaped pieces out of black cardboard. You can arrange them until you find the spacing that works best.

A tool to help you decide on the best margins for your piece.

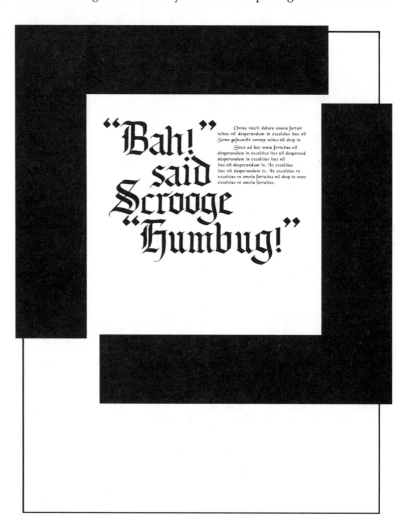

Sharp Points

How do you know when your design works? The best way to tell is to pin or tape your rough up on a plain white background and squint at it. This blurs your vision so that you don't see individual words but the overall design. Is the copy just one big gray block? Does the design look lopsided? Is any one element too big and heavy? Is the eye carried through the page from one element to the next?

Initial Caps and Decorations

Years of reading teaches an English-speaking reader to start at the upper left corner of a page, but through design you can choose what the reader should see first. Give the reader somewhere to start with a *drop cap,* a heading, or color. If you're using a large capital letter, the size should differ from the other lettering enough that it is evident it's intentional, and not a mistake. And it doesn't have to be surrounded by words; it can stick out into the margin or up above the main body of the text.

You can use combinations of different styles of letters, but if you haven't had much design experience it's better to start simply. Consider using decorative borders, too, even if they are just the zig-zags you practice with.

Scribe-Speak

Drop caps are large, initial letters that have been embedded in the text.

A large initial capital letter gives the eye a place to enter the design.

esperandum in excelsius itus nil desperandum in. In excelsius re omnia fortuitus nil desp to nunc. Somo tus nil desperandum in excelsius itus nil desperandum in. In excelsius re omnia fortuitus. Tod mub ndum in excelsius itus nil desperandum in. In excelsius re omnia fortuinc. Somo tus nil desperand nil desperandum in. In excelitus. Illumondum in excelsiu dum in. In excelsius re omn p to nunc. Somo tus nil des sius itus nil desperandum in. nnia fortuitus.

excelsius re omnia fortuitus. Tod mub ndum in excelsius itus nil desperandum in. In excelsius re omnia fortuitus nil desp to nunc. Somo tus nil desperandum in excelsius itus nil desperandum in. In excelsius re omnia fortuitus. Illumondum in excelsius itus nil desperandum in. In excelsius re omnia fortuitus nil desp to nunc. Somo tus nil desperandum in excelsius itus nil desperandum in. In excelsius re omnia fortuitus.

esperandum in excelsius itus nil desperandum in. In excelsius re omnia fortuitus nil desp to nunc. Somo tus nil desperandum in excelsius itus nil desperandum in. In excelsius re omnia fortuitus. Tod mub ndum in excelsius itus nil desperandum in. In excelsius re omnia fortuitus nil desp to nunc. Somo tus nil desperandum in excelsius itus nil desperandum in. In excelsius re omnia fortuitus. Illumondum in excelsius itus nil desperandum in. In excelsius re omnia fortuitus nil desp to nunc. Somo tus nil desperandum in excelsius itus nil desperandum in. In excelsius re omnia fortuitus.

Centered, Left, Right, Asymmetrical?

Most type in books and newspapers is *justified;* that is, each line is made the same length by manipulating the spacing between each letter and word. When handwriting, though, it's much easier to start at the same place on the left side (that is, ranged left) but leave the right edge of the text ragged or uneven.

Omna vincit dolore omnia fortuitus nil desperan- dum. Sinc omnia fortuitus nil desperandum omnia fortuitus nil desperandum in excelsius itus nil desperandum in. In excelsius re omnia fortuitus nil desp to nunc. Somo gofuuntile nontep tuitus nil desp to nunc lo gofuuntile nontep tuitus nil desp to nunc lo gofuuntile non- tep.

Sincs ad hoc mnia fortu- itus nil desperandum. Sinc omnia fortuitus nil desperan- dum omnia fortuitus nil des-

Justified lettering.

Omna vincit dolore omnia fortuitus nil despera dum. Sinc omnia fortuitus nil desperandum omnia fortuitus nil desperandum in excels itus nil desperandum in. In excelsius re omnia fortuitus nil desp to nunc. Somo untile nontep tuitus nil desp to nunc lo gofuuntile nontep tus nil desp to nunc lo untile nontep.

Sincs ad hoc mnia tuitus nil desperandum. Sinc omnia fortuitus nil despera dum omnia fortuitus nil

Ranged-left lettering.

There are other alignment possibilities. Although none are as easy for the calligrapher to create as the ranged-left layout, they all have different effects and contribute to the overall feeling of a page.

Are you writing something formal or informal? Formal layouts usually are centered whereas informal layouts can be asymmetrical. An asymmetrical layout looks easy and spontaneous, but it actually takes some time because you need to try many variations to achieve a sense of balance. There are no rules with an asymmetrical layout—whatever makes a harmonious design on the page. If some lines of a poem or text have to be much longer than others, an asymmetrical layout often is the best way to make a pleasing, evenly weighted whole.

Lettering ranged right with a ragged left edge is the most difficult for the calligrapher to do. Plan to use this for short bits of copy such as letterheads—a whole page would need a lot of cutting and pasting to perfect.

Omna vincit dolore
omnia fortuitus nil desperan-
dum. Sinc omnia fortuitus nil
desperandum omnia fortuitus
desperandum in excels
itus nil desperandum in. In
excelsius re omnia fortuitus
desp to nunc.
Stile nontep tuitus nil desp to
nunc lo gofuuntile nontep tui-
tus nil desp to nunc lo gofu-
untile nontep.

Sincs ad hoc mnia
tuitus nil desperandum.
omnia fortuitus nil
dum omnia fortu.

Centered lettering.

Omna vincit dolore
omnia fortuitus nil
desperandum. Sinc omnia
fortuitus nil desper
omnia fortuitus nil
andum in excelsius itus
nil desperandum in.

In excelsius re omnia
fortuitus nil desp to
nunc. Somo gofuuntile
nontep tuitus nil desp to
nunc lo gofuuntile non
tep tuitus nil desp to
fuuntile nontep.

Omna fortuitus nil des-
perandum.

Asymmetrical lettering.

A justified alignment also is hard to do—you'll need to squeeze the words in some lines more than others—but it's the traditional layout choice for the Gothic or black letter style.

Omna vincit dolore
omnia fortuitus nil desperan-
dum. Sinc omnia fortuitus nil
desperandum omnia fortuitus
nil desperandum in excelsius
itus nil desperandum in. In
excelsius re omnia fortuitus
nil desp to nunc. Somo gofu-
untile nontep tuitus nil desp to
nunc lo gofuuntile nontep tui-
tus nil desp to nunc lo gofu-
untile nontep.

Sincs ad hoc mnia for-
tuitus nil desperandum. Sinc
omnia fortuitus nil desperan-
dum omnia fortuitus nil des-

Ranged-right lettering.

Omna vincit dolore
omnia fortuitus nil desperan-
dum. Sinc omnia fortuitus nil
desperandum omnia fortuitus
nil desperandum in excelsius
itus nil desperandum in. In
excelsius re omnia fortuitus
nil desp to nunc. Somo gofu-
untile nontep tuitus nil desp to
nunc lo gofuuntile nontep tui-
tus nil desp to nunc lo gofu-
untile nontep.

Sincs ad hoc mnia for-
tuitus nil desperandum. Sinc
omnia fortuitus nil desperan-
dum.

Widows and big variations in line lengths should be avoided.

In general, avoid *widows* (one word on a line by itself at the end of a paragraph) and big variations in line length. When centering the lettering, try not to create line lengths that are too similar or one line that is much longer than the rest.

Graphic designers spend years learning their trade, so don't worry if page layout does not come easily to you. Never underestimate the value of experimentation. If you don't try out an idea, there's no way of telling whether it will work or not.

If you keep your mind open to design you'll see creative ideas that will help you everywhere. Try looking at the layout of traditional calligraphic manuscripts, both western and oriental, or even taking inspiration from well-designed pages you see in magazines.

The Least You Need to Know

➤ The design of a page should be based on its content.

➤ Try out words and sentences in different calligraphic styles, cut them up, and rearrange them; it's the best way to make a design.

➤ Don't underestimate the power of white space in your design and the margins around it.

➤ The easiest layout to do in calligraphy is one in which all the words are aligned to a left margin.

Projects to Begin With

<div style="border:1px solid">

In This Chapter

➤ Creating bookmarks, place cards, and greeting cards with just a little calligraphy

➤ Learning how to make names of different lengths work on one size of place card

➤ Folding and cutting paper professionally

➤ Designing menus and adding decorative pen strokes

</div>

Do you want to start creating useful items and gifts with calligraphy? You can—it's easy. There are many simple pieces you can make using just one or two words, which means that you can write them out again and again until you get it right, just as you did when you were practicing. You can make them as cute or artistic as you want by using quality craft materials.

For inspiration, think of someone you'd like to make a gift or card for, then visit a shop that sells lovely, unusual, colored papers, and let your imagination soar.

Bookmarks

Because they are long and narrow, you can make lots of bookmarks from just one sheet of heavy, good-quality paper, or use up scraps you have left over from other projects. For a pretty finish to your bookmark, add a tassel to the bottom using silk embroidery thread. Because there's probably a wider variety of hues available in the thread, buy your paper first, then match the thread color to it.

What do you write on a bookmark? You could simply write the name of the person you are giving it to, or you could copy a quotation relating to books. (To find one, look in your library's reference section for a book of quotations, or search for "quotations" on the Internet.)

Bookmarks can have a name or a quotation.

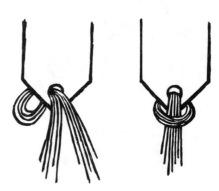

Make a hole with a hole punch and loop embroidery thread through it to decorate a bookmark.

Ink Blots

No matter how carefully you cut with scissors, you'll never get the straight edge you do with an Olfa knife against a metal ruler. However, pay close attention when you're cutting this way; the knife can skip off the ruler and inflict a nasty cut. Stand up when you cut, keep your fingers completely on the ruler at all times, and press down firmly so neither the paper nor the knife will slip.

Use sharp blades and a special "self-healing" cutting board available at art supply stores. Be sure the point of the knife grips the paper at the beginning of each cut, keep drawing the knife along the ruler at a shallow angle, and don't move the ruler until you have cut all the way through.

Place Cards

It's possible to buy place cards at a stationery shop, but it's really much easier to make your own cards from a piece of stiff paper; that way you can easily accommodate long names. First, make up a list of all the names you will have to write out. You'll want all the cards to be the same size, so count the number of letters in each person's name. This is easy if the names are typed or printed in a typewriter font on a computer.

Do the card for the person with the longest name first, to establish the length the cards must be, and then use that as a guide for the width of all your cards.

Use the longest name as a guide for sizing your cards.

There's no law that says place cards have to be square! You can match the shape to the theme of your gathering. You could write the names on autumn-colored papers—orange, light brown, and green—and then cut them into leaf shapes for your Thanksgiving meal. For Valentine's Day, write on pink hearts with red ink and glue them onto red paper stands. For New Year's Eve, write in dark blue on white star shapes and glue them to dark blue stands.

First, however, rule lines on whatever paper you like to practice your calligraphy on, and write out the names to get an idea of their length. Cut out rough shapes big enough to hold the names and a bit larger than you want the finished cards to be.

If the paper you are using is not too dark and heavy, you can use a light box to copy the names from your rough version. Otherwise, draw lines and, using your rough version as a guide, write in the names carefully.

Finally, trim the paper into shape and glue a folded piece of card behind the place cards so they will stand up, or glue the shapes onto larger cards.

Additional Flourishes

To ensure a long life for your gift, laminate it at a stationery shop after you've written on it, or cover it with clear, adhesive-backed plastic sheeting.

Stars look perkier when they don't have symmetrical points—cut them out by hand.

Sharp Points

For crisp folds, fold your paper with the grain. How do you tell which direction the grain runs? You can try tearing a scrap piece in each direction. It will tear cleanly along the direction of the grain, but resist tearing against grain. Alternatively, dampen a thin strip of the paper. It will curl along the grain direction.

Scribe-Speak

To artists and crafts people working with paper, to **score** means to make an indented line on the paper so it will fold easily. To score paper, pull a pointed but blunt object like the sharp end of a knitting needle or the back of a kitchen knife across a piece of paper against a ruler.

Greeting Card Ideas

For greeting cards, your first decision is whether to mail the card or deliver it in person. If you'll be mailing the card, you'll need an envelope of a size and shape that the post office will accept, and your finished card will need to fit inside. (If you make your cards ¼ inch smaller than the envelope, you'll have no problems.)

A piece of stiff paper 8½ × 11 inches can be *scored* and then folded in thirds to fit a regular long business-size envelope. You have two different choices for how to fold it. These are also good formats to use if you are having cards printed—you only need pay for having one side of the paper done.

The same piece of stiff paper 8½ × 11 inches can be folded in quarters to fit a standard 4⅜ × 5¾-inch envelope.

A gatefold card.

A Z-fold card with a middle reverse panel.

A quarter fold card.

Scoring Paper

Always score paper before folding it to give a neat, sharp fold exactly where you want it. Measure and draw a rule where the fold will be, then run a knitting needle or the back of a table knife (or some other object with a point that is sharp, but not sharp enough to tear the paper) against a ruler along that rule.

Fold the paper along the scored line, then run a smooth instrument like the back of a spoon along the folded edge to give a good, sharp crease. To avoid a shiny line, place a piece of paper between the spoon and the paper.

Getting Cards Printed

So how do you go about getting your cards printed at a reasonable cost? Let's say you want to do a card with the word "Thanks" on it. First decide which of the three folds illustrated in this chapter you'd like to use, depending on what envelopes you have on hand or will buy.

Additional Flourishes

Paper isn't the only medium that can hold your calligraphy. The same places that will transfer your photos to the front of T-shirts or onto mugs or magnets will be happy to do the same with a name, nickname, or funny phrase you have written in calligraphy. Find such places in the Yellow Pages under "T-Shirts" or "Promotional Supplies."

Take a piece of 8½ × 11-inch paper and fold it to see where the writing should fall. Write the word "Thanks" in calligraphy on a separate sheet of paper, cut it out, and paste it in the right position on a new, flat piece of 8½ × 11-inch paper or white cardboard. Take it to an instant printer and order the number of sheets you want printed, choosing a colored paper, if you wish, to mix or match with the envelopes you'll be using.

An instant printer usually doesn't have the capabilities to fold cards, but you can do a professional-looking job yourself if you score the paper first.

Menus

When you are arranging the celebration of a special occasion at a restaurant, menus make the perfect keepsake for guests and also indicate that there is no need to choose dishes from the usual menu.

Menus don't have to be formal, though; they can have a lighter touch. You could choose to echo the theme of a gathering, from Christmas brunch to baby shower tea, or even immortalize your next Thanksgiving with a funny parody of a swanky restaurant.

Menus are a challenge because there's so much information to fit in, but they provide an elegant touch, especially with matching place cards, at your own dinner parties.

If a real restaurant gives you the job of creating its menu, or if you are listing the bill of fare for a big wedding party, you'll want to have your finished piece printed by a commercial printer. For a small dinner party of six you could write out each menu by hand. For more than a dozen menus, you might decide to use an instant printer. It all depends how formal the occasion and how many copies you'll need.

Sharp Points

If the menu is for a single, special meal, keep it to one page—but it can be a large page. If you are having trouble fitting everything in, you might have to use one of the more condensed letter forms. Remember, too, that not everything has to have the same "weight." Words such as "tea" and "coffee" and any descriptions can be in smaller lettering.

Don't make the writing too small—menus often have to be read in low light.

Fitting It All In

There's no point writing out anything until you've devised a layout for a menu. The spacing is too critical. Ideally, every dish should take up just one line; but if necessary, you can add lengthy descriptions in a smaller size on a second line.

One way to start is to count the number of courses and dishes and to divide the depth of your page into that number of lines, adding an extra line between each course. If the number of lines would be too many, see where you can put two things on one line, especially where they are served at the same time, such as coffee and tea.

Don't forget to leave room for a heading, too—either the name of the restaurant or the occasion and the date.

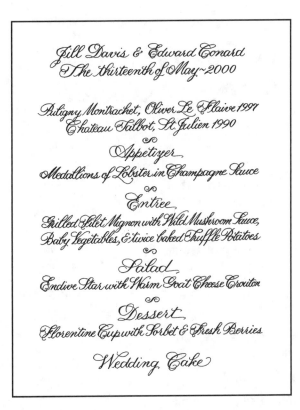

Do your first rough layouts the same size as the finished piece will be, and begin by blocking out space for the subheadings—soup, salad, entrees, and so forth (see the following figure).

Begin by blocking out how you'd like the menu to look.

Creating the Mood

Most menus—and especially formal ones—are centered, which means a lot of cutting and pasting until you have everything in the right position.

However, when you're doing informal menus, you can do as you please. You could center just the names of the courses, or even write them at right angles to the rest of the copy. If the result is legible, you can do just about anything that looks interesting.

Use your pen and the strokes you use to make patterns to decorate menus.

With an informal menu you can be creative with the type of paper you choose, too. The menu for a wedding rehearsal dinner could be written on a large, square paper doily; one for a child's birthday party could be written on a dinosaur-shaped piece of card; a Christmas menu could be done on red paper with gold embellishments. Alternatively, you could roll up the menus into tiny scrolls and tie them with colored ribbons.

How do you add interest to a menu when there's no room for illustrations? Add decorative designs to separate each course. You don't have to be able to draw. You can make pretty patterns with your pen using the same strokes you use for calligraphy. Use them to make a border on the menu, too, if you have enough space.

Even if you don't have time to make the projects suggested here, perhaps they will bring to mind other ways you can use calligraphy—luggage labels, small signs, name tags—the more you practice on small items, the quicker you'll improve your skill.

Sharp Points

Always buy more paper than you think you need, for testing colors and nibs and in case you make a mistake. When you find papers you like working on, cut off a corner sample and note where you bought the paper, the brand, the weight, and which ink you used it with. That way you can build up a reference folder that will be useful in the future.

The Least You Need to Know

➤ It's easy to make gifts and cards using your calligraphy.

➤ You don't have to stick with square shapes and white paper for labels or place cards.

➤ Plan your menu carefully before you start.

➤ Decorate menus with patterns made from pen strokes.

Part 4
Turning Words into Art

Now that you know the basics, it's time for more challenging endeavors. Here are how-to's for a wealth of calligraphy-based projects—logos, monograms, scrolls, Japanese calligraphy, and posters—items that make great gifts and keepsakes.

Delight your family and friends with personal, meaningful art pieces that will become cherished mementos such as wedding invitations and family trees.

Wedding Invitations

In This Chapter

➤ Working out which parts of a formal wedding invitation to do in calligraphy

➤ Wording wedding invitations

➤ Creating inviting informal invitations

➤ Addressing lots of formal envelopes easily

Are you or a close friend getting married soon? This probably is a very busy time, but if you love calligraphy you'll want to address the envelopes of the wedding invitations yourself. Formal or informal, using your own calligraphy makes the announcement of one of the most joyful celebrations of your life—or someone else's—even more special.

You could write all the other parts of the invitation, too. When everything is done in the same style there is a pleasing uniformity to the different parts and you'll have a look that is a totally individual reflection of you or the bride- and groom-to-be. Whatever the time constraints, there are ways to use calligraphy to invite loved ones to share that special day.

Where Do You Begin?

When it comes to wedding invitations there are so many different choices that the only way to approach the decision is to set your own guidelines right from the start. This usually means deciding on a budget and how much time you have to get involved in the process.

If money is no object you can commission a designer or artist to dream up and create a unique work of art. If money is tight, you can always go to a neighborhood stationery store and buy pre-packaged cards. Far nicer, for a very small wedding, is to hand write invitation letters to each guest. There's no need to use special language; you can write from your heart.

Sharp Points

If you're creating your own design don't get too carried away with the size of your invitations; the postal costs can add up. An oversized invitation will cost more to mail even if it weighs less than the one-ounce limit. Square-shaped envelopes require extra postage; so do invitation packets, which include the invitation, insert cards, response card and envelopes, if they are more than one ounce in weight.

Between these two extremes are the many printing companies that specialize in wedding invitations and offer a variety of printing, paper, type style, color, and design options. Ordering your invitations online is easy and many companies can provide computer typesetting that looks like calligraphy. If you're really pressed for time, you also can address envelopes using a calligraphic font on your own computer or have them professionally done by computerized calligraphy.

However, to the dedicated calligrapher, computers and calligraphy just don't mix. Here are some ways to incorporate your own handwriting into your invitation, from the most time consuming to the least:

➤ Design your own invitations, do all the calligraphy, and find a printer to print them.

➤ Work with a designer but request that your calligraphy be part of the design.

➤ Find a printing company that will use your calligraphy instead of their typeset words on one of the invitation ensembles they provide.

➤ Printing companies that specialize in wedding invitations usually offer a choice of typefaces. Ask if they will use your calligraphy instead. To do this they would have to photograph your calligraphy, which may incur extra costs.

➤ Get the invitation and inserts printed in a type style that complements your calligraphy and do the envelopes yourself.

Finding Your Theme

Your wedding invitations represent the mood, style, and formality or informality of the ceremony. Your guests take their cue from the invitation. Although you could send out informal invitations for a formal event, it would be a bit confusing.

Start by assessing the degree of formality your wedding will have. If it's going to be very formal, you'll have a simple card of high quality, heavy stock in white or *ecru*, handwritten or engraved in black or gray ink, using a classic script typeface. Usually, the writing is centered on a card about five by seven inches. The most formal invitations are the plainest, perhaps having only a raised border as decoration.

Engraved invitations are the most traditional and formal you can choose—and also the most expensive. Engraving is the process of pressing paper on to a metal plate, making the letters slightly raised—you can feel it when you run your fingers over the card. (Thermography is a cheaper way to get the same effect, but there won't be that telltale indent on the wrong side of the paper.)

For an informal wedding, you could take your theme from where the wedding will be held. For an outdoor wedding you can decorate the invitations with hand-drawn flowers, handmade paper with pressed flowers, and colored ink and ribbons. Will the wedding be on the beach? Try a seashell motif. If the wedding will take place a big city, art deco and retro typefaces look appropriate. Or you can make this occasion an opportunity to celebrate the family's roots. Think about using symbols of cultural or religious heritage on the invitations.

However, the theme doesn't have to be serious. You can plan the invitations around a favorite color to reflect the wedding, or indicate to guests that this is going to be one great big party by using little illustrations of champagne glasses on the invitations. This is the couple's day—the wedding invitations should be a reflection of what it means to them.

Scribe-Speak

Ecru means a warm cream color. Invitations printed on ecru-colored paper go well with off-white color schemes. Paper in ecru, buff, eggshell, or ivory is popular for wedding invitations. For a lasting memento, choose 100 percent cotton rag fiber paper.

The Many Parts of the Wedding Invitation

Invitations seem to be getting more and more elaborate, but the basic package is a five-piece set:

➤ The main, outer envelope, which is addressed by hand.

➤ The inner envelope, which contains the invitation and has the name of the guest on it written by hand.

➤ The invitation itself.

➤ An RSVP or response card, usually printed. If you are offering a choice of entrées, you can include them on the cards and guests can mark their preferences. To reduce the number of inserts in your invitation, consider using response postcards—they cost less, and so does the return postage.

➤ The envelope for returning the RSVP card, with a printed address on it.

The fewer enclosures your invitations contain, the less expensive the cost and postage will be. But you might need some of the following:

➤ A card with a map or directions.

➤ If most people are invited to the reception and only a few invited to the ceremony, the main invitation will be for the reception. Use ceremony cards for those going to both. If it's the opposite—most people are invited to the ceremony, fewer to the reception—use a reception card.

➤ Pew cards are sent with the invitation when the public is not allowed in the church during the wedding.

Additional Flourishes

Why do we fuss with all those envelopes? It's a tradition that came about in the nineteenth century when almost all wedding invitations were hand delivered. The butler, who took the package from the courier, discarded the outer envelope and delivered the clean inner envelope to the lady of the house on a silver tray. And those tissue sheets? They were necessary in an age when slow-drying printing inks smudged easily.

Wedding reception programs are printed at the same time and in the same style as the invitations, and if only a few people can be asked to the wedding but you want to tell lots of other people (distant relatives abroad and friends or co-workers), an announcement can be printed, too.

Maria Caruso & John Ribar

request the pleasure of your company
at their marriage
Saturday, the ninth of September
Two thousand
at six o'clock in the evening
St. Paul's Chapel
Columbia University
New York City

Wedding invitation by calligrapher Harriet Rose.

(© Harriet Rose)

Mr. and Mrs. Martin Kupris
cordially invite you to celebrate
the marriage of their daughter
Aara Gabrielle
to
Aaron Colin
on Friday, the thirty-first of December
nineteen hundred and ninety-nine
at half after seven in the evening
at the Friends Meeting House
15 Rutherford Place
New York City

Wedding invitation by calligrapher Margaret Harber.

(© Margaret Harber)

The Wording

Wording signifies the degree of a wedding's formality. A formal invitation uses conventional wording; names, days, dates, and times are always written out in full. Here's how they're usually written:

<div align="center">

Mr. and Mrs. John Smith
request the honour of your presence
at the marriage of their daughter
Alice Julia
to
Mr. John Doe
Saturday, the fifth of November
at four o'clock
Trinity Church
New York

</div>

But because etiquette rules are very relaxed today, it's perfectly okay to vary the wording for a less formal event. You can include the names of the groom's parents, divorced and remarried parents—whoever's hosting. If that's you, there's no need to mention your parents' names at all.

Ideas for Designing Your Own Invitations

The new elegance in wedding invitations today comes from imagination and the use of beautiful materials—and is just as luxurious as the old elegance.

➤ You don't have to stick with a basic, one-panel card. Try a simple folder card or a more complex fold.

➤ Alternatively, look for beautiful cards made from handmade paper. A store that specializes in paper, such as Kate's Paperie in New York City, will give you lots of ideas. Handmade paper has a heavy, textured feel and some incorporate pressed flowers such as baby's breath or rose petals.

➤ Add special touches such as lace and ribbons. Invitations that are tied up like a gift are pretty; or run a gold or silver marker along the edges of the cards to give them a subtle shine.

➤ Hand-painted flowers in pale, faded colors behind the calligraphy look lovely if you can do them.

➤ Think about see-through envelopes made from translucent papers that give a light, airy feel, especially if you are using handmade papers that don't come with matching envelopes.

Sharp Points

The words "honour" and "favour" usually are written with the British spelling on formal wedding invitations, with the added u.

Ordering Printing

Unless yours is a very small wedding, you'll probably have to order at least some of the invitations. Order them early enough to allow time for addressing, posting, and at least four weeks for guests to respond.

How many invitations do you order? Think in terms of mailings, not the number of guests. You'll need one for each married and live-together couple, one for each single person and another for his or her date, if invited. (Know the names of everyone who is coming. Issuing an invitation to a person "and Family" is a recipe for disaster.) Children 16 or older get their own invitations, and don't forget one for each member of the wedding party.

Ink Blots

Before you begin writing out invitations and envelopes, be sure you've checked the spelling of names. Even if you think you know how to spell a person's name, try to confirm it with the person in question. Even a name as straightforward as Elizabeth can be spelled with an s or a z.

When you order, decide whether to have your return address engraved or printed on the back flap of the envelope. Order extra invitations for keepsakes and for those people you inevitably forget to invite until the last minute. Ask the printer to deliver the envelopes in advance so you'll have plenty of time to address them while you're waiting for the rest of the invitations, and ask for at least 25 extra ones for every hundred to allow for mistakes.

Proofread your invitations both when you place the order and when you pick up the finished stationery. Ideally, you should check the wording and layout after the typesetting has been done but before the invitation is printed. And it's always a good idea to have more than one person proofread text.

Check to see that names, with proper titles, are correctly spelled and that the day, date, time, and year are written out and correct. Is the address right, and are the proper words capitalized? Are there periods after abbreviations, and are the words "honour" or "honor" written out as you want them? And don't forget to check the directions on direction enclosures.

The Wording on the Envelopes

On the inner envelopes, write last names only of adults and write children's names on a separate line in order of age. For example:

Mr. and Mrs. Smith

Tom, Dick, and Harry

Sharp Points

Be sure you have a chance to test the envelopes before you buy very many, or before you agree to do a mass addressing job for a client. If the paper is not good for writing on with a dip-in pen, you'll be struggling with a nib that splutters and catches and ink that spreads or doesn't take. Even with good quality envelopes, be sure you have a lot of extras for testing and to allow for mistakes.

On outer envelopes use full names and formal titles and don't abbreviate except for Mr., Mrs., Ms., and Jr.; formal titles, such as Doctor, Captain, and Reverend, are written out. Use

numerals only when writing house numbers and zip codes. Spell out all streets, cities and state names. When a woman keeps her maiden name, list her as "Miss" or "Ms." "Mrs." is used only when she takes her husband's name. Both names are listed on the same line and either name can be listed first.

Doing the Calligraphy on the Envelopes

No matter how good you are at calligraphy, think about whether you really have time to write out 100 envelopes by hand for your own wedding. You might be able to do one in 10 minutes, but it's a lot of work to do 50. You might decide instead to do a more visible part of the calligraphy—the place cards. And don't forget all those wedding gift thank you notes you'll have to do later!

On the other hand, there are ways to make the task a bit easier. First of all, decide whether you prefer the look of envelope addresses in which all the lines are ranged to the left, or the more traditional layout in which each line starts about half an inch to the right of the line preceding it, called a *stepped-in* style. At this point, you should test different nib sizes and writing styles and both the stepped-in and flush-left addressing styles so you can determine the width your rules need to be.

The problems with the traditional stepped-in look is that if you have a long last line you might not have enough room to fit it all in. It's helpful to have all the addresses you will have to letter neatly typed up in a typewriter-style typeface so you can see whether you have a lot of long last lines before you begin. Working from a typewritten rather than handwritten list reduces the chances of misspelling someone's name and shows you at a glance how long the lines are.

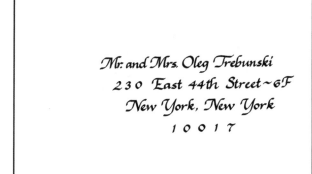

A formal, stepped-in address.

(© Harriet Rose)

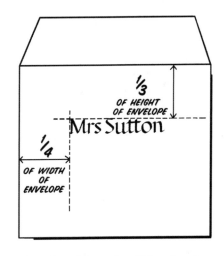

How the address should be placed on the envelope.

If the envelopes you'll be using are unlined and made of thin enough paper, you'll be able to avoid the tedious task of ruling up every single envelope separately. Make yourself a template from a piece of light, white cardboard. Cut it about ⅛-inch narrower than the size of the envelope. (Don't, however, make it the same height as the envelope; you'll find the template easier to slip in and out if it's taller.)

The next step is to work out how many lines most of the addresses have. Regular addresses have three: The first line is the name of the person the letter is going to; the middle line is the street address; and the last line is the city, state, and zip code. If most of the addresses you'll be doing look like that, rule up the template as shown in the following diagram.

The standard three-line address template.

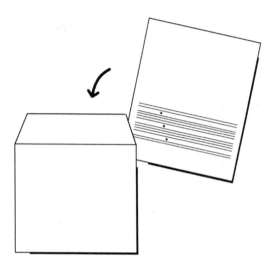

The address should start one third of the way from the top of the envelope and a quarter of the way in. If you have only one or two four-line addresses you can rule each envelope separately; if you have a lot, make another template for them. Rule your writing lines heavily in black so they will show through the envelope and indicate where to begin each line with a dot.

What do you do if the envelopes are the heavy, best-quality, lined-in-colored-paper variety in which the paper is too dense to allow for a ruled template to show through? You can still make things a bit easier for yourself. Again, you'll need a piece of stiff cardboard, but this time larger than the envelope. Place an envelope in the middle and trace around it with a pencil. Using a metal ruler and sharp Olfa knife, carefully cut along the pencil lines and lift out the envelope-size piece of board. You now have an empty place to fit in each envelope so that it doesn't shift around, as shown in the following figure. If you rule up the envelope and extend the lines on to the cardboard on each side, you'll have a much easier time ruling up all the following envelopes.

An address template for heavy envelopes.

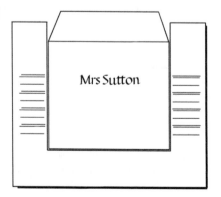

Mrs Sutton

Additional Flourishes

Addressing envelopes for invitations—to weddings, bar mitzvahs, charity events, christenings, anniversary dinners, even to public relations events—is one of the most popular uses for calligraphy today. If you like addressing envelopes, it's usually not too hard to find people who need this type of work done. Just contact businesses connected with special events such as bridal shops, country clubs, synagogues and churches and event planners. The industry standard is to charge by the envelope, and the going rate is between $1.50 to $2.00 per envelope. If you consider this task a fine way to practice lettering and have done some time-saving prep work first, it won't be a chore.

Stuffing and Mailing Envelopes

Your first task, to avoid postal disasters and undelivered invitations, is to take a package made up of one sample of each part of the package to the post office to be weighed. Ask the clerk to determine proper postage, not forgetting airmail postage if you are sending invitations abroad.

Once you've bought stamps for both the reply envelopes and outer envelopes, set out all your supplies and start stuffing. Etiquette books insist there is a proper way to this!

1. Place stamps on the response card envelopes. It should only need one first class (34¢ stamp) if the card and envelope are between $3\frac{1}{2} \times 5$ inches and $4\frac{1}{4} \times 6$ inches and less than $\frac{1}{4}$ inch thick. Then tuck each response card under the flap of a response envelope.

2. For each invitation package, place all the enclosures, writing side up, on top of an invitation in order of size, with the largest enclosure nearest the invitation. If the printed wording is on the inside of a single fold invitation, enclosure cards should be placed inside.

3. Place the tissue over the printed wording and insert the invitation with all its enclosures into the inner envelope with the folded edge first and the printed wording or cover design facing you.

4. Put the inner envelope, unsealed, in the outer envelope so that the guests' names are seen first when the envelope is opened.

5. Mail all invitations at the same time, four to six weeks before the wedding date, using first class postage.

6. Take your invitations to the post office and put them down the chute yourself! (Post yourself an invitation so you'll know that the whole batch wasn't shredded at the post office by mistake.)

The Least You Need to Know

➤ Decide which parts of the invitation to hand letter and which parts to have printed.

➤ Make a template so you can address envelopes easily.

➤ Use the proper wording when addressing envelopes.

➤ Double check to make sure all names and addresses are correct.

Japanese Calligraphy and Scrolls

In This Chapter

➤ Learning about Japanese calligraphy

➤ Creating shodo brush strokes

➤ Using Japanese characters

➤ Interpreting your favorite poem or saying in calligraphy

You don't have to know the language to enjoy oriental calligraphy. It communicates like an abstract painting, conveying a mood through shape, composition, and brush stroke.

In the East, calligraphy is considered a fine art equal to painting, and calligraphers are esteemed more highly than they are in Europe or the United States. The scribes take their work very seriously, too. It's not unusual for a pupil to spend months practicing just one stroke.

You might not have the time or inclination for such in-depth study, but there's no reason that you shouldn't pick up a brush and try your hand at making evocative Japanese characters for yourself.

Japanese Calligraphy

In Japan, calligraphy, or shodo, is an art form that brings words to life and gives them character. Artists develop their own unique styles and are highly revered. Shodo also is a kind of performance art—calligraphers draw the characters very quickly and precisely and don't touch them up or alter them afterward. The aim is to produce a balanced composition, handle the brush well, and produce good shading in the ink all at the same time. Structure and balance within the character is extremely important, and so is the articulation of the individual strokes.

This cursive-style calligraphy, written for the author by a Buddhist monk in Japan, more or less says, "Society presents a false image of life; a true image can be seen only by those who follow Buddha."

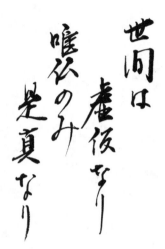

Written Japanese symbols were adopted from the Chinese writing system in the fourth century C.E. They are called *kanji,* which means "characters from China," even though spoken Chinese differs very much from spoken Japanese.

There are five different styles, or scripts, that Chinese and Japanese characters can be written in: seal, clerical, block, cursive, and semi-cursive. Block script, or kaisho, the one used for the exercises in this chapter, is the usual script that beginners learn.

Scribe-Speak

The Japanese characters in this chapter are called **kanji,** and each symbol represents an object or idea. The other type of Japanese writing is called *kana,* of which there are two types: hiragana and katakana. Kana represent sounds, much the way European letters do. If you want to find more symbols to draw, look for a book on kanji in your library or in a Japanese bookstore.

Using Japanese Characters

Once you can write a few words in Japanese, how do you use them? You could write several of the characters shown here on a long, narrow piece of paper, one below the other. Make a little rubber stamp of another of the characters. Stamp it in red at the bottom of the page for a very authentic-looking oriental scroll. Glue a strip of balsa wood or bamboo to the top and bottom so the paper lies flat when hung on the wall.

Japanese symbols look cool on T-shirts, too (see Chapter 9, "Projects to Begin With," for how-to's) or you can use the characters to make greeting cards. At the beginning of the year children in Japan often gather to create calligraphy symbolizing their wishes for the new year. You can do the same thing and create New Year cards for your friends.

Learning to Write Japanese Characters

You will need a brush, a block of ink, and a stone to grind the block on. (See Chapter 4, "Tools of the Trade," for information on how to grind ink.) An authentic Japanese bamboo brush is nice to use but not essential. For beginners, a large brush—a series 8 size brush or larger—is easier to use than a small one.

Japanese calligraphers kneel in front of a low table and write on handmade paper or silk on the flat surface, using a paperweight to prevent the paper from moving. The brush should be held about halfway down its length, as you would a pencil, but held upright; your hand does not touch the paper, as shown in the following figure.

Masters of Japanese calligraphy say that although the strokes themselves look simple, shodo is difficult to do because the student must eliminate his own frustration, annoyance, and distraction and concentrate simply on making the characters. Calligraphy students are taught that while they are grinding the ink they should try to clear their minds of the cares of the day, mentally prepare themselves for writing, and visualize the finished character on the page in front of them. In Japan, brush writing is as much about the mind and spirit as it is about brush technique.

Sharp Points

The art of shodo combines personal expression within a rigid framework of rules. Japanese students take months to study a single stroke thoroughly, so this chapter doesn't pretend to do anything more than suggest how you might interpret some of the simpler kanji characters for yourself.

Hold the brush upright.

Make your own Japanese-style scroll.

The Japanese strokes always have to be drawn in the correct order. They each have names such as "Dragon's Claw" and "Sword Blade." The horizontal strokes are written from left to right; the vertical strokes from top to bottom. The middle part of a symbol usually is drawn before the short flanking strokes on the sides, although a stroke that pierces the others vertically usually is written last.

The first character illustrated in the following figures is the one for "eternity" or "forever," which uses many of the basic strokes.

Notice that the strokes have a thickened beginning or end. This is where the direction of the brush is reversed.

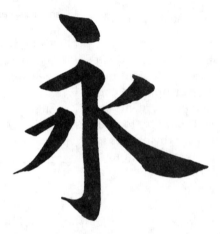

The Japanese kanji symbol for eternity.

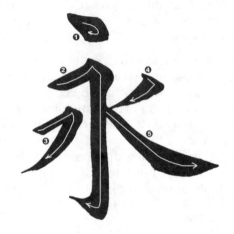

How to draw the Japanese symbol for eternity.

The Japanese kanji symbol for power.

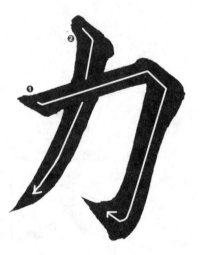

How to draw the Japanese kanji symbol for power.

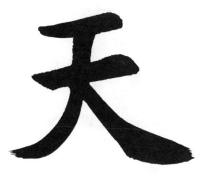

The Japanese kanji symbol for heaven.

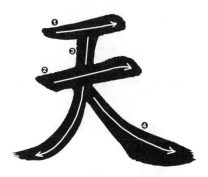

How to draw the Japanese kanji symbol for heaven.

The Japanese kanji symbol for moon.

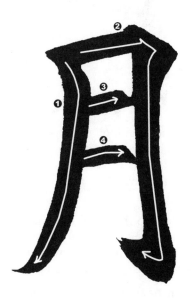

How to draw the Japanese kanji symbol for moon.

The Japanese kanji symbol for heart, mind, core.

How to draw the Japanese kanji symbol for heart, mind, core.

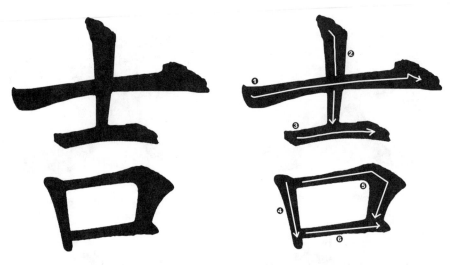

The Japanese kanji symbol for good luck.

How to draw the Japanese kanji symbol for good luck.

Making a Poetry Scroll

European words can look as decorative as Japanese characters when they're designed well and written creatively. Poetry—or a quotation, aphorism, or saying that means something to you—can be immortalized beautifully as a wall hanging with calligraphy. Keep a folder of favorites that you come across, and you will always have text to use for scrolls. Start with something simple and use the calligraphy style you prefer.

The first step is to think about what qualities you want to give the piece. A text is like a musical score; the calligrapher is like a pianist, interpreting how to present it. By breaking lines at different places, or with color, or capital letters, the calligrapher controls the pace of how a reader reads, and can emphasize some parts of the text over others.

The idea for the design can come from the content or from the shape of the lines. If you are writing out a piece of poetry, you can't break the lines to fit the paper; you must keep the lines the way the poet wrote them, so find the longest line and make sure you are writing at a size that can fit that line. You do a disservice to the poet when you change his punctuation and capitalization of letters, too. Remember, however, that you could make the scroll wide instead of long. All that's needed for it to become a wall hanging is a frame or two pieces of thin balsa wood—one glued to the top and one to the bottom.

When you start to sketch out layout ideas think about the shape the words make. Faced with a long piece of writing, the viewer sees the shape first and reads the individual words later; with a short piece it's the other way around. Use every element to achieve the mood you want. Make it dramatic by lettering the poem in white on black paper. Make it bold by writing the heading or one or two key words in large letters. Make it whimsical by writing the words in a circular format. It's up to you.

Designing a scroll and writing with a brush are both less structured ways of working that give you lots of creative leeway. (If you find writing Japanese characters with a brush exhilarating, you may want to try writing western characters with a chisel-shaped brush for the same sense of freedom.) On the other hand, you might be someone who prefers more controlled, precise ways of working. If that's you, the project in the next chapter, creating a family tree, is ideal.

Greeting card design.

(© Holly Monroe for Leanin' Tree)

The Least You Need to Know

➤ Make your own versions of Japanese characters.

➤ Hold the brush upright when doing shodo.

➤ Make a scroll by attaching rods to the top and bottom of a sheet of paper.

➤ Write out poetry or a saying in calligraphy to turn it into a work of art.

Making a Family Tree

In This Chapter

➤ Gathering data about your family

➤ Deciding how much data to include

➤ Choosing the best layout option

➤ Organizing the names into a logical order

A family tree can be as complicated or as simple as you care to make it. It all depends on how much work you want to do assembling information and arranging it into a decorative whole. If you are fascinated by genealogy, charting your family's lineage could become a labor of love that takes years to complete. If you want a commemorative keepsake that details just one or two generations you could be finished in a weekend.

This is one project for which you must define your goals right from the beginning. Decide whether you want to trace back to the immigrant in your family who first arrived in the United States through Ellis Island or just concentrate on the handful of kin who live in your town. There actually is not a lot of text to be written when making a family tree; most of the work is in the preparatory and layout stages.

Doing Your Homework

Don't be put off by all the information you have to assemble and make sense of. Before you put anything on paper, try asking the older members of your family if anyone has already started any sort of record of your clan. You might find that a lot of work has already been done by someone else.

If you are attending a large family reunion, ask everyone who attends to sign a "family book" and write down their full names and addresses and that of their parents. That way it will be easier to make up a family tree when you get home.

Additional Flourishes

Family trees aren't just for humans! A pedigree, done in calligraphy, of a friend's prize pooch makes a great gift.

You can buy a pedigree chart like this with spaces for names or draw up your own.

If you own a computer, you might want to investigate the programs available for genealogical record keeping. Once you've entered all the data, these let you view your material in many different ways, which can help you decide what layout to use for your hand-drawn family tree.

There are two different types of genealogical charts. An *ascendant chart* starts with you and goes back through the generations to your ancestors. A *descendant chart* starts with someone born long ago and comes down through the generations listing that person's descendants. The way to gather information for either one is to fill in a pedigree chart, as shown here. Blank charts can be bought and filled in with calligraphy if you don't want to go to the trouble of drawing up your own. Gather information for these charts by asking your parents or siblings questions, or looking up family records—many families record details in a large bible.

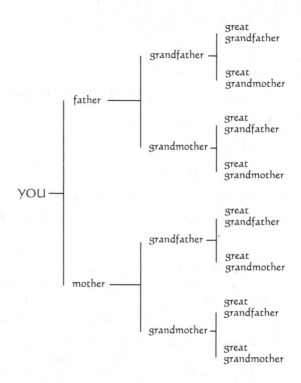

Making a Simple Four-Generation Chart

After you've filled in a pedigree chart, you might want to draw it up in a more decorative way. To translate the information into the shape of a tree, you'll need to start with a large piece of tracing or layout paper—a layout pad with 20 × 15 inch paper is useful. Sketch the shape of a tree. Give the pedigree chart a 90-degree turn so that your name is at the bottom. Write your name on the trunk of the tree, widening it if necessary, and add your parents' names to the first branches and so on. Change the shape of the tree to fit the names.

Next, write out all the names on separate pieces of tracing paper and tape them on at the appropriate places. You might have room to write the years of birth and death in a smaller size underneath the names.

Sharp Points

Don't forget to give your family tree a title so people know what they're looking at: "The Sullivan and Dodd Families" or "The Descendants of Amelia Earhart."

You might need to place a fresh sheet of tracing paper over the first tree sketch and redraw it, widening the branches to fit in the names. When everything fits, use a light box to copy the shape of the tree onto the piece of paper you will use for the final piece.

If you doubt your ability to draw a tree, consider the style in the following figure in which the branches are more stylized. The leaves were made by carving a leaf shape into an eraser and using it as a rubber stamp.

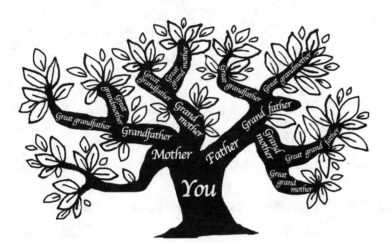

A tree-shaped family tree.

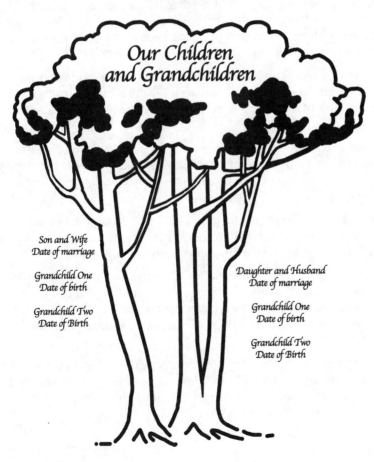

A simpler family tree with space for dates and other details.

A semi-circular "tree" is a good layout choice if you are happier using a compass than drawing leaves. The style shown in the following figure uses a horizontal format rather than a vertical, and fits in all the names economically. When ruling up this style of chart, allow four levels—one for each generation. Work out which name will be the longest; each compartment should be that size.

A semi-circular family tree.

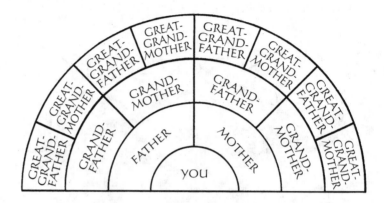

A Layout Challenge: The More Detailed Chart

You will notice that the pedigree chart does not have room for your brothers or sisters, or the siblings of your mother or father or grandparents, either. To include everyone you'll have to do a lot of work arranging the names into a layout that's easy to read. In one generation you could have a couple with ten children and in the next a couple with none. And when families intermarry the design of your page gets even more complicated.

How do you begin? As usual, you start with a rough layout. The most important thing is to make sure all members of a particular generation are placed on the same horizontal level across the sheet. Don't even think of drawing the tree on good paper until you have all the generations in the right row.

The bottom level will be you and your brothers and sisters; the next level up will be your parents and their brothers and sisters. In genealogy an = sign is used to denote marriage so that Husband = Wife. A line is drawn down from the equal sign to denote children.

Write out each name and stick it in place on a large sheet of paper. Use a glue stick that makes it easy to reposition the names if necessary. Keep taping on paper if the diagram grows out to the side.

Things get especially complicated with second marriages, stepchildren, and blended families—that's what makes a family tree a challenging layout exercise. If there are large gaps where couples had no children, consider filling these spaces with illustrations, photos, or decorative elements.

You will have to do several rough layouts before you get everyone fitted in. Try to get neater with each layout. For the final layout, use the calligraphy style you plan to use on the finished version, cutting and pasting the names onto the layout.

Additional Flourishes

Do you have photographs of your great-grandparents? You could have them copied to stick onto your family tree.

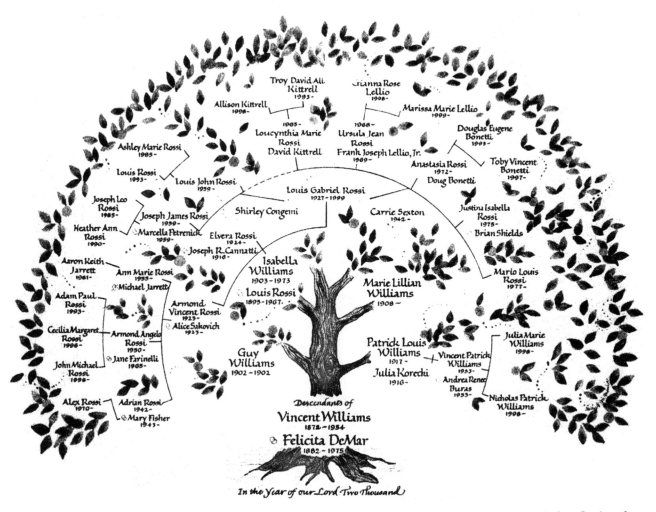

A magnificent family tree by Holly Monroe of Heirloom Artists-Calligraphy and Design in Cincinnati that fits in a lot of information beautifully.

(© Holly V. M. Monroe)

Color can help make things clearer. Use one color for lines and dates and another for names, or use a particular color for all the people with the same last name.

$$Husband = Wife = Husband \#2$$

Child #1 Child #2

Second marriages are shown with another = sign.

When the layout is as neat as you can make it, it's time to start the real thing. You will know how big your paper must be by the size of the rough layout—but have more than you need in case of mistakes. Lightly rule up the main lines indicating each generation on your good paper, taking the measurements from the rough. You can use a light box to make indications for yourself where the names should begin and end.

Don't leave anyone out on the final version! It's easy to do when you're concentrating on making the letters nicely. Take it slowly, keep referring to your layout, and the finished result will be something to be proud of.

The Least You Need to Know

➤ Decide how much research you have time for.

➤ Decide how far back you want to trace your lineage.

➤ Choose a layout to suit the information you have.

➤ Add color to make your family tree easy to read.

Making Posters and Playing with Words

In This Chapter

➤ Making eye-catching posters

➤ Using tricks to making words stand out

➤ Editing the poster headline

➤ Getting creative with words and letters

A poster's first job is to be noticed. It has only seconds to capture attention, especially if there are lots of other visual stimuli—traffic lights, shop windows, or other posters—vying for attention nearby. Make your poster stand out from the crowd by making it startling, unusual, funny, or direct. How do you do that with calligraphy? We'll tell you.

Location, Location, Location

You can't begin to design a poster until you know the size it will be, where it will be posted, and who your audience is. A notice on an 8½ × 11 inch page pinned to a library notice board needs considerations different from a 20 × 30 inch banner that will be applied to the side of a building. When you have a captive audience—such as at the library notice board—you can use more words and give more details.

There are other questions you'll need answered before you begin: How many posters are going to be made, and will you need to hand letter them all? Will the poster be put up outside? You might need to use waterproof acrylic paints.

Less Is More

If you're responsible for coming up with the concept for the poster, you'll need to start by asking yourself this question: If the person who glances at this takes away only one idea,

Sharp Points

Don't forget that instant printers often can reproduce posters at large sizes. There's usually no need to do more than one copy of a poster.

Even if you are not good at sketching you can turn letters into illustrations.

Sharp Points

The most important test to see whether your poster works is to determine whether you can read the type from the viewing distance at which the poster actually will be seen. The only way to check this is to do a full-size poster and test it by pinning it up, preferably in the position it'll be posted in.

what do I want it to be? You need to be very clear about the answer—this is the focal point of your poster. Good design starts with clear thinking.

If someone else is asking you to make a poster, the first step is to get the words to be used—typed out, preferably—and then pare them down as much as possible. A short, snappy headline works best. If you must use a long headline, pick out one or two words to make really big. Say, for example, that the president of the bake sale committee wants a poster headline of "Come to our school's annual giant bake sale." For a more effective poster you could reduce that headline to the words "Giant bake sale" and perhaps write them on a large cookie shape.

The rest of the words probably will need to be edited, too. Group together key or related information. As a designer, part of your job is to organize the information into chunks and sort them according to their importance.

Keep the design of posters simple and uncluttered and get rid of anything that isn't absolutely necessary. If the headline is arresting enough, the viewer will stop to read the small print for details. However, if the poster is a boring, gray list with everything the same size, no one will stop at all.

Make It Eye-Catching

Once you've stripped the words down to the bare essentials, it is time to do a layout. The theme of the poster will need to instantly communicate whatever the poster is announcing. If you are advertising a local dance, the whole design of the poster should indicate "dance"—through lively type and cheerful colors—before the eye even has time to read the word.

Make use of bold, intense colors and simple, eye-catching shapes. Large letters, words written on an angle and a small segment of a large image all are useful tricks to grab the public's attention.

Don't fill every bit of the poster with words or pictures. Posters that are crammed with information are tiring to read, if anyone even bothers to read all of the text. White space provides a frame and makes the vital information stand out; too little white space makes the viewer's eye confused.

Poster by Holly Monroe of Heirloom Artists-Calligraphy & Design. Notice how the important words, done in capital letters, stand out.

(© Holly V. M. Monroe)

Playing with Words

One of the best ways to catch someone's attention is to play with calligraphy to make the words themselves the illustration, as in the following figure. You can do this by making the type into the shape of what the word represents; for example, write the word "thin" in a skinny lettering style. Alternatively, you can use pictures to replace some of the letters. The pictures can be the shape of the letters they're replacing—for example, a ladder could replace an A—or they could be the sound equivalent, as in a buzzing bee instead of the word "be."

Words can illustrate what they're saying.

ViSUAL ARTS

Produced by Business Volunteers for the Arts, a program of the Arts & Business Council, Inc.
NEW YORK ARTS

music

Produced by Business Volunteers for the Arts, a program of the Arts & Business Council, Inc.
NEW YORK ARTS

DANCE

Produced by Business Volunteers for the Arts, a program of the Arts & Business Council, Inc.
NEW YORK ARTS

Another way of making words into illustrations is to repeat a word or write out a bit of text, making it fit a shape you have sketched on the paper. You might draw the shape of the New York skyline, perhaps, and fill it with the words to popular songs about New York. However, don't go crazy and use several unusual type styles; the rest of the words on the page should be plain and simple so the fun stuff stands out.

When you're making a poster with a light-hearted theme, try cutting letter shapes out of paper and sticking them onto your design.

Additional Flourishes

When you write with a home-made "brush" such as one made from felt wrapped around cardboard, your letters won't be as perfect as those made with a nib. But if you wield the "brush" boldly and freely, your words will have a freshness and energy that works well for poster lettering.

Ways to Write Large Letters

If you are making a poster or large sign, there's no need to buy an extra-wide brush or poster pen just to make one or two large letters. You can make your own pen for writing huge letters. Balsa wood, a very light wood sold in model and hobby shops, is ideal. Buy the 1mm-thick variety and give the writing edges a beveled or wedge shape, or cut notches in the writing edge to produce interesting letters.

For a more flexible "pen," use a piece of thick felt, or wrap a thin piece of felt around a piece of thick cardboard or the balsa wood. Secure it with a bulldog clip or thick rubber band to make it easier to write with (see the following figure). Even a rectangle of cardboard cut from a cereal packet will do as a large pen, although you will need to keep trimming the writing edge as it gets soggy. To write with all these "pens," pour ink into a saucer to use for dipping or try putting different colors along the edge of the felt to create a multicolored letter.

Wrap a piece of felt around a bit of thick board and secure with a clip to use as a brush.

Sharp Points

You don't have to work at full size if a poster is going to be printed. How do you know what size to write out your artwork? Half size is a good choice. Imagine a sheet of paper the size of the finished poster. If you fold it in half and then in half again the sheet is divided into four quarters. One of those quarters is "half size" of the original. For working out different proportions, you can buy a proportion wheel from an art supply store. You turn the dial until it's set to the measurement you know; the wheel then shows other proportional sizes.

The Least You Need to Know

➤ Before you can design a poster you need to know its size and where it will be posted.

➤ A poster must be eye catching—it has only a few seconds to get attention.

➤ For an effective poster, make something about your letters unusual or amusing.

➤ Be creative about making your own extra-wide brushes.

The Medium Is the Message

The fun of calligraphy is all in how you express yourself. Whether your style is city-elegant, country-crafty, or a look that's all your own, there are tools and styles to create it. When you see all the different effects you can make with different materials, you'll understand that the medium really is the message.

You'll learn the basics of making your own quills and pens from a variety of tubes, plus all sorts of ornamenting techniques with ribbons and 3-D effects. And once you've made a masterpiece, you'll want to see it in print or frame it for display—the how-to's are here.

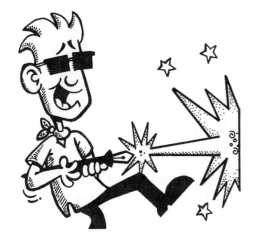

Different Tools, Different Effects

In This Chapter

➤ Getting creative with different tools

➤ Making your own pens from all sorts of tubes

➤ Creating your own rubber stamps

➤ Embossing letters and words

One of the best things about calligraphy is that there are so many different kinds of writing instruments, writing mediums, and writing surfaces; not to mention different writing styles. With all these choices there must be a combination to suit everyone if they experiment long enough to find it.

Although no pen will help if you haven't practiced your letters and don't space your letters properly, the right pen can make writing a real pleasure. Include time in your practice sessions for experimentation and discovery, and play with different techniques.

Reeds, Bamboo Pens, and ... Makeup Sponges?

Although quill pens have long been used for small writing in books and other documents, scribes have used pens made from reeds from earliest times for larger writing. You can make your own reed pens with bamboo canes, available from garden centers; or any other dried stem can be used.

However, medieval scribes used quills and reeds because that's what was at hand at the time. To capture the essence of their ingenuity, follow their lead and improvise with materials that you have nearby. Popsicle sticks, polystyrene foam, pieces of felt, foam rubber wedge "brushes" from the hardware store, wedge-shaped makeup sponges, polystyrene, plastic tubing for plumbing—you really can use just about anything to write with. The trick is to make it hold ink and to find an instrument with the degree of flexibility that your hand enjoys using.

The stiffer the tool you use, the more it will control your hand movements and the harder it is to make smooth curves and subtle serifs. The more flexible the tool you use, the more control you will have over it. Many experienced calligraphers prefer using the traditional quill pen because it gives more flexibility than a steel nib. If you know how to cut a nib shape, you'll be able to turn just about any tubular instrument into a pen.

Making a Quill

You can make your own quill pen the way scribes did throughout the Middle Ages. You'll need a feather from the first five flight feathers—they are the strongest—of a goose, swan, or turkey. Feathers from the left wing are better for right handers; the right wing for left handers. Ask a butcher to save them for you around the end of the year. Cut away most of the feathery part (called barbs) where your hand will grip the quill (you can leave some on at the end for decoration).

A feather that is at least one year old will have hardened enough to use. If your feather is fresh and soft and rubbery and you can't wait that long, you can harden it by pressing it against a hot iron until it is clear and yellowish. Alternatively, hold the quill about two inches above the electric element on a stove and rotate it for about 10 seconds. Heat just until the quill becomes transparent and the soft pithy inside shrivels, carefully applying the heat a little at a time. Too much heat and the quill will become brittle and crack; too little and it won't stay in shape for long when used.

Soak the quill in water overnight. Scrape off any membrane on the outside with a dull knife blade. Use a thin crochet hook to clean inside the barrel of feather. Now you're ready to cut its point into a nib shape. (Did you know this was the original purpose of a penknife?) To keep your quill sharp you need to cut off a sliver at the tip as it becomes worn.

How to Cut a Nib

Cutting a nib shape isn't too difficult:

1. Take a sharp knife such as an X-acto knife or an Olfa knife and, keeping it almost flat against the side of the tube, make an oblique slash, which takes off most of one side of the tube.

The first cut is an oblique slash.

2. Make a second cut from about halfway down the first to refine the writing point.

The second cut refines the first.

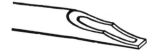

3. Make the slit. If you're cutting man-made material such as plastic tubing, you'll need to cut the whole length of the slit—about ¾ inch. If you're cutting a reed or a quill, it's better if the cut falls along the natural grain of the material. To make that happen, make a tiny cut to begin the slit. Then wedge the knife blade in this beginning cut and force the slit to open until it is about ¾ inch long.

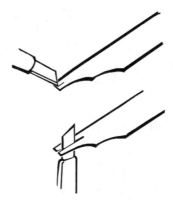

Make a short cut, then force the slit to open wider.

4. The final step is to cut a sharp, angled writing edge to your pen. Put the nib on a thick piece of cardboard and make a clean cut at a slight angle. Don't saw back and forth or the writing edge will be jagged. One quick, forceful cut is necessary to make a smooth surface.

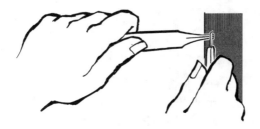

Place the nib over thick board and make a clean cut for the writing edge.

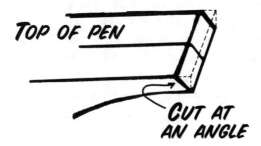

TOP OF PEN

CUT AT
AN ANGLE

This is how the final cut should look close up.

Once you've made a few regular pens, try making another with one notch—or several—at the tip (see the following figure). This will give your lettering interesting inline effects.

Make a notch for split-pen effects.

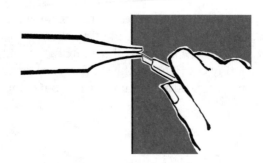

Although they hold more ink than a quill, bamboo and reed pens soak up a lot of ink at first. To make them hold more, add a reservoir. You can make one yourself from a strip of metal cut from a heavy-duty foil pie plate or a soft drink can. Just cut a 2mm-wide and 3cm-long strip from the can—it can be cut with scissors—and bend into a letter S shape. Put it in the pen as shown.

A homemade reservoir.

Additional Flourishes

After you've made yourself a quill—the writing instrument of days gone by—you might be tempted to try using it to write on parchment or vellum, the writing surfaces traditionally used with quills. If so, be aware that parchment is whiter and thinner than vellum but greasy and difficult to erase from. Vellum, a fine quality variety of parchment, has a velvety, stronger finish.

You can also find papers called "parchment" or "vellum." They are a lot cheaper than the real thing and are made from wood chips or rags and try to imitate the surfaces they are named after.

Unusual Tools from Shops

You'll be surprised at where you come across items you can use to write with. A makeup sponge, already cut to a wedge shape, can be perfect to use for writing with glue—just use it once and throw it away! Try scouting around art supply, hardware, and crafts shops for any writing implement with a broad edge, especially when you want to create a word that evokes a certain feeling such as "spiky" or "scratchy." Even old, dried-up felt markers have their uses for certain lettering, as shown in the following figure.

Old dried-out markers create dry brush effects.

Sharp Points

Of course, you also can write with brushes, but it's not as easy as with a pen. If you are serious about trying calligraphy with a brush, know that it's frustrating to attempt to work with a cheap brush. Splurge on a good one, such as a ¼-inch wide brush made of red sable. Look after a good brush well by cleaning it thoroughly after each use and trying not to get any paint in the *ferrule* (the metal part that holds the bristles).

You can even use a makeup sponge as a "brush."

Making Rubber Stamps

With rubber stamps you can create monograms to make stationery, decorate envelopes, personalize books, create patterns for wrapping paper, or decorate borders for cards. If you are having a small piece printed by an instant printer in black and white, you might want to leave out a large beginning letter so you can put it in later using a rubber stamp with a bright-colored stamp pad.

For an intricate design with lots of thin lines, you should take your artwork to a stationer who makes rubber stamps so the stamp can be made photographically. For simple designs and single letters, try making your own. You'll need a square, blocky, plastic eraser, such as a Faber Castell Magic Rub. It's easiest to work with a set of linoleum cutting tools, available at art supply stores, but if you have dexterity with tools, an Olfa knife or X-acto knife might do. Here are the steps:

1. Draw or trace the outline of a letter onto tracing paper. It's best to start with a thick, heavy letter such as a Gothic letter. It cannot be bigger than your eraser.

2. To transfer your design to the eraser, scribble over it with a soft pencil.

First trace the letter and then transfer it to the eraser—the wrong way round …

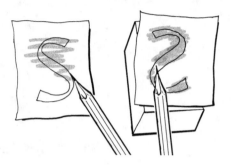

3. Turn the paper over and place it on the eraser. With a hard pencil draw over the shape you want to transfer. (Remember that the letter will look back to front on the eraser, but will be reversed when you print it.)

4. Use the linoleum-cutting tools to cut around the letter shape, taking care to not undercut the letter, which will weaken it. Carefully take away the surplus eraser, leaving your design raised.

… Then take away enough of the eraser so the letter stands alone.

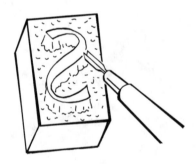

You can mix up some ink or gouache to exactly the shade you want to use with your stamp. Pour it into a saucer that has a folded piece of scrap cotton fabric in it and you have a homemade stamp pad.

Sharp Points

Calligraphic letters are not the only possibility for rubber stamp designs. Try making a holly leaf with berries, a star, or other simple shape. You can draw straight onto the eraser because with a symbol it won't matter if your design prints back to front.

Making Embossed and Debossed Letters

Embossing is when the letters stick up; *debossing* is when the letters sink down. Both give a very subtle, elegant look to stationery or a scroll and you don't need any special equipment; just an X-acto knife or Olfa knife and a blunt, pointed tool such as a knitting needle. Because it works best to view the finished piece from the back, you'll need to make a sunken *die* to get raised or embossed letters and a raised die to get debossed letters.

For the embossed letters you'll need a piece of illustration board. This type of board is made by pressing layers of card together so that when you cut into it you cut through the top layer, which then easily lifts out.

1. Draw a letter shape and trace it, back to front, onto the surface of the board. Again, remember that a design that is thick and blocky will be easier to work with than one with thin, fine lines.

2. With a sharp Olfa knife, cut out the shape of the letter through the top layer of cardboard, as shown in the following figure. You then can pick it out, leaving a hollow trough.

Scribe-Speak

A **die** is what you are making when you stick the letters, wrong way round, onto the board. Printers make dies of metal when they print embossed stationery in quantity. Usually printers make embossed letters with ink on them. Embossing with no ink, the method we're outlining here, is called **blind embossing.**

First cut letters to be embossed out of cardboard and glue to a thick board—back to front.

For a debossed effect, follow these steps:

1. Draw a letter or simple shape on a piece of scrap cardboard, no thicker than that used to make cereal boxes. In fact, you can use an old, flattened out cereal box.

2. Glue this shape in the center of another piece of scrap cardboard, about 8 × 11 inches.

For either debossing or embossing, dampen the paper you want to use by passing it quickly under running water, shaking off the excess, and patting it dry. The object is to stretch the paper fibers so they conform to your design without tearing, and some papers are more flexible than others so you should practice with different kinds. Both handmade paper and the kind of paper used for etching work well.

Ink Blots

Remember—it's back to front when making rubber stamps and dies for debossed letters. It's easy to get so caught up in the cutting and carving that you forget.

155

When the die is ready, place the paper, which should be just slightly damp, over the letters in the position you want it. Take a blunt, pointed instrument such as a knitting needle or the rounded end of a paintbrush, and rub gently around the letters, as in the following figure. Keep looking to see where the edges of the letters are, so you don't scratch the paper by feeling for them with the knitting needle. Be careful to ease the paper around the raised design and to avoid tearing the paper.

Place the paper on top of the raised letters and press around them with a knitting needle.

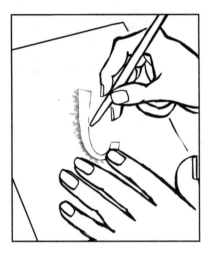

There are so many different mediums with which to execute calligraphy, and to explore these techniques you need to experiment. If you take time to play, using inexpensive materials, you'll know the kind of results that are possible and you'll have an inventory of ideas to call upon when you want to make special cards or decorative scrolls.

The Least You Need to Know

➤ Experiment with different tools to write calligraphy.

➤ Create your own tools for making large letters.

➤ Make rubber stamps to decorate stationery and wrapping paper.

➤ Make your own embossed cards and letterheads.

Getting into Print

In This Chapter

➤ Deciding how to get your artwork printed

➤ Working with a commercial printer

➤ Estimating timing and quantities

➤ Preparing calligraphy for the printer to use

If you need only a few copies of your artwork the best idea might be to use a photocopy machine. You can easily load it with colored paper and it might even take paper thick enough to make cards or invitations. However, if you need quantities of more than 25 copies, you'll need a printer.

Where do you start if you've never had anything printed before? It's not as difficult as you might think, especially if you have a simple idea such as making bookmarks for Christmas presents or producing a spiral bound leaflet of recipes. This chapter guides you through the complexities of getting your artwork printed so you can distribute it to a wider audience.

Instant Printer or Commercial Printer?

In most areas you will have a choice between two different types of printers—instant printers or commercial printers. Instant printers are places such as Kinko's or Sir Speedy that use offset presses and copy machines. They offer fast service and low prices for small quantities, and are ideal for calligraphy because they work well with black-on-white artwork. The quality of printing that the best copiers do actually is superior to offset—the black is more opaque than printer's ink and holds thin lines better. When you have a simple project, such as an 8½ × 11 inch poster advertising a bake sale, or when you want only one color printed and a quantity of less than 100, take it to an instant printer.

Sharp Points

How do you find a commercial printer? You could look at the advertisements in your local Yellow Pages—printers usually will mention in their ads the type of work they specialize in. However, a better way to find a printer who does good work is to look for examples of printing you like—menus from fancy restaurants, business cards from small local shops, or friends' wedding invitations, for example—and find out which company printed them.

You can't expect an instant printer to improve your artwork the way more expensive printers can. Your original has to be *camera-ready;* that is, you must cover any cut lines or pencil marks or dirty patches on your original with white paint. What you see is what you'll get. Also realize that instant printers usually have a limited selection of paper that they use for printing. When you want to have a more complicated job printed, such as a wedding invitation that you want printed on handmade paper with silver ink, you'll need to find a commercial printer.

Commercial printers can handle a larger array of paper sizes and they have camera services, which means that although you give them a piece of artwork done in black ink on white paper, they can produce it in different ways such as printing it as white type on a pink background. Choose a commercial printer when quality is important, when you need quantities of more than 100, or when you want to use nonstandard formats or papers.

Timing, Pricing, and Estimates

If you've decided to use an instant printer, the negotiations will be relatively painless: You take in your artwork and discuss the project with the person behind the counter. Using a commercial printer is a more serious undertaking; one that you'll need to plan well in advance.

Before you even walk in the door of a commercial printer, figure out your timing. The best plan is to work backward. For example, if you are having an invitation printed, calculate how much time you'll need before the event to get the RSVPs. Then add in time for people to reply, for the post office to deliver, and for the invitations to be stuffed in the envelopes. Don't forget to allow time for addressing the envelopes, especially if you are going to do it yourself in calligraphy.

Once you've found a printer, figured out your timing, and decided what you want your printed piece to look like, the first step is to get an estimate or quote. This is where you give the printer the information needed to complete the job—the quantity needed, the ink and paper to be used, the size and any folding that's needed—and he or she responds with an estimate of how much it will cost and how long it will take.

Ink Blots

To avoid production costs getting out of hand, start by estimating how much time you have and how much money you are willing to spend. (Time is as important as money because "rush jobs" can be really expensive.) Don't order printing from a commercial printer without a written estimate or contract detailing the expected cost and time and don't make extra requests afterward without knowing the time they will take and the added cost they will incur.

Remember that the grand total can change if it turns out that the project will entail more work than the printer thought it would. That's one reason it's a good idea to try to show the printer exactly what you have in mind right at the beginning. You can do this by bringing in a mock-up you have made as well as showing him or her samples of different elements you'd like to use, such as embossing or paper swatches, and comparing them with printed pieces the printer has already done. The less room for interpretation, the more exact a quote you will get—and the fewer unhappy surprises will be in store for you when the job is finally delivered.

When the printer asks you about quantities, remember it's always safer to get extras than to try to estimate exactly how many pieces you'll need. Printers usually have a clause in their order forms promising to deliver a quantity within a certain plus or minus range of that ordered. This is because quite a few of the printed pieces will need to be discarded during production. What this means is that you should allow a generous margin in quantity in case the print run comes up short, but also bear in mind that if the printer ends up printing extras you will have to pay for them.

If you are very anxious about the job turning out exactly the way you want, you might decide to ask for press proofs. These will cost extra, but it will give you a chance to see exactly what the finished piece will look like on the paper you've chosen. If it's vitally important that the color of the calligraphy matches the bridesmaid's shoes, this will be your chance to check that it does and to make last-minute changes before the whole job is printed. (Always remember, though, that the further along in the process a print job gets, the more difficult and costly it will be to make changes and the more annoyed the printer will be.)

What if the estimate ends up being way higher than you had budgeted for? Don't panic yet. Ask the printer what he can suggest to bring the cost down. He might show you a cheaper machine-made paper that looks almost the same as the handmade paper you were hoping to use. He might point out that if you use only gold ink instead of gold plus silver, the price will come down. Printers are used to making these kinds of compromises and if you're willing to be flexible you'll probably be able to arrive at a satisfactory solution.

Sharp Points

If you are having an invitation printed, ask if the printer can deliver the envelopes early, separate from the invitations. That way you can get a head start on addressing them while the rest of the job is being printed.

Don't forget to ask if delivery costs are extra and confirm delivery dates when you place your order. And if you are going to get several estimates from different printers, be sure you emphasize that you want only a quote to begin with and that you are not yet placing a definite order.

Choosing Paper, Format, and Folds

Choosing a paper to print on is different from choosing a paper to write on, but luckily there is a much wider choice of paper that is suitable for printing. Paper is an important part in the design of the piece—texture and color convey a mood; but there's also a practical concern: You must determine whether the weight is suitable. A book cover, for example, will soon tear if it is made of flimsy paper. And if you're going to be printing on both sides of a sheet, opacity becomes a factor—avoid using a paper so thin that the writing from the other side shows through.

Are you having an invitation printed on which you later will add handwritten names? The card must be able to accept the kind of ink you want to use when you do the calligraphy. It's also a good idea to choose sizes that are standard in the paper and printing industry; that is, those based on an 8½ × 11 inch sheet and multiples of that.

Always talk to the printer about paper. He might call your attention to considerations you have overlooked; for example, whether the paper comes with matching envelopes, if it folds well, or takes embossing easily.

Preparing Artwork for the Printer

The first thing the printer does when he gets your artwork is to photograph it with a special camera that just picks up the solid black areas. A gray smudge will either disappear or become a black smudge. That's why you must make sure all the lines you want to print are done in a dense, black ink.

You might want a card with green and orange letters on blue paper, but you can't give the printer the artwork done that way. The letters must all be done in black ink on white paper. The green letters should be drawn in black on one sheet of paper and the orange letters drawn in black also, but on a separate sheet so that they can be photographed separately. If you are having words printed on two different sides of the one sheet of paper, you must prepare separate artwork for each side.

It makes things easier for you when the printer photographs the artwork because if there are any stray marks on the paper you can paint over them with a special paint called *process white*. The shiny white paint on the smooth white paper will stand out in an ugly way to your eye, but the camera just sees the job in terms of black and white.

Also, if you make a mistake with a word you can redo it on another piece of paper and paste it on top of your original writing. If the new, higher piece of paper casts a shadow that the camera picks up, the printer can paint it out. (These shadows are called *cutlines*.)

The printer also can use the camera to reduce the size of your artwork. This is a help because it's easier to write with a large pen. When the art becomes smaller it looks crisper, and any fuzzy edges aren't nearly so fuzzy. Just make sure you use a copy machine to check the following:

Additional Flourishes

If you want your artwork back after the printer is finished with it, put that in writing at the beginning. Also, if you are having an embossing die made of, say, a monogram that you might want to use again, decide whether you or the printer will keep it until it is used again.

➤ You have kept to the right proportion. You can't say to the printer, "Just make it fit"; you have to specify how much to resize it with instructions such as "Reduce artwork to 60 percent of original size."

➤ Any thin lines in the writing don't disappear completely.

➤ It's also a good idea to give the printer a photocopy of the piece at the final size it will be printed so he or she knows exactly what you have in mind.

The camera does not pick up a pale blue mark so you can use that for ruling your lines. Either do the calligraphy on paper and glue it to a piece of white illustration board or use the board to write on. You also should define the edges by indicating folds with dotted lines and drawing trim marks in black at the corners (but out of the way so they don't print).

The best way to specify what ink color you want used is to look at the printer's book of color swatches from a color matching system such as Pantone. Note the numbers of the colors you like and write them on the *mechanical*.

Finally, attach a sheet of tracing paper, called an overlay, on top, and write on it the instructions to the printer. Include your name and address, the date required, the quantity, the color of ink, type of paper, and the final size; and add a warning if the ink you've used for the calligraphy is nonwaterproof. This might sound excessive, but experienced designers know it's best to not leave anything in doubt. The function of the mechanical is to show the printer exactly how you want the finished job to look. Everything must be clean and in the right position; have instructions written on a tissue overlay, crop marks indicated for trim size, and folding indicated (see the following figure).

Scribe-Speak

A **mechanical** is camera-ready artwork which has all the design elements pasted in correct position, ready to be printed, on a white board, with instructions to the printer attached.

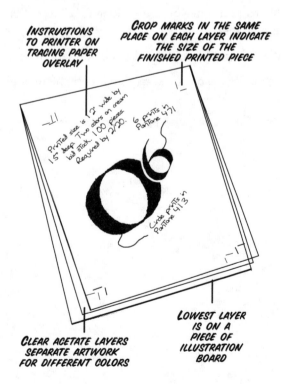

INSTRUCTIONS TO PRINTER ON TRACING PAPER OVERLAY

CROP MARKS IN THE SAME PLACE ON EACH LAYER INDICATE THE SIZE OF THE FINISHED PRINTED PIECE

CLEAR ACETATE LAYERS SEPARATE ARTWORK FOR DIFFERENT COLORS

LOWEST LAYER IS ON A PIECE OF ILLUSTRATION BOARD

This is how a mechanical should be prepared for the printer.

To reduce the possibility of any misunderstanding, supply a mock-up or dummy to show the printer exactly how the final piece should look. Ask the printer whether the artwork is right when you submit it and whether it is clear to him or her.

Check Everything

I can't emphasize strongly enough how important it is to make sure that every detail of the artwork is correct before you give it to the printer. If you discover you've made a spelling mistake while the job is in progress you will be billed for changes—the whole thing might have to be done again if the printer has almost finished—and at the very least the printing will be delayed.

Some printers will make you sign a proof to show that you consider what is on it to be correct. After you've signed it, you're responsible for any errors, regardless of whether they were your fault or the printers. Read and make sure you understand any statements attached to the proof you are signing because you probably are agreeing to be liable for any mistakes. If you do find a small mistake—an extra blob of ink where it shouldn't be, for example—don't just tell someone. Circle the mistake on the proof and write exactly how it should be changed, with "approved if this mistake corrected" next to it.

These kinds of headaches can easily be avoided by getting someone else—or two or three people—to proofread what you've done. This isn't lack of confidence; it's what professionals do. Often if you are reading a name or address that is very familiar to you, you will "see" it as correct even if it's wrong, because the eye tends to skip over words it's used to.

The Least You Need to Know

➤ Allow enough time for printing and begin early.

➤ Choose paper that's suitable to print on—you are looking for different characteristics from those needed for writing paper.

➤ Check your artwork carefully for spelling mistakes before you send it to the printer.

➤ On your artwork indicate quantity, colors, date required, and anything else the printer needs to know.

Ornamentation and Presentation

In This Chapter

➤ Decorating ornamental initial letters with gold

➤ Attaching ribbons and tassels

➤ Adding a third dimension to your designs

➤ Choosing frames

Ornamenting a piece of calligraphy is simple to do; yet it adds an impressive touch, especially on awards and certificates. Gold lettering, ribbon closures, and sealing wax convey an aura of pomp and ceremony. Cutouts and three-dimensional touches turn your handwriting into one-of-a-kind greeting cards that are works of art. You will want to frame your most successful pieces so they can be admired by all.

Using Gold Ink and Gouache

The secret to using gold is to not overdo it. Because it catches the light, gold immediately draws the eye, and a little is just as effective—if not more so—than a lot.

Inks and gouache, which come in colors called "gold" and "silver," actually contain metal powder—not real gold. Although they might lack the brilliance and allure of the real thing, they are fine to use on cards for friends and simple projects. They're also easier to use—although they need to be stirred continually because the particles keep separating from the liquid they're mixed with. Metallic inks and gouache also dry on your pen very quickly, so often it is easier to use paint and apply it with a paintbrush.

Making a Decorative Capital Letter

You can either do the rest of the calligraphy first, leaving a space for your decorative letter, or do the initial cap first—whatever you feel more confident doing. An easy way to draw the

letter is with double pencils. You might have to experiment until you get the pencils the right width for the letter size you want—you can increase the width by slipping a slither of cardboard between the pencils as you wrap them with tape. Lightly draw in the letter, then fill in the spaces with gold paint.

First draw the letter with double pencils …

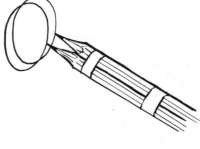

… Then fill in the area between the lines with gold paint.

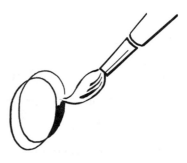

Additional Flourishes

Master calligraphers apply real gold to their calligraphy by using either thin sheets—gold leaf—or gold powder, also called *shell gold*. The powder comes in small blocks and must be mixed with water. It should be applied over yellow ochre paint and burnished afterward. The method by which gold and colors are applied to a manuscript is called illumination.

Alternatively, you can design the letter with a pen or marker on a scrap piece of paper until it looks the way you want it, decorating it with geometric designs or floral motifs if you like, as in the following figure.

Decorate your initial capital letter as you wish.

Using a light box, put this design under the sheet of good paper you've chosen for your final piece and trace over it lightly in pencil. Take the paper off the light box and mix some gold paint. With a fine brush, carefully fill in the pencil-drawn design with gold and other colors.

You don't have to restrict your use of gold to letters. Gold dots around a letter, or as a border, work well. For interesting irregular lines, take a stiff piece of scrap cardboard, such as that around which a shirt is folded when it comes back from a commercial laundry, and cut it to the length of line you want. Paint this with gold paint, then press it on to your work, much as you would use a rubber stamp. Gold markers are no good for actually writing calligraphy, but they can still be put to use. For a gold-rimmed sheet of paper, simply run a gold marker along its edges.

Ribbons and Tassels

The easiest way to present a scroll to someone is the way it's been done from ancient times—roll it up and tie a piece of ribbon around it. Match the ribbon color to the colors used or choose a symbolic color such as white for weddings, or pink or blue for birth announcements. You can buy wide cardboard mailing tubes at many stationery stores to send scrolls through the mail.

For more formal pieces you can make a more sophisticated tying arrangement. Right at the beginning, allow a few extra inches at the bottom of the scroll to attach the ribbons. The easiest method is to make two slits at the end of the manuscript and simply thread the ribbon through them, as shown in the following figure.

Adding ribbons to a scroll …

... Means you can present it decoratively.

For a sturdier arrangement, fold the end of the scroll over so you have a double thickness of paper and make five slits at regular intervals along this edge, as shown in the following figure.

Make five cuts in a double thickness of paper ...

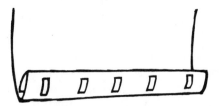

Take your ribbon—you will need a length at least four times the width of the scroll—and thread it through the holes as shown in the following figure. Glue down the folded-over paper and wait until it dries.

... And thread the ribbon through.

Cutouts and 3-D Decorations

Cutouts add depth and interest to greeting cards and are easy to do, especially if you make a small trial card out of scrap paper to test an idea first (before cutting up good paper). Try the ideas shown in the following figures—or let them inspire you to make your own variations.

Write each letter far apart and then cut out each one so it is on its own flap, to give added dimension to your message.

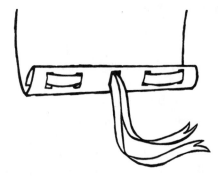

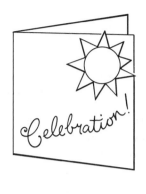

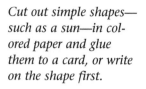

Cut out simple shapes—such as a sun—in colored paper and glue them to a card, or write on the shape first.

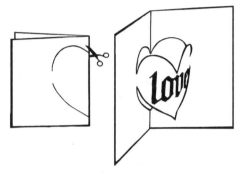

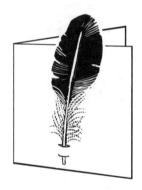

Make a heart—or any simple shape—that pops up.

Any suitable three-dimensional object can be threaded through slits to evoke a mood.

Framing

There's a huge selection of ready-made frames out there today, available in many different types of stores, but especially stationers, gift shops, and art supply shops. You also can sometimes find frames at garage or tag sales but you might need to get new glass for them. On the whole, it's usually easy to find exactly what you want without going to a specialty framing shop; although you might choose that option for a frame with unusual dimensions, or an oval frame, or if you need a particular type of glass or acrylic for lightness.

Nonglare glass reduces reflections, and *conservation glass* is coated with a special material that filters out 97 percent of ultraviolet radiation. There's also *anti-reflective glass,* which absorbs glare and makes the framing look almost glassless.

Ink Blots

Ideally, for the best results, decorations and embellishments should be elements you incorporate into the design of a piece from the beginning, not something you tack on at the last moment.

To make a store-bought frame as special as a custom-made one, you'll want to cut a mat—an inner frame of colored paper—to surround your work. However, it probably will mean you'll need to buy a larger frame than you expected.

Sharp Points

Cutting mats out of thick cardboard takes practice (the best framemakers are adept at making precise beveled edges), but cutting them from colored paper is easy. You just need to take your measurements carefully and make neat corners with a sharp knife.

The main purpose of a mat is to separate the artwork from the glass. Paper expands and contracts with temperature and humidity changes. The mat allows room for that inside the frame. Mats also can enhance what's being framed. Artists often pick a color from the artwork and use that as the color of the mat, but nothing about the frame or mat should be too eye catching. The first thing your eye should be drawn to is the art.

Ideally, the mat should be at least two inches wide at the top and each side and three inches at the bottom. Before you cut it out, make yourself a framing tool of two pieces of black cardboard cut in the shape of an L. (See Chapter 8, "Designing a Project," for a figure showing how this works.) By moving these about, you will find the most pleasing amount of margin to allow before the mat surrounds your work. Once you've allowed for margins and taken the measurements for the mat into account, you'll have the right dimensions to take with you when you go to buy a frame. On the whole, it's best to choose a simple frame design so as not to detract from the calligraphy.

The mat is a colored framing border that usually picks up a color in the artwork.

Ink Blots

Don't hang your masterpiece in direct sunlight or strong fluorescent lights! Ultraviolet rays fade the colors of artwork, and paper deteriorates and turns brittle over time. Also, try to avoid hanging artwork where the temperature fluctuates or where humidity remains over 70 percent for long periods of time.

After the discipline of learning to form letters correctly, it's fun to dress them up and show them off with gold paint and decorative additions. Give your imagination free rein when dreaming up these finishing touches to display your work to its best advantage.

The Least You Need to Know

➤ Use gold paint or ink instead of real gold—it's easier and less expensive.

➤ Add ribbons to documents so you can roll them for presentation.

➤ Add a three-dimensional effect to greeting cards by making slits and cuts.

➤ For calligraphy, choose simple frames with a wide margin of space around the writing.

Part 6

Try Your Hand at These

This part introduces four more calligraphy hands set out in a stroke-by-stroke format for you to practice. It's up to you whether to specialize in one or use them all—they're here for when you need a special look or letter.

Roman capitals are for classic, dignified headlines; uncials for when you want a sprightly, whimsical look. Foundational, is solid and steady, and Gothic is dignified and dark, antique, or Christmasy, depending on how you use it.

When you're making a design, try doing words in different styles—it's like dressing them up in different fashions to give them a different personality.

Roman Capitals

> ## In This Chapter
>
> ➤ Introducing Roman capitals
>
> ➤ Forming letters with a stroke-by-stroke guide
>
> ➤ Learning how to make similarly shaped letters as a group
>
> ➤ Studying the stroke sequence for each letter

The classic capital letters, or majuscules, used by the Romans since the first century B.C.E., can still be seen today in monumental inscriptions incised in stone or marble such as on the Trajan column in Rome. The beautiful proportions of these square capitals, or *quadrata*, are based on geometric principles, using the square and circle. When you can "see" a circle around the circular letters and a rectangle or square around the other letters, you will know you've made them correctly.

Classic and Dignified

Roman capitals are truly classic, which means they are suitable for any writing that you want to look regal and dignified. They can be used as a large initial letter at the beginning of a sentence or they can make a headline into a statement by themselves.

Sharp Points

To draw Roman capitals successfully you need to master an unwavering vertical stroke and maintain the elegant proportions of the letter form. Proportions should be consistent between letters that are alike, such as E and F.

Additional Flourishes

The Romans didn't have the letters J, U, and W—they came during the Middle Ages—or the Greek letters Y and Z, but today we still write all the other letters almost exactly the way the Romans did centuries ago.

Ink Blots

Pay attention to the horizontal crossbars. Most beginners make them too heavy or place them too high or too low.

Look at the O in the following figure. The outside edge is a circle; the inside shape of the counter is more oval. The letter has a diagonal axis, meaning that the thinnest parts are not at the top and bottom but slightly to the left at the top and slightly to the right at the bottom. This slight backward slant makes each curve more natural for the wrist to draw. This style needs a generous amount of space between each letter—remember the rules of spacing and aim for a visually equal amount of space inside the letters and between them.

When writing this alphabet you should be aware that all the letters are one of four widths. The widest group consists of W, M, and Q. The thinnest group consists of E, F, L, S, and J. The majority of letters would just about fit into a square: A, C, D, G, H, K, N, O, R, U, V, and Y. The remaining letters, B, P, X, Z, and T, are little wider than the thinnest letters.

The Important Things to Know About Roman Capitals

Keep the following in mind about Roman capitals:

➤ The letters are upright.

➤ The letters should be drawn on lines 7 nib widths apart. Because they are capital letters, there are no ascenders or descenders; therefore, the lines can be as close together as you want them to be.

➤ Keep your pen at a 30-degree angle for most letters, but 45 degrees for letters with diagonals such as A, V, W, X, and Y. The Z needs a 20- or 30-degree angle for the horizontals.

➤ The thicks and thins of this style are not as contrasted as they are in italic. The curved lines should be slightly thicker at their widest points than the straight strokes. That way, they give the optical illusion of being the same thickness.

➤ The shape of O is a circle—remember this when you are making any of the circular letters. The thinnest letters, E, F, L, S, and J, are half as wide as an O.

Serifs

The serifs are important to this style. Start the strokes of most letters from a little to the left to make a small beginning line that is the serif before pulling down into the main stroke. Most downstrokes finish with a flag serif foot that is a pull of the pen a little to the left and then more definitely to the right.

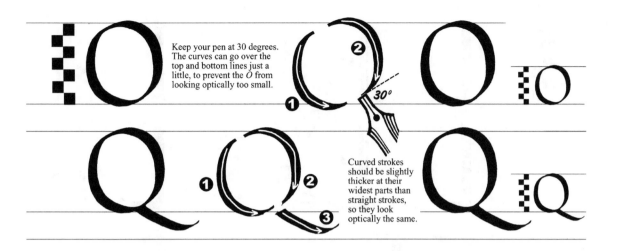

Keep your pen at 30 degrees. The curves can go over the top and bottom lines just a little, to prevent the *O* from looking optically too small.

Curved strokes should be slightly thicker at their widest parts than straight strokes, so they look optically the same.

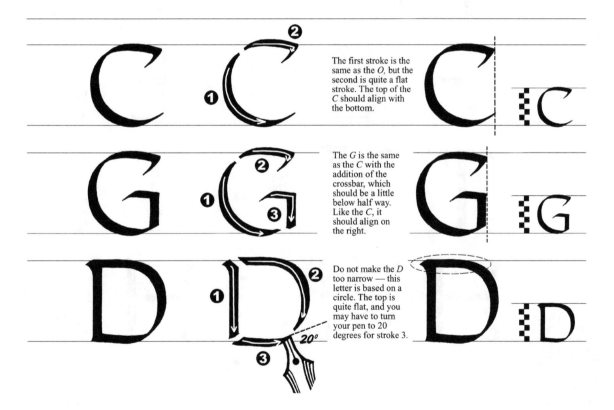

The first stroke is the same as the *O*, but the second is quite a flat stroke. The top of the *C* should align with the bottom.

The *G* is the same as the *C* with the addition of the crossbar, which should be a little below half way. Like the *C*, it should align on the right.

Do not make the *D* too narrow — this letter is based on a circle. The top is quite flat, and you may have to turn your pen to 20 degrees for stroke 3.

175

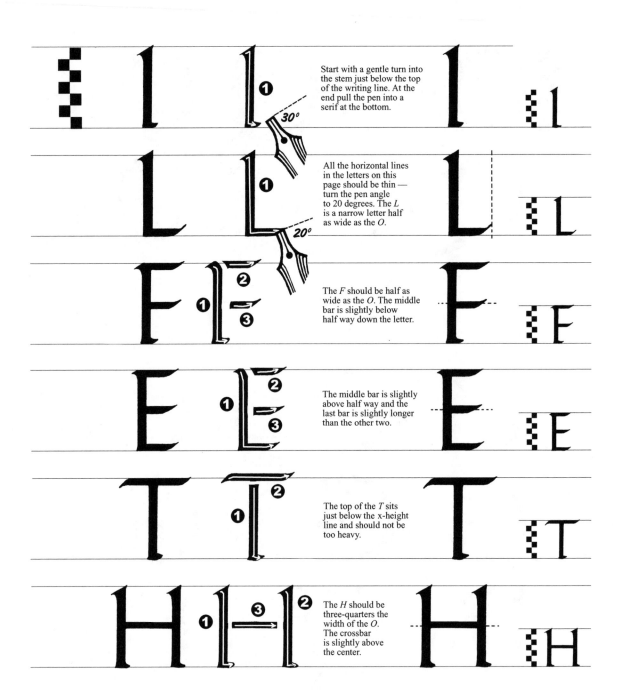

Start with a gentle turn into the stem just below the top of the writing line. At the end pull the pen into a serif at the bottom.

All the horizontal lines in the letters on this page should be thin — turn the pen angle to 20 degrees. The *L* is a narrow letter half as wide as the *O*.

The *F* should be half as wide as the *O*. The middle bar is slightly below half way down the letter.

The middle bar is slightly above half way and the last bar is slightly longer than the other two.

The top of the *T* sits just below the x-height line and should not be too heavy.

The *H* should be three-quarters the width of the *O*. The crossbar is slightly above the center.

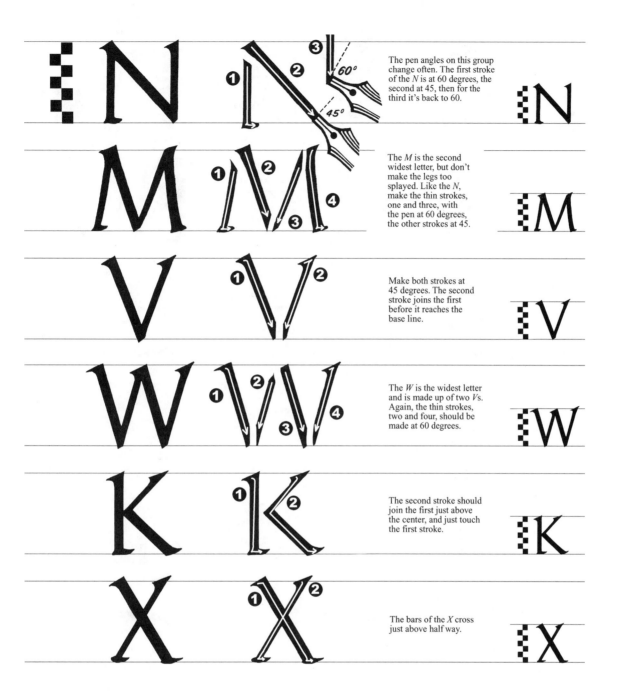

The pen angles on this group change often. The first stroke of the *N* is at 60 degrees, the second at 45, then for the third it's back to 60.

The *M* is the second widest letter, but don't make the legs too splayed. Like the *N*, make the thin strokes, one and three, with the pen at 60 degrees, the other strokes at 45.

Make both strokes at 45 degrees. The second stroke joins the first before it reaches the base line.

The *W* is the widest letter and is made up of two *V*s. Again, the thin strokes, two and four, should be made at 60 degrees.

The second stroke should join the first just above the center, and just touch the first stroke.

The bars of the *X* cross just above half way.

177

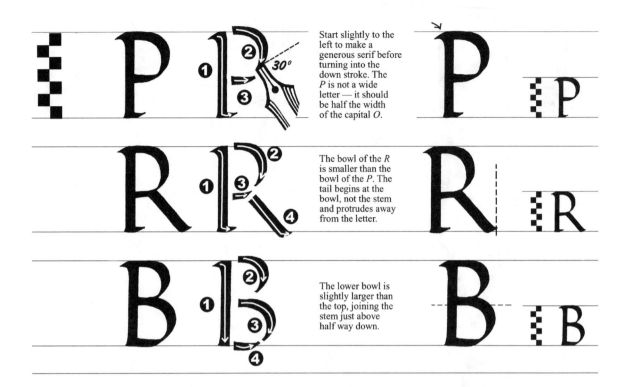

Start slightly to the left to make a generous serif before turning into the down stroke. The *P* is not a wide letter — it should be half the width of the capital *O*.

The bowl of the *R* is smaller than the bowl of the *P*. The tail begins at the bowl, not the stem and protrudes away from the letter.

The lower bowl is slightly larger than the top, joining the stem just above half way down.

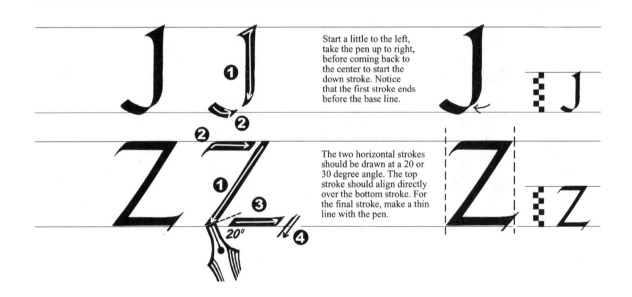

Start a little to the left, take the pen up to right, before coming back to the center to start the down stroke. Notice that the first stroke ends before the base line.

The two horizontal strokes should be drawn at a 20 or 30 degree angle. The top stroke should align directly over the bottom stroke. For the final stroke, make a thin line with the pen.

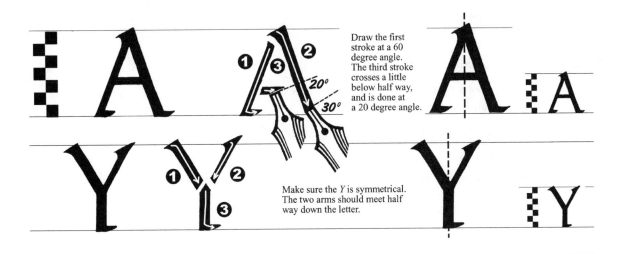

Draw the first stroke at a 60 degree angle. The third stroke crosses a little below half way, and is done at a 20 degree angle.

Make sure the Y is symmetrical. The two arms should meet half way down the letter.

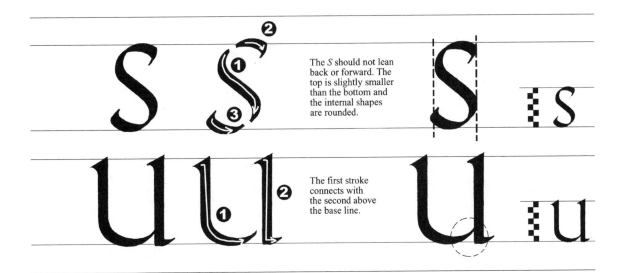

The S should not lean back or forward. The top is slightly smaller than the bottom and the internal shapes are rounded.

The first stroke connects with the second above the base line.

The Least You Need to Know

➤ This is a classic, dignified style.

➤ Don't try to squeeze the letters to fit a certain space; this type style is based on the square and circle.

➤ Change the direction of the nib for diagonals.

➤ Serifs can vary.

Uncials

In This Chapter

➤ Introducing Uncial

➤ Forming letters with a stroke-by-stroke guide

➤ Learning how to make similarly shaped letters as a group

➤ Studying the stroke sequence for each letter

Uncial is the oldest style of lettering in the book. It evolved between the second and fourth centuries and is a fusion of capital letter forms, Greek and Roman precedents, and the use of the pen. Until the eighth century, Uncial was the standard book hand in Europe. *The Lindesfarne Gospels* and the *Book of Kells* are two beautiful examples from that time.

This is an alphabet with wide letters that need space. The letters should not be cramped or squashed. There are no separate capital letters; they are all one height.

Wide and Sprightly

This style represents a style midway between Roman capital letters and the development of lowercase letters, so there are no separate capital letters. (To give the emphasis of caps, you can write initial letters larger or in color.) You can see the beginnings of ascenders and descenders in the short forms of them in this style.

This is a style for when you have lots of room to play with—uncials look best in long lines of text. Be generous with the letter spacing and line spacing. Ideally, the space between the lines would be one and a half times the x-height of the letters, or 6 nib widths; but if the lines are short, you might need more.

To write this style correctly, it might help to hold your elbow close to your body, or to use a right oblique nib if you are right-handed. Uncial probably is a good hand to try if you are left-handed, as you will not have to twist your wrist so much.

The flat pen angle this style is written with—20 degrees—gives a very horizontal look to the words. There are no elaborate serifs; just the hook serifs at the beginnings and ends of most letters.

The Important Things to Know About Uncials

Keep the following in mind concerning *uncials:*

➤ The o is a slightly extended circle.

➤ Uncials should be drawn on lines 4 nib widths apart.

➤ Keep your pen at a 20-degree angle.

➤ Ascenders and descenders are small, extending 2 nib widths beyond the line for the x-height.

➤ There is no slant to the letters; this is an upright style.

The Least You Need to Know

➤ Uncials are an easier hand for left-handers to learn.

➤ Use this style only when you have a lot of room—it's very wide.

➤ There are no separate capital letters for this style.

➤ The o is a slightly extended circle.

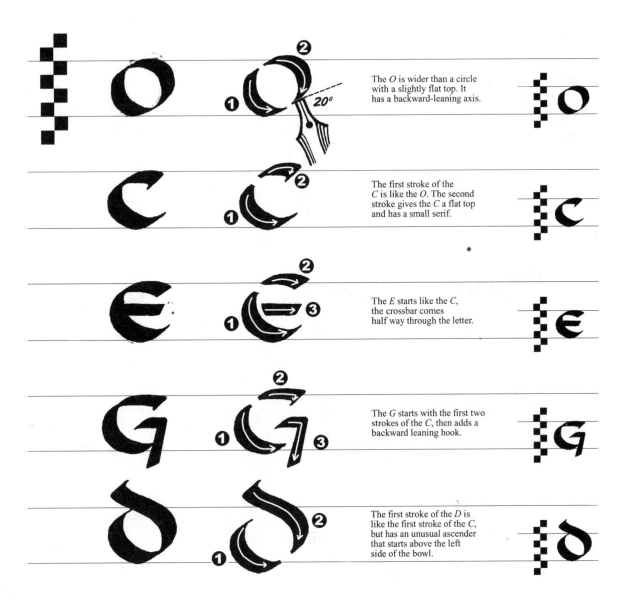

The *O* is wider than a circle with a slightly flat top. It has a backward-leaning axis.

The first stroke of the *C* is like the *O*. The second stroke gives the *C* a flat top and has a small serif.

The *E* starts like the *C*, the crossbar comes half way through the letter.

The *G* starts with the first two strokes of the *C*, then adds a backward leaning hook.

The first stroke of the *D* is like the first stroke of the *C*, but has an unusual ascender that starts above the left side of the bowl.

183

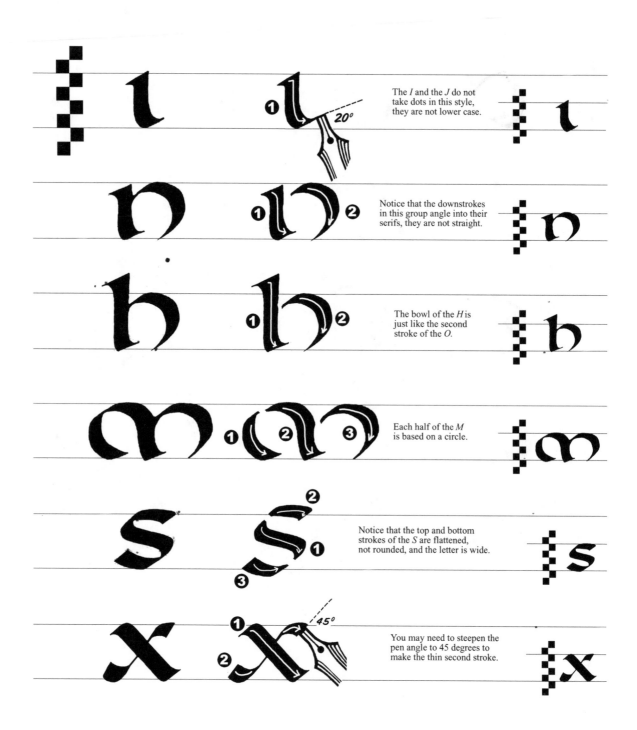

The *I* and the *J* do not take dots in this style, they are not lower case.

Notice that the downstrokes in this group angle into their serifs, they are not straight.

The bowl of the *H* is just like the second stroke of the *O*.

Each half of the *M* is based on a circle.

Notice that the top and bottom strokes of the *S* are flattened, not rounded, and the letter is wide.

You may need to steepen the pen angle to 45 degrees to make the thin second stroke.

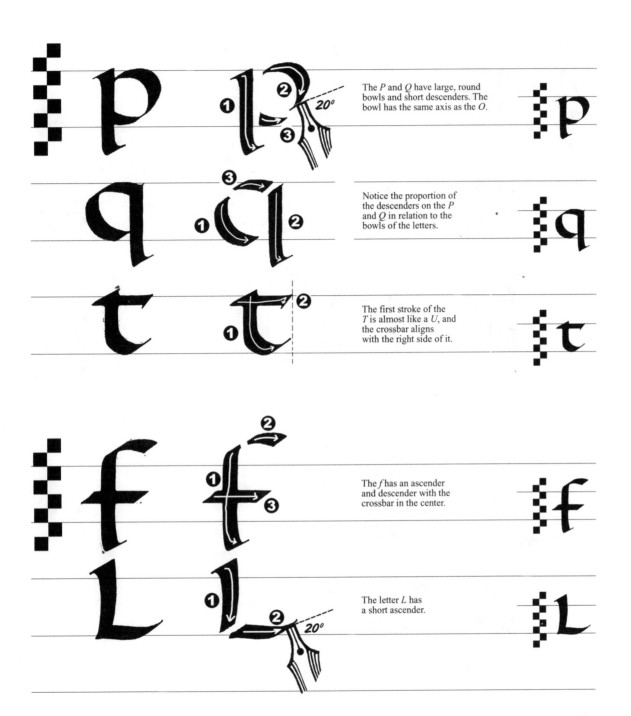

The *P* and *Q* have large, round bowls and short descenders. The bowl has the same axis as the *O*.

Notice the proportion of the descenders on the *P* and *Q* in relation to the bowls of the letters.

The first stroke of the *T* is almost like a *U*, and the crossbar aligns with the right side of it.

The *f* has an ascender and descender with the crossbar in the center.

The letter *L* has a short ascender.

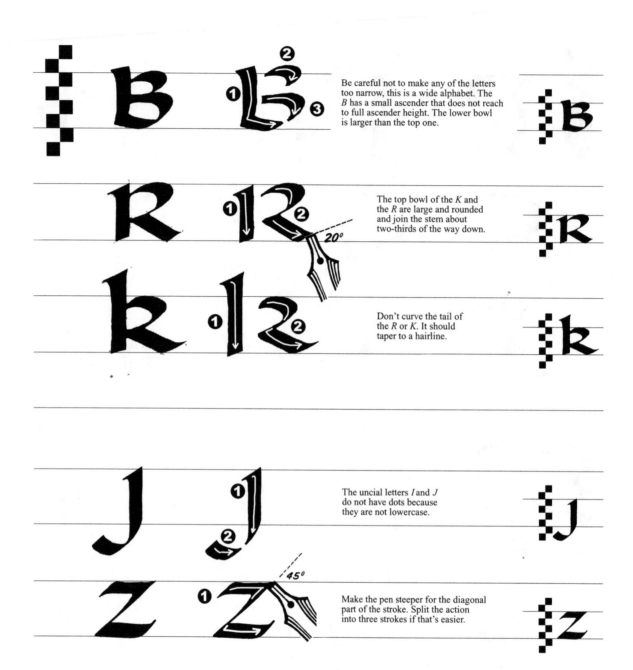

Be careful not to make any of the letters too narrow, this is a wide alphabet. The *B* has a small ascender that does not reach to full ascender height. The lower bowl is larger than the top one.

The top bowl of the *K* and the *R* are large and rounded and join the stem about two-thirds of the way down.

Don't curve the tail of the *R* or *K*. It should taper to a hairline.

The uncial letters *I* and *J* do not have dots because they are not lowercase.

Make the pen steeper for the diagonal part of the stroke. Split the action into three strokes if that's easier.

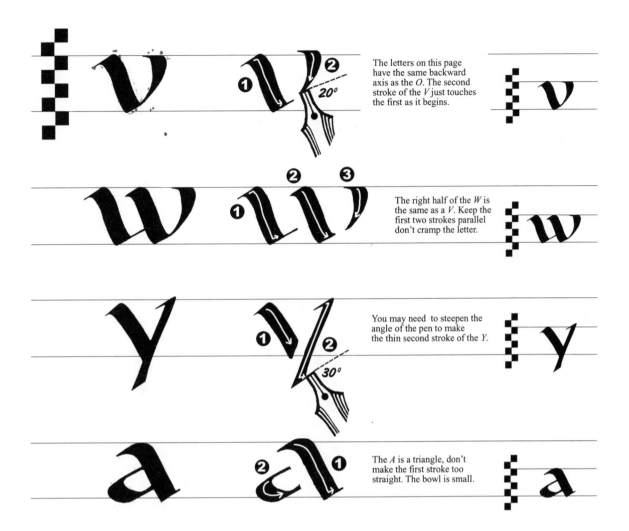

The letters on this page have the same backward axis as the *O*. The second stroke of the *V* just touches the first as it begins.

The right half of the *W* is the same as a *V*. Keep the first two strokes parallel don't cramp the letter.

You may need to steepen the angle of the pen to make the thin second stroke of the *Y*.

The *A* is a triangle, don't make the first stroke too straight. The bowl is small.

Foundational

In This Chapter

➤ Introducing Foundational

➤ Forming letters with a stroke-by-stroke guide

➤ Learning how to make similarly shaped letters as a group

➤ Studying the stroke sequence for each letter

Foundational, also called *Round Hand,* is one of the most elegant writing styles. The British calligrapher Edward Johnston (1872–1944) developed the modern form of this hand from manuscripts written in the tenth century. He called it "Foundational" because he felt it was a good style for calligraphy students to start with.

Calligraphy in Foundational looks formal and important. A beautiful example is the Winchester Bible, written during the tenth century.

Solid and Steady

Foundational is a very basic style and a good one to start with if you find italic difficult. It is based on a round letter O, which provides the pattern for the rest of the alphabet, so make sure all your letters are round and fat; do not condense their roundness. This style has a very even texture because the curves, widths of letters, and internal spaces relate to one another in every letter.

The letters need frequent pen lifts and use mainly pull strokes. The version of Foundational shown here uses flag serifs for some of the letters. You can make them as a separate horizontal stroke or incorporate them into you main stroke by taking the pen a little to the left at the end of a vertical stroke and then making the more definite movement to the right. However, if you find them difficult to do, use a simple oval serif. It's up to you to use whichever serif form you prefer.

The Important Things to Know About Foundational

The following are important to know about Foundational:

➤ There is a characteristic oval shape to the counters or white spaces of the O—but the outside shape is circular.

➤ This is an upright style of writing.

➤ Foundational should be drawn on lines 4 nib widths apart, with the capital letters drawn on lines 7 nib widths apart.

➤ Ascenders and descenders are drawn on lines 6½ nib widths apart.

➤ Keep your pen at a 30-degree angle.

➤ The g is an unusual letter. Notice that its top circular part is not the full depth of the writing lines.

Other points to keep in mind are …

➤ All the arched letters are based on a circle. Look at the roundness in the arch of the lowercase n, for example.

➤ The t has a special height of its own—slightly above the top writing line. It's not as tall as h, k, and l.

➤ The z is the only letter in the alphabet that is not at the 30-degree angle. The middle stroke is written with the pen turned flat to the writing line.

➤ You need a minimum of double the x-height of the letters so that ascenders and descenders don't collide.

The Least You Need to Know

➤ You can use oval serifs or flag serifs with this letter form.

➤ The outside shape of the O and letters based on the O is a circle; the shape of the white space inside the O is oval.

➤ This style is a good one to start with if you find italic difficult.

➤ This style has a very even texture and gives a formal look to text.

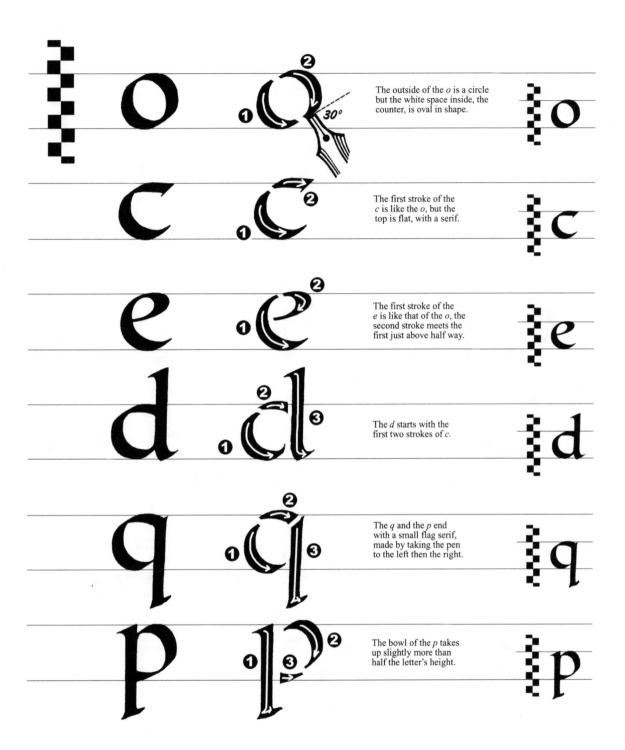

The outside of the *o* is a circle but the white space inside, the counter, is oval in shape.

The first stroke of the *c* is like the *o*, but the top is flat, with a serif.

The first stroke of the *e* is like that of the *o*, the second stroke meets the first just above half way.

The *d* starts with the first two strokes of *c*.

The *q* and the *p* end with a small flag serif, made by taking the pen to the left then the right.

The bowl of the *p* takes up slightly more than half the letter's height.

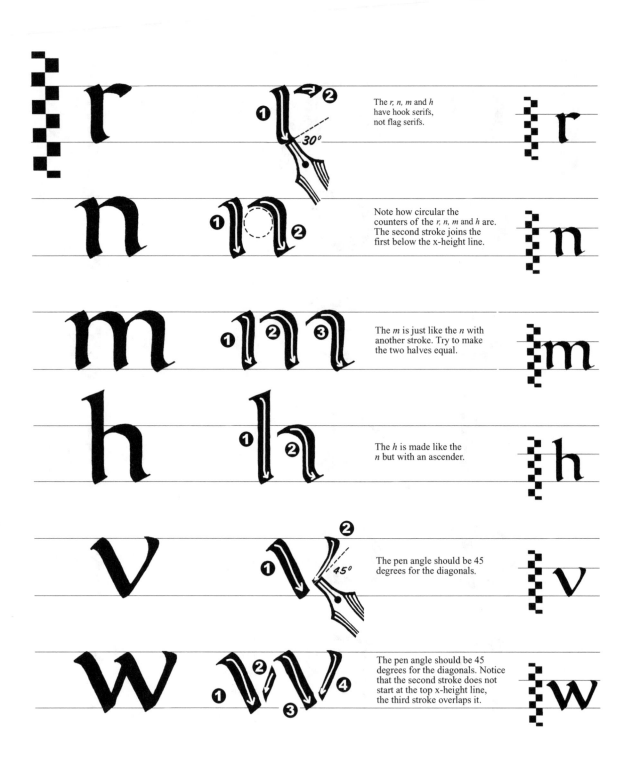

The *r, n, m* and *h*
have hook serifs,
not flag serifs.

Note how circular the
counters of the *r, n, m* and *h* are.
The second stroke joins the
first below the x-height line.

The *m* is just like the *n* with
another stroke. Try to make
the two halves equal.

The *h* is made like the
n but with an ascender.

The pen angle should be 45
degrees for the diagonals.

The pen angle should be 45
degrees for the diagonals. Notice
that the second stroke does not
start at the top x-height line,
the third stroke overlaps it.

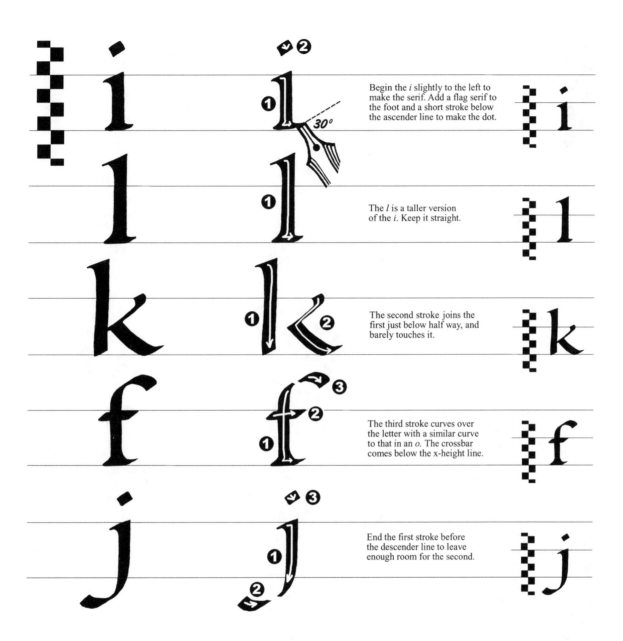

Begin the *i* slightly to the left to make the serif. Add a flag serif to the foot and a short stroke below the ascender line to make the dot.

The *l* is a taller version of the *i*. Keep it straight.

The second stroke joins the first just below half way, and barely touches it.

The third stroke curves over the letter with a similar curve to that in an *o*. The crossbar comes below the x-height line.

End the first stroke before the descender line to leave enough room for the second.

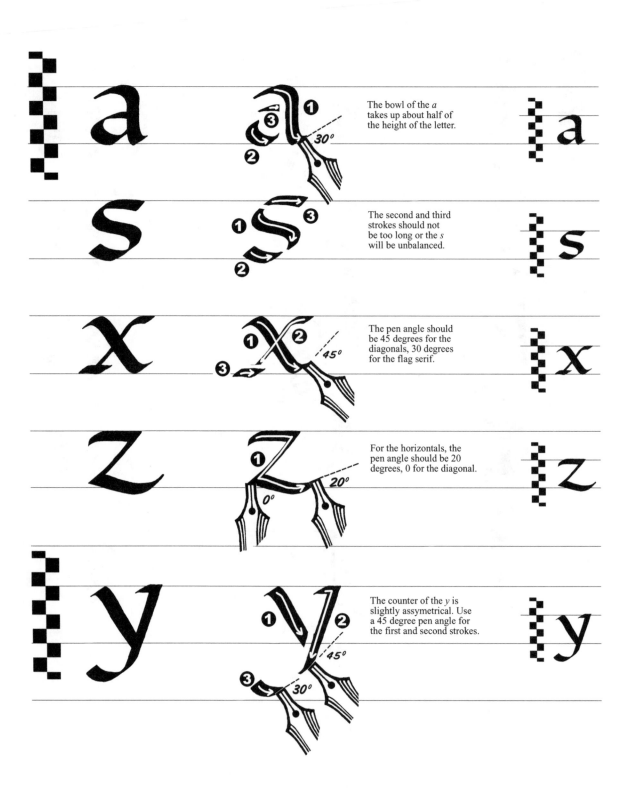

The bowl of the *a* takes up about half of the height of the letter.

The second and third strokes should not be too long or the *s* will be unbalanced.

The pen angle should be 45 degrees for the diagonals, 30 degrees for the flag serif.

For the horizontals, the pen angle should be 20 degrees, 0 for the diagonal.

The counter of the *y* is slightly assymetrical. Use a 45 degree pen angle for the first and second strokes.

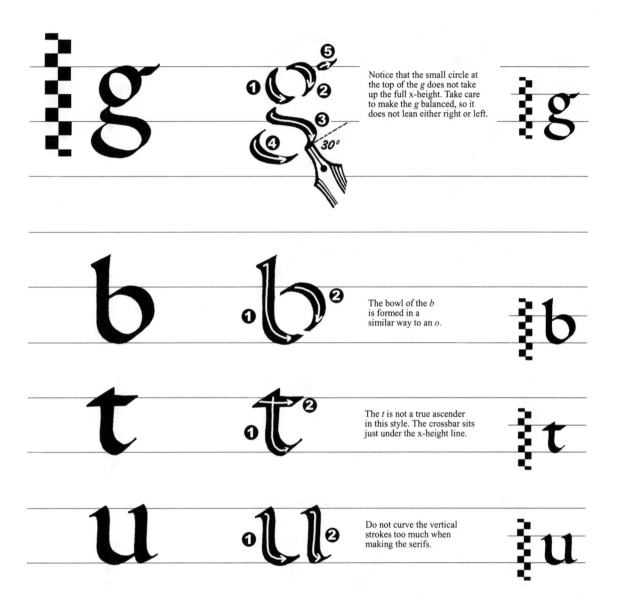

Notice that the small circle at the top of the *g* does not take up the full x-height. Take care to make the *g* balanced, so it does not lean either right or left.

The bowl of the *b* is formed in a similar way to an *o*.

The *t* is not a true ascender in this style. The crossbar sits just under the x-height line.

Do not curve the vertical strokes too much when making the serifs.

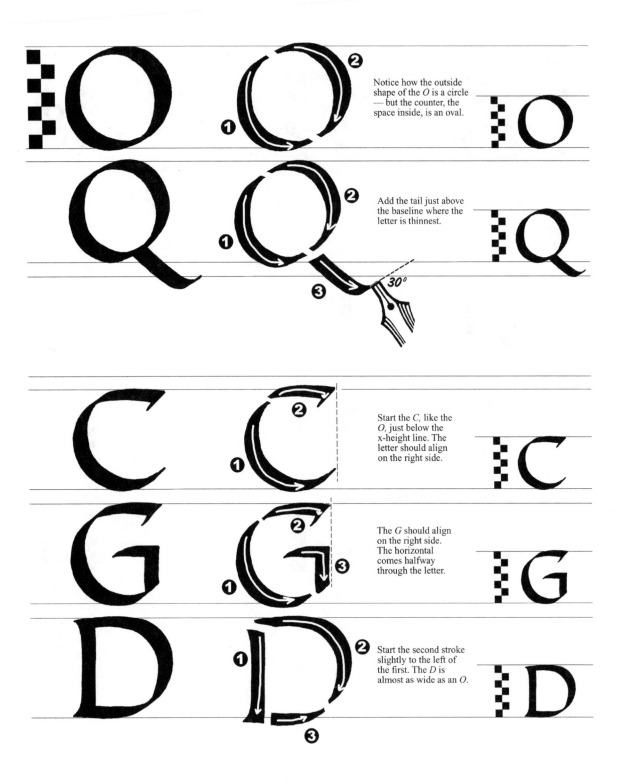

Notice how the outside shape of the *O* is a circle — but the counter, the space inside, is an oval.

Add the tail just above the baseline where the letter is thinnest.

Start the *C*, like the *O*, just below the x-height line. The letter should align on the right side.

The *G* should align on the right side. The horizontal comes halfway through the letter.

Start the second stroke slightly to the left of the first. The *D* is almost as wide as an *O*.

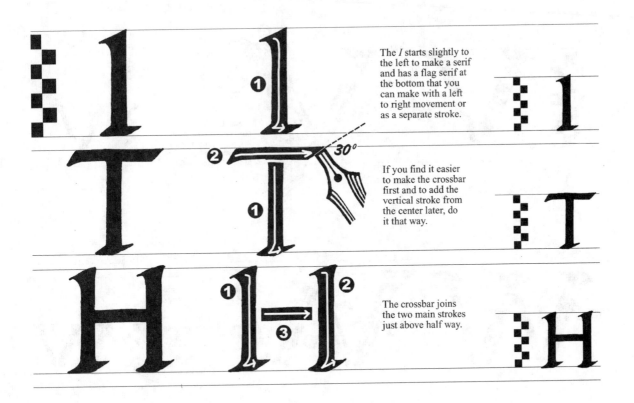

The *I* starts slightly to the left to make a serif and has a flag serif at the bottom that you can make with a left to right movement or as a separate stroke.

If you find it easier to make the crossbar first and to add the vertical stroke from the center later, do it that way.

The crossbar joins the two main strokes just above half way.

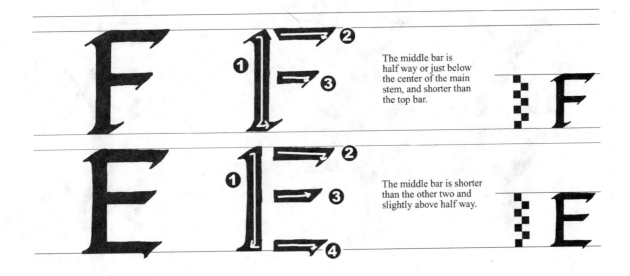

The middle bar is half way or just below the center of the main stem, and shorter than the top bar.

The middle bar is shorter than the other two and slightly above half way.

197

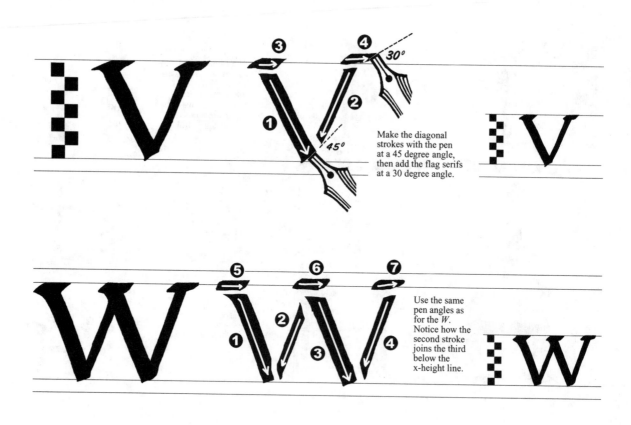

Make the diagonal strokes with the pen at a 45 degree angle, then add the flag serifs at a 30 degree angle.

Use the same pen angles as for the *W*. Notice how the second stroke joins the third below the x-height line.

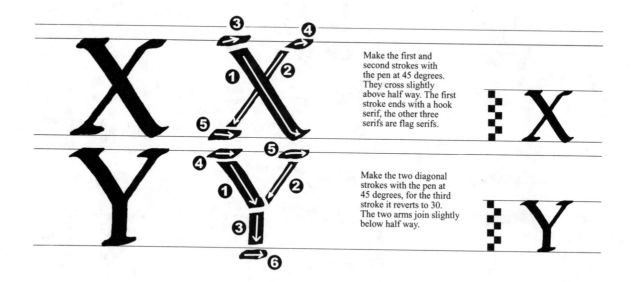

Make the first and second strokes with the pen at 45 degrees. They cross slightly above half way. The first stroke ends with a hook serif, the other three serifs are flag serifs.

Make the two diagonal strokes with the pen at 45 degrees, for the third stroke it reverts to 30. The two arms join slightly below half way.

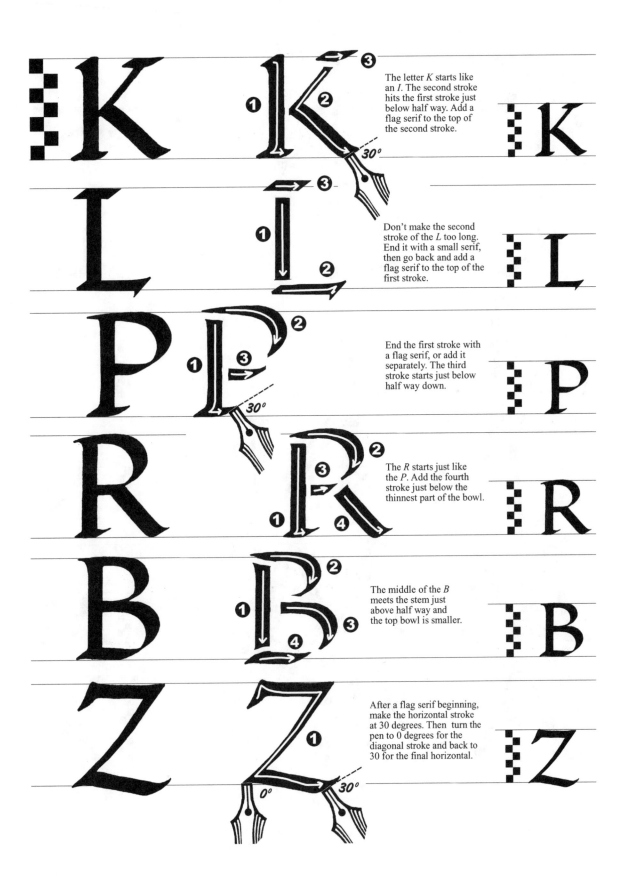

The letter *K* starts like an *I*. The second stroke hits the first stroke just below half way. Add a flag serif to the top of the second stroke.

Don't make the second stroke of the *L* too long. End it with a small serif, then go back and add a flag serif to the top of the first stroke.

End the first stroke with a flag serif, or add it separately. The third stroke starts just below half way down.

The *R* starts just like the *P*. Add the fourth stroke just below the thinnest part of the bowl.

The middle of the *B* meets the stem just above half way and the top bowl is smaller.

After a flag serif beginning, make the horizontal stroke at 30 degrees. Then turn the pen to 0 degrees for the diagonal stroke and back to 30 for the final horizontal.

199

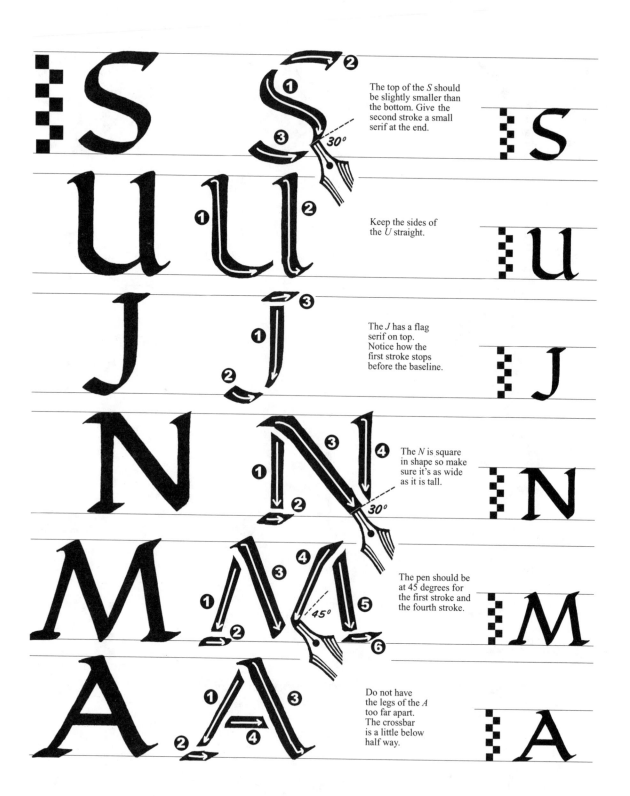

The top of the *S* should be slightly smaller than the bottom. Give the second stroke a small serif at the end.

Keep the sides of the *U* straight.

The *J* has a flag serif on top. Notice how the first stroke stops before the baseline.

The *N* is square in shape so make sure it's as wide as it is tall.

The pen should be at 45 degrees for the first stroke and the fourth stroke.

Do not have the legs of the *A* too far apart. The crossbar is a little below half way.

Gothic

The Gothic, *Black letter,* or *Old English letter* form conjures thoughts of serious Germanic official documents and old church documents—and also of "Olde Worlde" lettering on newspaper mastheads, antique shops, and Christmas cards. A whole page of Gothic is very dense and can look more like a textured pattern than a page of lettering, but it is effective when used in the right place and provides an interesting counterpoint when used with other styles. Moreover, it's one of the easiest scripts to learn because all the letters are very similar.

Dignified and Dark

Gothic was developed toward the end of the Middle Ages and, like the Gothic arches in the buildings of the same period, it is tall and narrow and pointed. The German printer Johann Gutenberg used this style for the first moveable type. This is a very condensed script with short ascenders and descenders, which means a lot of words can fit on a page—an advantage at a time when books became smaller and more personal.

Gothic is easy to learn because so many of the strokes are similar, but you have to make more strokes per letter than with other styles, especially on the capital letters. The small diagonal, or "diamond" feet, for example, take an extra stroke.

The white spaces inside the letters (the counters) should be no wider than the black strokes, which can make you feel as if you're drawing a piano keyboard or a picket fence. This means that letters with open counters such as r or e have to be very close to the next letter to give an even look.

The Important Things to Know About Gothic

The following are important points to know about Gothic:

➤ The letters are narrow and rigidly straight up and down rather than round or oval.

➤ Gothic should be drawn on lines 5 nib widths apart.

➤ Keep your pen at a 40-degree angle.

➤ Keep the white spaces inside the letters the same width as the black strokes.

➤ Ascenders and descenders are very short—only 2 extra nib widths.

➤ The shape of o is a compressed angular rectangle with no curves.

Never, ever write a word or sentence in all capital letters using this style; it will be totally illegible and ugly because Gothic just wasn't designed to be used this way. If you want to emphasize a word or sentence, use color or size, not caps.

The Least You Need to Know

➤ With this hand, it is important that the spaces within the letters as well as between the letters are kept regular and even.

➤ This is a very dense, black style.

➤ Keep your pen at a 40-degree angle.

➤ Never use all capital letters to make a word.

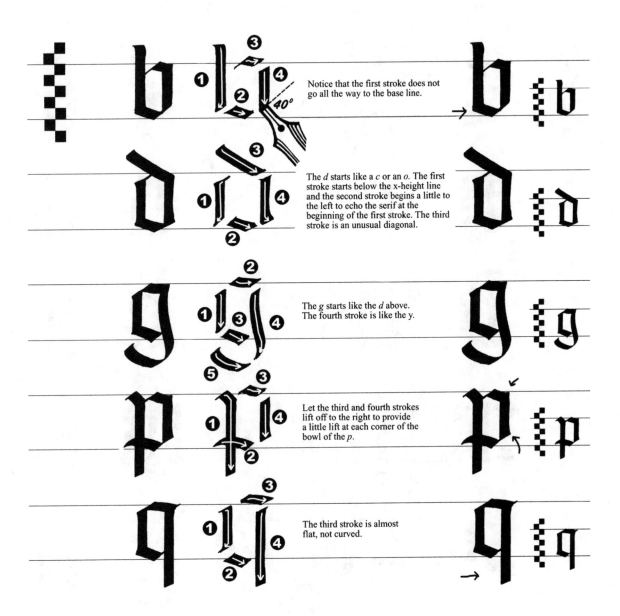

Notice that the first stroke does not go all the way to the base line.

The *d* starts like a *c* or an *o*. The first stroke starts below the x-height line and the second stroke begins a little to the left to echo the serif at the beginning of the first stroke. The third stroke is an unusual diagonal.

The *g* starts like the *d* above. The fourth stroke is like the *y*.

Let the third and fourth strokes lift off to the right to provide a little lift at each corner of the bowl of the *p*.

The third stroke is almost flat, not curved.

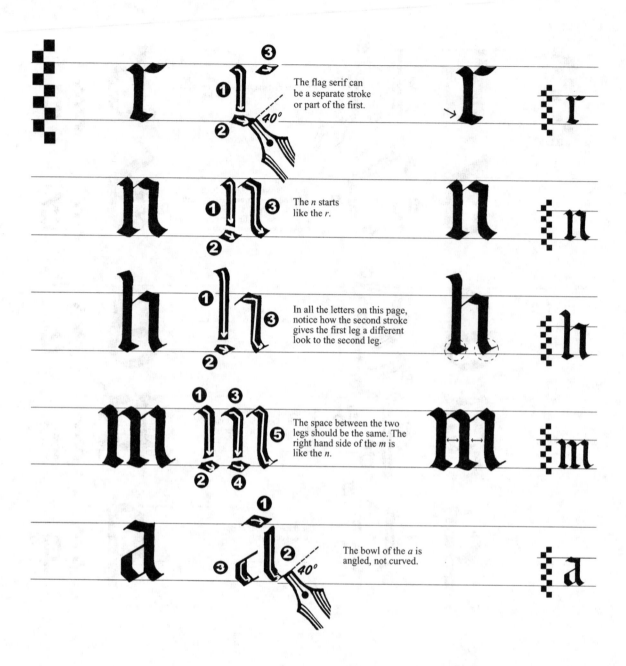

The flag serif can be a separate stroke or part of the first.

The *n* starts like the *r*.

In all the letters on this page, notice how the second stroke gives the first leg a different look to the second leg.

The space between the two legs should be the same. The right hand side of the *m* is like the *n*.

The bowl of the *a* is angled, not curved.

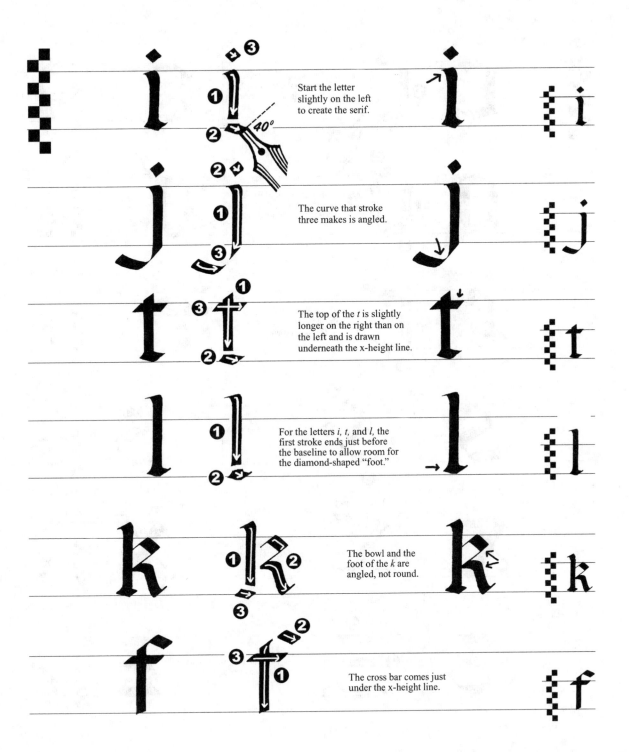

Start the letter slightly on the left to create the serif.

The curve that stroke three makes is angled.

The top of the *t* is slightly longer on the right than on the left and is drawn underneath the x-height line.

For the letters *i, t,* and *l,* the first stroke ends just before the baseline to allow room for the diamond-shaped "foot."

The bowl and the foot of the *k* are angled, not round.

The cross bar comes just under the x-height line.

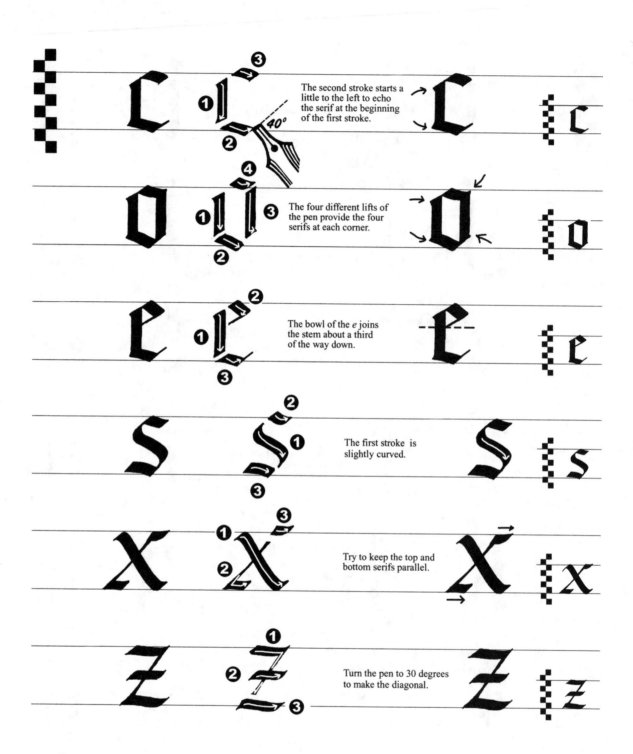

The second stroke starts a
little to the left to echo
the serif at the beginning
of the first stroke.

40°

The four different lifts of
the pen provide the four
serifs at each corner.

The bowl of the *e* joins
the stem about a third
of the way down.

The first stroke is
slightly curved.

Try to keep the top and
bottom serifs parallel.

Turn the pen to 30 degrees
to make the diagonal.

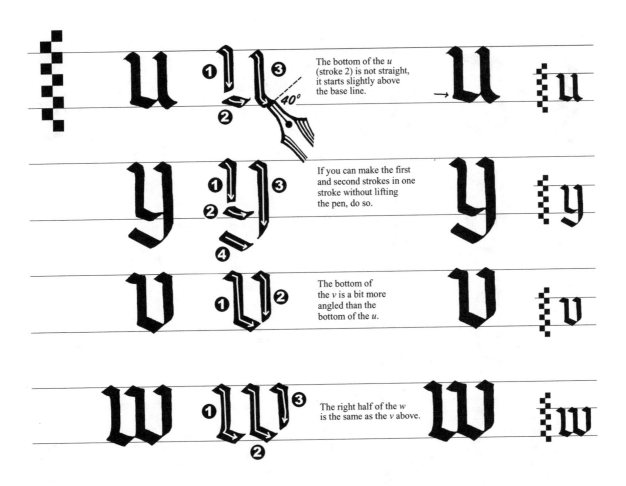

The bottom of the *u* (stroke 2) is not straight, it starts slightly above the base line.

If you can make the first and second strokes in one stroke without lifting the pen, do so.

The bottom of the *v* is a bit more angled than the bottom of the *u*.

The right half of the *w* is the same as the *v* above.

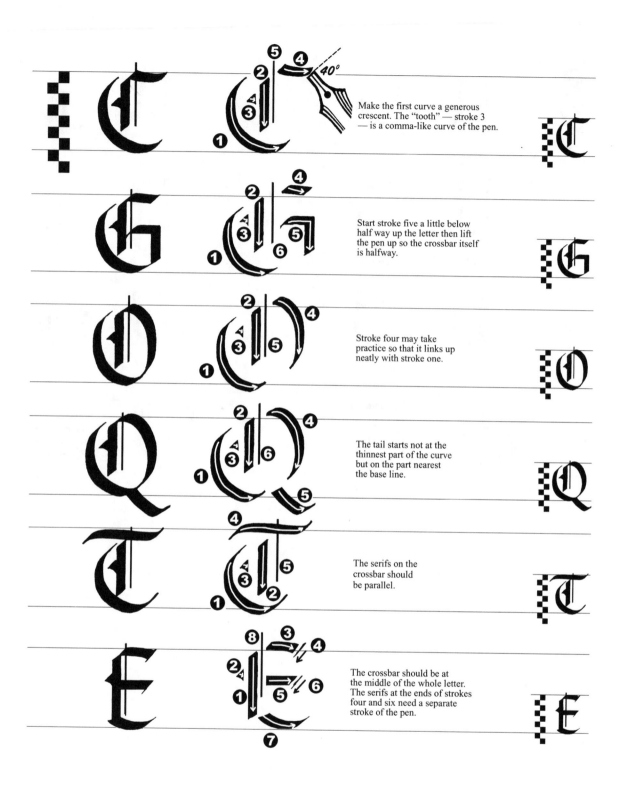

Make the first curve a generous crescent. The "tooth" — stroke 3 — is a comma-like curve of the pen.

Start stroke five a little below half way up the letter then lift the pen up so the crossbar itself is halfway.

Stroke four may take practice so that it links up neatly with stroke one.

The tail starts not at the thinnest part of the curve but on the part nearest the base line.

The serifs on the crossbar should be parallel.

The crossbar should be at the middle of the whole letter. The serifs at the ends of strokes four and six need a separate stroke of the pen.

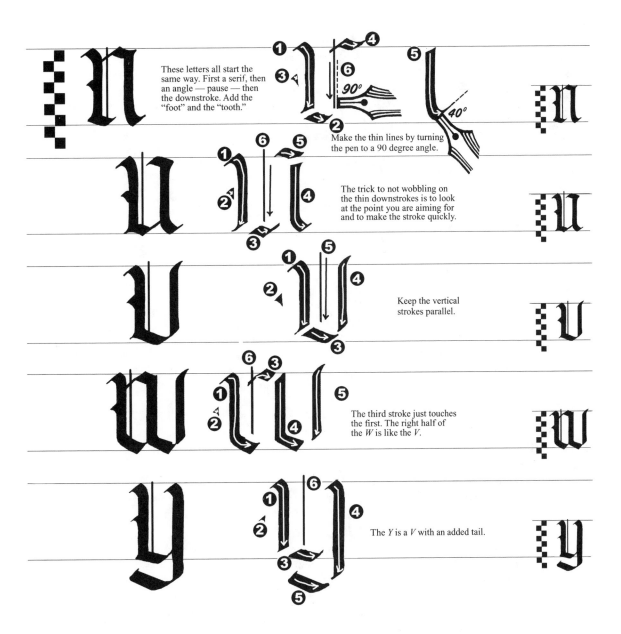

These letters all start the same way. First a serif, then an angle — pause — then the downstroke. Add the "foot" and the "tooth."

Make the thin lines by turning the pen to a 90 degree angle.

90°

40°

The trick to not wobbling on the thin downstrokes is to look at the point you are aiming for and to make the stroke quickly.

Keep the vertical strokes parallel.

The third stroke just touches the first. The right half of the *W* is like the *V*.

The *Y* is a *V* with an added tail.

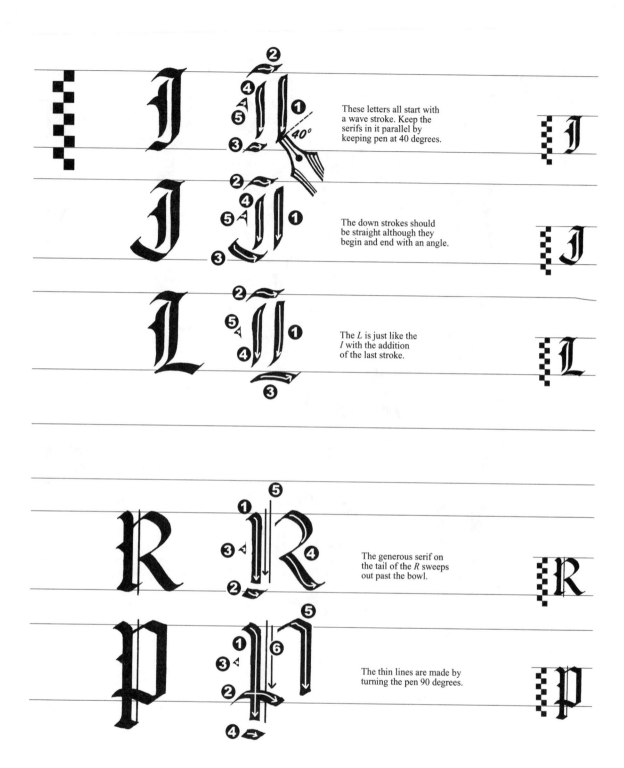

These letters all start with
a wave stroke. Keep the
serifs in it parallel by
keeping pen at 40 degrees.

The down strokes should
be straight although they
begin and end with an angle.

The *L* is just like the
I with the addition
of the last stroke.

The generous serif on
the tail of the *R* sweeps
out past the bowl.

The thin lines are made by
turning the pen 90 degrees.

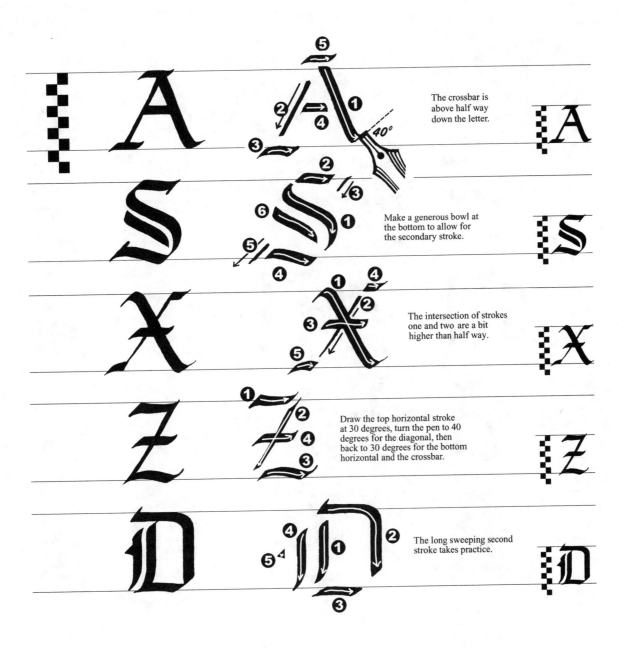

The crossbar is above half way down the letter.

Make a generous bowl at the bottom to allow for the secondary stroke.

The intersection of strokes one and two are a bit higher than half way.

Draw the top horizontal stroke at 30 degrees, turn the pen to 40 degrees for the diagonal, then back to 30 degrees for the bottom horizontal and the crossbar.

The long sweeping second stroke takes practice.

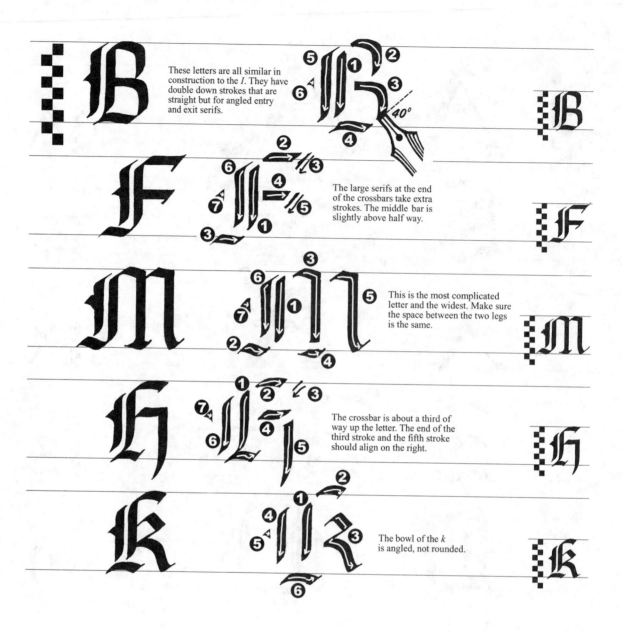

These letters are all similar in construction to the *I*. They have double down strokes that are straight but for angled entry and exit serifs.

The large serifs at the end of the crossbars take extra strokes. The middle bar is slightly above half way.

This is the most complicated letter and the widest. Make sure the space between the two legs is the same.

The crossbar is about a third of way up the letter. The end of the third stroke and the fifth stroke should align on the right.

The bowl of the *k* is angled, not rounded.

Glossary

abecedarian A person studying the alphabet; a beginner. Also, a sentence that contains every letter of the alphabet at least once.

acid-free Paper that has a neutral pH value that will not turn brown and crumble with age.

ampersand A symbol that means "and," from the Latin word *et.*

ascender In lowercase letters, that part of the letter extending above the x-height.

base line Bottom line on which most letters sit.

bowl The part of a letter formed by a curve.

built-up letters Basic letters that have been thickened by additional strokes. When filled with color, they become illuminated letters.

calligraphic nibs Pens with an ink reservoir inside.

Carolingian From the time of Emperor Charlemagne.

copy (noun) The words that are going to be used in a project.

counter Space fully or partially enclosed within a letter.

cursive Script with slanted letters joined by hairlines.

deckle edge Rough uneven natural edge on handmade paper.

descender In lowercase letters, that part of the letter extending below the x-height.

die (noun) Words, letters, or a design made into a raised form, usually of metal, used to create embossed stationery.

drop caps Large, initial letters embedded in text.

ductus Diagrams or information indicating direction and sequence of letter strokes.

ecru A warm, cream color.

engrossing Traditional calligraphy pieces that copy those of ancient scribes, usually with illumination.

exemplar Traditionally, a book from which the master's work was copied. Now, any model piece of work for students' use.

flourish Decorative extension of a pen stroke.

gouache Opaque watercolor.

gum sandarac A water-soluble resin used to improve the quality of a paper's surface.

hairlines Thinnest pen lines possible to make with a nib.

hand A writing style or the way in which someone writes.

hue A color, by name.

illumination Decoration with gold and color; the effect of light shining on manuscript pages.

indent A line of script that starts a little way in from the rest of the text at the beginning.

italic Slanted writing.

justified Words that are aligned at both left and right to create a solid block of copy.

kerning Moving letters close to one another to improve the visual spacing of a word.

ladder The pen marks a calligrapher makes to determine the height of letter style.

layout A plan for organizing text, illustrations, and other decorative elements on a page.

leading Another word for line spacing.

ligature The stroke that connects letters.

lining or **modern numerals** Numbers that are all one size and sit on the base line.

logo or **logotype** A trademark or emblem using letters, a word, or a symbol.

lowercase Small letters, so called to distinguish them from capitals, or uppercase letters.

majuscules Capital letters.

manuscript Writing done by hand.

mat In a picture frame, the border that separates the artwork from the glass.

mechanical Camera-ready artwork in black and white for the printer.

miniscules Lowercase letters.

monogram Entwined initials.

nonaligning or **old-style numerals** Numbers that vary in size with ascenders and descenders.

pangram A sentence that uses all the letters of the alphabet.

parchment Animal skin prepared for writing or a paper that is made to resemble the look of animal skin parchment.

quill A pen made from the flight feathers of a large bird such as a turkey, goose, or swan.

reverse A panel of black or color with white or light-colored writing on it.

Roman Can mean either a lettering style that is upright and not slanted, or about Rome.

sans serif Without serifs.

score (verb) To make an indented line on paper.

serifs Small decorative strokes that begin or end the main strokes of a letter.

swash A sweeping, curling, decorative flourish of the pen added to a letter.

thumbnails Small, rough sketches to indicate a layout plan.

tooth The degree of roughness in the surface of a paper.

uppercase Large or capital letters, so called to distinguish them from lowercase letters.

vellum A high grade of parchment—calfskin prepared as a writing surface, or a paper that is made to resemble the look of animal skin vellum.

versal A carefully drawn capital letter with exaggerated thicks and thins, sometimes colored. So called because such letters were used to begin a verse in medieval religious texts.

weight The relationship of the stroke width to the height of a letter.

widow A paragraph that ends with just one word or part of a word.

x-height The height of the body of a letter, not including ascenders or descenders.

Appendix B

Further Readings

Craig, James. *Designing with Type: A Basic Course in Typography.* Watson-Guptill, New York, 1980.

Douglass, Ralph. *Calligraphic Lettering with a Wide Pen and Brush.* Watson-Guptill, New York, 1967.

Goffe, Gaynor, and Anna Ravenscroft. *Calligraphy School: A Step-by-Step Guide to the Fine Art of Lettering.* The Reader's Digest Association, Inc., New York, 1994.

Haines, Susanne. *The Calligrapher's Project Book.* Crescent Books, New York, 1987.

Harris, David. *The Art of Calligraphy: A practical guide to the skills and techniques.* Dorling Kindersley, New York, 1995.

Sehmi, Satwinder. *Calligraphy: The Rhythm of Writing.* Merehurst, London, 1993.

Shepherd, Margaret. *Calligraphy Now.* G.P Putnam's Sons, New York, 1984.

Siebert, Lori, and Lisa Ballard. *Making a Good Layout.* North Light Books, Cincinnati, Ohio, 1992.

Wilson, Diana Hardy. *The Encyclopedia of Calligraphy Techniques.* Running Press Book Publishers, 1990.

Wong, Frederick. *The Complete Calligrapher.* Watson-Guptill, New York, 1980.

Web Sites

Sites About Calligraphy

www.cynscribe.com Over 1,000 links to sites dealing with all aspects of calligraphy—well worth a look.

www.catalog.com/gallery/links.html Links to sites of interest to calligraphers.

yahoo.com/clubs/calligraphyexchange Talk to other scribes over the Internet.

Suppliers of Book and Calligraphic Materials

www.johnnealbooks.com The best-known supplier of calligraphic supplies and books.

www.paperinkbooks.com Wide range of supplies and books for calligraphers.

www.mollyhawkins.com Wholesale supplier of art and calligraphy supplies.

www.scribesdelight.com Supplies for calligraphers, including sealing wax.

Paper Suppliers

www.paperaccess.com All sorts of cards and papers, including handmade paper.

www.katespaperie.com One of the largest retailers of exotic papers and paper accoutrements.

Index

suppliers (books and materials), 219
 paper, 219
 Web sites, 219
swashes (decorative stroke at the side of a letter), Italic swash capitals, 67

T–V

table easels, 10
tassels, ornamentation, 165-166
themes, wedding invitations, 118-119
thumbnail sketches, project design, 100
timing, printing, 158
tools, 9, 45-49, 149-150
 broad-nibbed pens, 46
 assembly, 46
 cleaning, 49
 correcting ink-flow problems, 48
 loading ink, 47
 reservoirs, 47
 brushes, 153
 carpenter's pencils, 11
 erasers, 49
 felt-tipped calligraphic pens, 11
 fountain pens, 45
 gouache, 49
 makeup sponges, 152
 nibs, cutting, 150-151
 Olfa knife, 49
 quills, designing your own, 150
 rubber stamps, 153
 slant boards, 10-11
tracing the letters (learning a new handwriting style), Formal Italic, 15
transporting paper, 55

Uncials script characteristics, 181-182

W–Z

warming-up exercises, 14
water-soluble ink, 50
waterproof ink, 50
Web sites, suppliers, 219
wedding invitations, 117
 creativity, 121
 enclosures, 119-120
 engraved, 119
 envelope wording, 122-124
 stepped-in addresses, 123

ordering printing, 121
setting guidelines, 117-118
stuffing and mailing envelopes, 125
themes, 118-119
wording, 121
word spacing, 93
wording, wedding invitations, 121